Jack,

Only an editor knows
the pain!

Dai

A GUIDE TO THE COLLECTIONS

SMITH COLLEGE MUSEUM OF ART

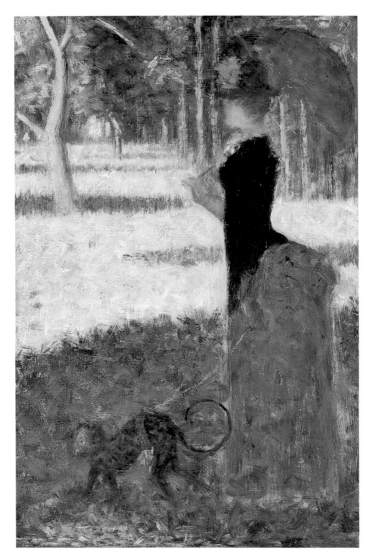

Seurat, *Woman with a Monkey,* no. 88.

A GUIDE TO THE COLLECTIONS

Smith College Museum of Art

NORTHAMPTON, MASSACHUSETTS · 1986

Published by the Smith College
Museum of Art, Northampton,
Massachusetts, 01063, with the aid
of funds provided by The National
Endowment for the Arts, Wash-
ington, D.C., a federal agency.
Additional funds provided by the
Museum Members, Smith College
Museum of Art; Mrs. Sherwood
E. Bain (Caroline Dwight '44); Mrs.
Priscilla Cunningham '58; Mrs.
Sidney W. Edmonds (Madeline
Thompson '13); Mrs. William A.
Evans, Jr. (Charlotte Cushman
'29); Mr. and Mrs. John Kenneth
Galbraith (Catherine Atwater '34);
Philip Hofer; the Maxine Weil
Kunstadter ('24) Fund; the Helen
Osborne Estate (Helen Foster '27);
Mrs. Duncan Phillips; Mr. and
Mrs. James E. Pollak (Mabel
Brown '27); Mr. and Mrs. Morton
Sosland (Estelle Glatt '46); Mr.
and Mrs. Alfred R. Stern (Joanne
Melniker '44); and Enid Silver
Winslow ('54). Copies of this
guide can be obtained from the
Museum.

EDITORS:
Charles Chetham, David F. Grose,
Ann H. Sievers

COPY EDITORS:
Michael Goodison, Linda Muehlig

PHOTOGRAPHERS:
E. Irving Blomstrann,
Hyman Edelstein, John A. Ferrari,
Marjorie de Wolf Laurent,
Alan Spencer, David Stansbury,
Herbert P. Vose, Herrick Studio

ISBN 0-87391-039-7
Library of Congress Catalog Card
Number 86-64015

This guide is dedicated to all those persons in Smith College's 116-year history who have contributed ideas, energy, time, funds, and works of art in the belief that great art is essential for intellectual and spiritual well-being.

Table of Contents

About this guide

This publication is the first overview of our collection to appear in forty-six years. Previous collections catalogues were published in 1925, 1937, and 1941 (see p. 306). The present guide provides the reader with a basis for further study. It suggests the kinds of information available about the Museum's collection and its history.

The fact that only 302 out of 18,000 objects have been chosen for inclusion may make our selection seem arbitrary. The illustrations in each section, however, suggest the strengths and distribution of the collection. Clearly many other great works of art could have been shown. The scope of the collection is defined by brief essays that characterize curatorial divisions: painting and sculpture, prints, drawings, photographs, decorative arts, ancient art, Asiatic art, and the art of traditional societies. For each object included in this guide there is a complete provenance, attribution, exhibition, and bibliographical record in the documentary files of the Museum. It would have been financially prohibitive to publish these here. (Persons interested in this information should write the Museum.) In addition to the 302 illustrations and entries there is a list of painters, sculptors, printmakers, draughtsmen, and photographers whose works are included in the major areas of our collection. An outline of the history of the Museum is provided in the Chronology and in a section describing the four buildings that have housed Smith's collections since 1875. Finally, Alfred Vance Churchill's "Concentration Plan" — the Museum's collecting policy as envisioned by Mr. Churchill and confirmed by a vote of the College's Trustees — is reprinted in full.

During the several years devoted to the updating of our records, many members of the staff made contributions. Patricia Anderson, now Curator of American Art, Memorial Art Gallery of the University of Rochester, New York, began the organization of materials for this publication. She added to our research on American painting and she produced the basic formulation of the Chronology printed here. Christine Swenson, now Associate Curator of Graphic Arts, Detroit Institute of Arts, contributed information about works of art on paper. In her senior year at Smith, Leslie Mitchell (Leslie March '84) compiled the artists' name list. Betsy Jones, who retired in 1986 as Curator of Painting and Sculpture and Associate Director, did considerable research on works of art in her area of responsibility. Linda Muehlig, Associate Curator of Painting and Sculpture, shared this task and contributed valuable editorial advice. Louise

Laplante, the Museum's Registrar, counted and recounted the collection; Drusilla Kuschka and Ann Johnson typed more versions of the manuscript than seem possible. A more recent arrival to our staff, Anne Havinga, Curatorial Assistant, Print Room, read with fresh eyes our much-edited manuscript. Considerable credit is due all those named and to anyone inadvertently omitted from citation.

This publication could not have appeared without the assistance of the following: Kathryn Woo, Associate Director in charge of Administration, who carried on our many negotiations with The National Endowment for the Arts; Carol Webster, Associate Director, who assumed these responsibilities when Mrs. Woo left; Michael Goodison, Archivist, who prepared entries, read copy, offered editorial suggestions, and made himself indispensable in countless ways. Allen Renear, of Brown University, committed all our material to the world of computer typesetting and Joe Gilbert created the handsome design for the publication while carrying on many aspects of production. Congratulations are due Chester Michalik, Professor of Art, Smith College, for turning the skylights of the Elizabeth Mayer Boeckman ('54) Sculpture Courtyard of our Museum into the work of art that serves as the cover for this guide.

The undersigned moved in and out of the writing, planning, design, and production offering suggestions sometimes helpful, sometimes not, in the way museum directors do. Two persons were key to the completion of the work. After Patricia Anderson's departure, Ann Sievers, Associate Curator of Prints and Drawings, carried the full weight — administrative, editorial and conceptual — of this publication. David Grose, Professor of Classics, University of Massachusetts, while Acting Director of the Museum in the fall of 1986, contributed his expertise on ancient art, read all the texts, and is in effect co-editor with Ann Sievers.

In 1981, the Smith College Museum of Art received an endowment from The Albert Kunstadter Family Foundation in memory of Maxine Weil Kunstadter ('24). The income from that fund, combined with financial assistance from The National Endowment for the Arts, Museum Members and patrons, has made this publication possible.

CHARLES CHETHAM
Director

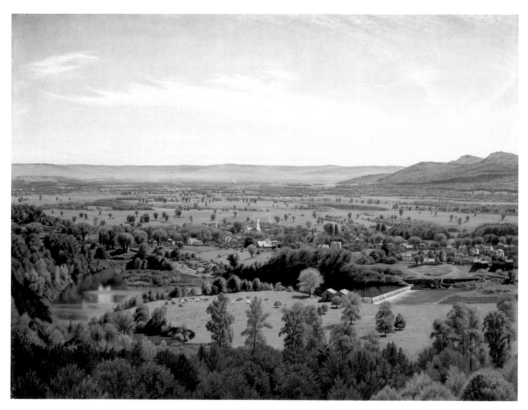

Farrer, *View of Northampton* (with Paradise Pond and the adjacent fields
that Smith College now occupies), no. 119.

Introduction

The works of art illustrated in this guide and the list of artists represented in the collection affirm the brilliant results of Smith College's more than 116 years' adherence to an innovative idea. The notion that undergraduates should regularly come in contact with original works of art was based on the belief that such experiences received at one of the most impressionable periods of young persons' lives would remain with them and enrich their existence for years to come.

It is not the aim of this introduction to trace the development of that theory or to outline the history of the formation of this collection. That has been done in other publications, most notably in *19th and 20th Century Paintings from the Smith College Museum of Art* (Northampton, 1970). Nor is it, strictly speaking, to present the ways in which the collection has been put to educational use. That has been detailed in the article "Why the College Should Have Its Gallery of Art" (*Smith Alumnae Quarterly,* February 1980). Rather, this *apologia pro vita sua* concentrates on the fundamental reason for having works of art as part of the "equipment" (to quote College budget sheets of twenty-four years ago) of a liberal arts institution.

Why colleges and universities should have art collections has been debated for more than a hundred years. Sometimes the issue is optimistically addressed when a college or university embarks on an art collecting program. Sometimes a less sanguine attitude is expressed when trustees, administrations, and faculties come to the conclusion that such a use of funds is a dispensable luxury. The ambivalent notion that art has instructional value and high moral purpose and that, at the same time, it is expendable has a long history in academic settings.

By all evidence Smith's first President and founding Trustee, Laurenus Clark Seelye, had unusual vision. In his planning for this women's college Seelye affirmed that its curriculum would be as rigorous as that of any existing men's college, but in certain key ways it would also be different. At Smith the fine arts were to have equal standing with the disciplines then thought to prepare a person for a lifetime of continuing inquiry and self-education. Yet thirty years after his assumption of the Presidency, Seelye wrote of the continuing difficulty of convincing his faculty of the value of collecting and study of the arts in the context of higher education. Clearly his goals were not as easily

achieved as he had hoped, and even today in many institutions, although not at Smith, the "problem" of the plastic and performing arts within a liberal arts setting will probably never be laid to rest.

Throughout the United States today there are remarkable art collections on the campuses of American colleges and universities. The American Association of Museums lists more than 150 such museums. These museums are often spoken of as "teaching" museums, but then, whether actively or passively, all museums teach. Works of plastic art have no meaning apart from the emotional responses and intellectual constructions that take place in human minds when they reflect on a given object. Museums are the repositories of objects that countless individuals have concluded have some special pertinence to the past, to the present, and to the future. Some believe such objects embody the finest impulses of the human spirit and often the finest examples of human skill. That everyone does not always agree on the particular significance of a given work of art is of no consequence. In all human activity there are those more gifted in some things than in others, some more alert to certain kinds of experience, some less so. That we do not all agree is less important than that we do not ignore the phenomenon.

Often the term "teaching" museum carries a pejorative connotation. According to this view, a "teaching" museum's collection may vary considerably in quality. Therefore curators in such museums face ever-present dangers when acquiring objects. The decisive question should always be: is the work of art being considered only an acceptable "teaching" example or is it a fine or even a great work of art from and about which many levels of fact and meaning can be extracted?

Grasping the fact that a museum is an educational institution in and of itself (a status which the federal government has recognized for many years) has proven difficult for many. Proud boasts are regularly made in cities throughout the country of the cultural importance and value of formidable art collections, but by some individuals museums are regarded as elegant backgrounds for receptions, parties, and award-givings. The idea of collecting works of art, protecting them, studying them, pub-

lishing them, and educating through them is often only vaguely understood as the primary reason why collections of art exist.

Since art always reflects the society in which it is made, it provides an extraordinary entry into the understanding of the past and of the present. The breadth or kind of learning afforded by the study of actual works of art is seemingly infinite. It can include simple identification, the learning of technical means of the production of art, a growing familiarity with systems of classification, the development and refinement of a sense of chronology, the identification of changing social systems. It can encourage speculation about cause and effect in history. It can suggest the range of human intelligence, imagination, and ingenuity. It can demonstrate the accuracy of nonverbal communication and reveal to the viewer transcendent beauty. In every sense of the word, works of art in this collection and in all art collections are of use to the degree that human capacity and imagination can find for them. The fact that art brings up questions both prosaic and profound and that it can be linked to virtually all our present humanistic and technical studies justifies its presence in an educational community where the examination of ideas and the development of the habits of thinking, of learning, and of discovery are the central reasons for the community's existence.

Smith College, in particular, has a long tradition of making its collections useful in the study of an unusual number of disciplines. It is therefore no accident that numbers of Smith graduates have had extraordinary careers in and through the arts. Smith women see the arts as an integral and important part of a whole education. Thus they go into the world armed with an attitude that makes a profession in the arts or in an allied field a viable choice. After all, the collecting, study, and making of art has been a priority of the College for more than a century. The College obviously has proven the rightness of its values by the distinction of its alumnae in the arts. In a practical way this priority has brought to Northampton an unusual number of extremely high quality and varied works of art, the gifts of its informed alumnae. These works of art are appreciated and used; many of them are illustrated in this publication.

This guide can be seen solely as an overview of material possessions owned by Smith College or it can provide a sense of immense opportunities for the development of intellect and spirit. Obviously Alice Belden Tryon and Dwight W. Tryon

believed the latter when they composed the dedicatory plaque for Smith's third art gallery. Their words justified the existence of a collection of art on this or on any other American campus.

CHARLES CHETHAM
Northampton
1986

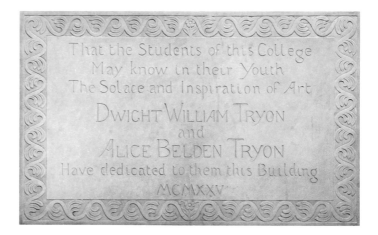

Chronology

1870 The Last Will and Testament of Miss Sophia Smith, late of Hatfield, Massachusetts, outlines her wishes for the College that bears her name.

Article 3. I direct... that the higher culture in the English Language and Literature be given in said College; also, in Ancient and Modern Languages, in the Mathematical and Physical Sciences, in the Useful and the Fine Arts, in Intellectual, Moral, and Aesthetic Philosophy, in Natural Theology, in the Evidences of Christianity, in Gymnastics and Physical Culture, in the Sciences and Arts, which pertain to Education, Society, and Government, and in such other studies as coming times may develop or demand for the education of women and the progress of the race.

1871 On April 12, the first meeting of the Board of Trustees was held, a charter accepted, and the organization of the Board completed.

On September 12, the Dewey homestead was bought as the site for the College. The College adopted for its seal the *Woman of the Apocalypse* from Murillo's *Assumption of the Virgin,* and the College's motto became "To virtue, knowledge."

1872 In September, a prospectus states the design of the fine arts curriculum:

More time will be devoted than in other colleges to aesthetical study, to the principles on which the fine arts are founded, to the art of drawing and the science of perspective, to the examination of the great models of painting and statuary, to a familiar acquaintance with the works of the great musical composers, and the acquisition of musical skill.
— L. Clark Seelye

1872 On June 17, L. Clark Seelye accepted the Board's invitation and was voted first President of Smith College.

1875 On July 14, Mr. Seelye was inaugurated President. In his inaugural address he said:

In the fine arts, as in literature and science, the College should simply aim to give that broad and thorough acquaintance with mind which is in itself the best preparation for special work in any calling. If this be its aim, however, it cannot be true to its character and ignore art. Too many of the grandest creations of

the human intellect are embodied in the fine arts to remain unnoticed by an institution which seeks the highest mental culture....

If our higher schools are to fulfill their mission, they must see to it that no unusual artistic gift be impoverished from lacking the nutriment of that broad and generous thinking on which alone it can grow to its greatest strength and beauty.... Not less, however, should the College see to it that artistic tastes are not starved and dwarfed from want of popular culture. It should have its gallery of art, where the student may be made directly familiar with the famous masterpieces....

Our art gallery we trust, will ere long be amply provided with all material requisite for such work....

1875 College Hall was completed; it included an art gallery, among the first of the few then in American colleges.

1877 The College received an offer from a Trustee of $2,000 for an art collection, with the provision that the Trustees should appropriate $2,000 for the same purpose. The money was duly appropriated and $3,000 more was raised by subscription, making a total of $7,000. President Seelye purchased a large collection of Braun's autotypes (reproductive prints) and arranged them on screens in the art gallery. Casts of famous statues were also procured. James Wells Champney was employed to give biweekly art instruction and a course of lectures on sculpture and painting.

1879 Mr. Seelye purchased from Thomas Eakins *In Grandmother's Time,* the first painting acquired by the College.
 Prominent artists in New York and Boston responded generously to President Seelye's suggestion of forming a permanent collection of American art and made concessions on the price of their works.

1881 Winthrop Hillyer, a retired Northampton businessman, gave $25,000 to construct an art building on the condition that $8,000 previously raised should be used to increase the art collection. Later Mr. Hillyer added $5,000 to the original gift. His offer was a complete surprise to the College. No one had solicited financial aid from him, and Mr. Hillyer had never voiced his interest in the College or in art. His gift was the largest the College had received since Sophia Smith's original bequest.

1882 Hillyer Art Gallery, designed by Peabody and Stearns of Boston, was completed.

1883 At Mr. Hillyer's death, a memorandum was found in his desk indicating his intention to bequeath $50,000 for a permanent fund for increasing the art collection. His surviving brother and sister, Drayton Hillyer and Sarah Hillyer Mather, recognized this intentional legacy as if it had been legally binding.

1886 Dwight W. Tryon was invited to teach art at Smith College.

1887 Drayton Hillyer and Sarah Hillyer Mather gave $10,000 for an addition to the Hillyer Art Gallery. That addition was completed in the same year. Mrs. Mather also left $15,000 to the art collection fund, held in trust during the lifetime of Mr. and Mrs. Drayton Hillyer.

 Beginning in the 1880s, lectures on art were sponsored by the College. Between 1901 and 1905, a few classes in art history were given by a professor from the University of Pennsylvania who made weekly visits to Northampton, bringing his own illustrative material. Technical courses, however, in drawing and painting were flourishing under Mr. Tryon.

1905 A chair of History and Interpretation of Art was created. Alfred Vance Churchill was appointed as its first incumbent, becoming the first resident teacher of these subjects at Smith. All lectures were given in Chemistry Hall. Mr. Churchill was also in charge of the art collection.

1911 The first special exhibition of borrowed works of art was held.

 ... A group of famous etchings was exhibited at Smith College in 1911, particularly for the benefit of students in Art 14. To many of the students this was their first sight of prints by great artists, and when it was discovered that Smith College owned no etchings, an enthusiastic group, members of the Studio Club and their friends, purchased a fine proof of the fourth state of *The Three Crosses* by Rembrandt van Rijn and gave it to the gallery. ...

 — Mr. Churchill,
 quoted in *19th and 20th Century Paintings from the Smith College Museum of Art*, 1970

1912 Mr. Tryon declared his intention of leaving his fortune to Smith College.

1913 Hillyer Gallery's lower floor was renovated; exhibits were arranged for the first time in chronological order; electric lighting was installed. For the first time, the Gallery was opened on Sundays.

1914 Mr. Churchill purchased Auguste Rodin's small bronze, *Children with Lizard,* and thereby demonstrated his commitment to collecting European art.

1919 Mr. Churchill was appointed Director of the Smith College Museum of Art, as the collection was then described for the first time. He spent five months in Europe collecting art at the request of the Trustees.

1920 The first annual Museum *Bulletin* was published. At the beginning of this decade, Museum membership was established. At the request of the Trustees Mr. Churchill developed the Museum's collecting policy, which he called the "Concentration Plan" (see pp. 23–24).

1924 Dwight W. Tryon retired from the faculty. After leaving Smith, he wrote from South Dartmouth, Massachusetts:

> ...I am greatly interested to hear how things are progressing at Smith. The great thing is to feel that there is real interest in the subject of art as a humanizer. Few persons are fitted by nature to be producers of so-called fine art, but all should be made richer by the sense of appreciation. Everyone should be an artist and when this day comes there will be better work done by all and more happiness in the world.
>
> > quoted in *19th and 20th Century Paintings from the Smith College Museum of Art,* 1970

1925 From 1923 to 1925, Dwight Tryon planned an art gallery for Smith College. In 1925, he and Mrs. Tryon presented the College with funds for the new building. In June of that year ground was broken, however, he died in July. The College received from him a bequest for the completion of the construction of the building, and for an endowment fund for its maintenance, the purchase of works of art, and the promotion of the study of art at Smith College.

1926 On February 19, the Trustees voted officially to give the name Smith College Museum of Art to the various collections of art belonging to the College.

1932–1946 Jere Abbott came to Northampton as Director of the Museum after three years as founding Associate Director of the Museum of Modern Art, New York City. He accepted the post with President William Allan Neilson's agreement that he run a professional museum on a college campus. Mr. Abbott acquired a number of excellent School of Paris paintings and sculptures and enlarged the collection's scope by obtaining other works from the fourteenth through the twentieth centuries. He also initiated acquisitions in photography. An accomplished musician himself, Mr. Abbott sponsored a concert by Virgil Thomson in the Museum (thus initiating the tradition of music in the Museum) when the latter was preparing *Four Saints in Three Acts* at the Wadsworth Atheneum in Hartford.

1946–1947 Frederick Hartt came to Smith as a Visiting Lecturer in Art and Acting Director of the Museum. Following his year at Smith he received a PhD from New York University and pursued a successful career as a teacher and a scholar of Renaissance and Baroque art.

1947–1949 Edgar Schenck was Director of the Honolulu Academy of Arts for thirteen years prior to assuming the directorship at Smith. After leaving the College he became Director of the Albright Gallery, Buffalo, and later Director of the Brooklyn Museum.

1949–1955 As Director, Henry Russell Hitchcock, this country's most distinguished architectural historian, added a number of works of quality, many of them with architectural elements predominating. The American and English collections grew considerably. Mary Bartlett Cowdrey assisted Mr. Hitchcock from 1949 to 1955, first as Curator and after 1952 as Assistant Director of the Museum. In the Director's absence, Ms. Cowdrey became Acting Director of the Museum. She made important contributions to the study of American art.

1951 Mrs. John Wintersteen (Bernice McIlhenny '25) and Henry Russell Hitchcock formed the Museum Visiting Committee, which consists of museum professionals and collectors, many but not all of them alumnae of the College. They advise on all phases of the Museum's operation.

1955–1961	Robert Owen Parks left his position as Curator of the John Herron Art Museum, Indianapolis, to become Director of the Museum. His eclectic and extraordinary taste brought to the Museum many great works of art, among them the only Grünewald drawing in America and the magnificent Kirchner painting, *Dodo and her Brother*. On June 20, 1977, Mr. Parks wrote to Charles Chetham, then the Museum's Director, that the obligation to work within the framework of Messrs. Seelye, Champney, Tryon, and Churchill's ideas perhaps was only incidental to the choices they made as directors:

Did Fred or Eddie or Russell or Jere really work within the framework? They had interests — built-in ones, not one of Smith's directors has ever been afraid of being a bore. And haven't all of us — busy with the cultivation of our respective interests — been exasperating to somebody a good deal of the time. . . .

Patricia Milne-Henderson acted as Assistant to the Director from 1959 to 1962. In 1961–1962 she served as Acting Director.

1962 to the present	Charles Chetham, formerly Assistant Director, University of Michigan Museum of Art, was invited to become Director. With the agreement of Presidents Mendenhall, Conway and Dunn, the professional status of the Museum was enhanced and the staff became more articulated. From a staff of three in 1962, the Museum grew to a staff of twenty-two persons in administrative, curatorial, curatorial support, and security capacities. During these years many distinguished persons worked for the Museum, among them, Margaret Paul (subsequently Acting Director, Wellesley College Museum); David Brooke (current Director, Sterling and Francine Clark Art Institute, Williamstown, Massachusetts); Michael Wentworth, author of the definitive work on the artist James Tissot, published by the Oxford University Press; Elizabeth Mongan, formerly Curator of the Lessing J. Rosenwald Collection and Curator of Prints at the National Gallery of Art; and Betsy Jones, formerly Curator of Painting and Sculpture at The Museum of Modern Art. During the Director's absences Michael Wentworth, Elizabeth Mongan, Betsy Jones, and David Grose served as Acting Directors.

In the 1960s, educational programs were initiated by the Museum as an active force in the offerings of the College. Among these are the Museum Seminar, one of the first such to be given at an undergraduate college. It was begun in 1964 with the exhibition *Beauty in the Beast*; its most recent exhibition was *Photosynthesis* of 1986. Innovative work-study and intern

programs were also initiated for students, as well as an annual student docent training program. A graduate intern program established in the 1970s and supported by The National Endowment for the Arts drew students first from the University of Michigan Art History Program and later from the Clark Art Institute-Williams College Program.

The Museum Membership was revived by Mrs. Charles Lincoln Taylor (Margaret Goldthwait '21) and Helen Foster Osborne ('27). Since that time, an annual Members' Day lecture and picnic have been held during the first weekend in May.

In the 1960s, concerts were reinstituted in the Museum by the Director and by Lory and Ernst Wallfisch and Philipp Naegele of the Music Department. The popularity of these concerts prompted the decision to plan a gallery in a new museum building to serve as a concert hall, as well as a gallery.

The planning of the new Museum was carried forth in the 1960s by the Director and the Museum Visiting Committee. Eventually this group participated in the selection of John Andrews as architect. The fundamental aim of the design of the building was to make all the Museum's collections and its records accessible. Toward this end, gallery spaces and storage spaces were designed for class visits and a Museum Archive for documentation was established. During the construction of the new building (1970–1972), a special exhibition of fifty-eight paintings *(19th and 20th Century Paintings from the Collection of the Smith College Museum of Art)* traveled to nine American museums. The tour began at the National Gallery, Washington, D.C. (as the first college collection to be shown there) and concluded with a showing at the Cleveland Museum of Art. The new Museum opened in 1973 with the return of these paintings.

Numerous distinguished publications, beginning with *Archaic Jades* (1963) and including *A Land Called Crete* (1967), *Antiquity in the Renaissance* (1979), *Speaking a New Classicism* (1981), and *Edwin Romanzo Elmer 1850–1923* (1983), underscore the Museum's emphasis on serious exhibitions and scholarly publications. In 1981, The Albert Kunstadter Family Foundation, at the instigation of its President, John W. Kunstadter, established the Maxine Weil Kunstadter ('24) Fund in her memory. This fund has been used for several Museum projects, chief among which has been the subvention of Museum publications.

In the 1960s, a program for the systematic conservation of the collection was established. Since the early 1970s, The National Endowment for the Arts has often funded it in part. Surveys of

discrete areas of the collection are periodically conducted by conservators from the Center for Conservation and Technical Studies, Harvard University Art Museums. Works of art are ranked according to their need for treatment and then appropriately conserved.

During the past two decades the collection has grown from approximately 6,000 to 18,000 objects. Major gifts and purchases have brought many works of art to the Museum, primarily from the eighteenth through twentieth centuries. Such gifts have also included whole or substantial parts of the Selma Erving ('27) Collection, the Priscilla Paine Van der Poel ('28) Collection, and the Collection of Mrs. Sigmund W. Kunstadter (Maxine Weil '24).

Concentration Plan

In 1920, Alfred Vance Churchill was asked by the Trustees of Smith College to devise a plan for collecting works of art for the Museum. He envisioned a "Concentration Plan," which he described in the *Bulletin of Smith College Museum of Art* (no. 13, May 1932, pp. 2–22).

It seemed to me that attention must be devoted, first of all, to the cultures from which our own is derived and on which it rests, — Egypt, Greece, Rome, and the rest, down through the Renaissance. We must follow the main stream of western civilization. The arts of Europe may not be more important in themselves than those of the Orient. They are more important *to us.*

But even this area was impossibly vast. While its chief phases might eventually be illustrated with a few examples we could never do justice to all. The only practicable plan was to do what we could for the great historic periods, and to choose a limited field for more adequate representation. The educated man has been defined as one who knows "everything of something and something of everything." So a college museum might hope to acquire "something" of every period, and richer and fuller illustrations (if not "everything") of one of them.

Moreover, the friends of a museum, when they see that a serious effort has been made and significant results achieved in a limited field, are apt to come to the rescue with gifts from other fields. This has been happily confirmed in our own experience.

The next step was the choice of a special field for concentration — a difficult choice. My proposal was this: Let us select, not a nation or school but a *topic* — the Development of Modern Art. That the plan might be quite clear it was necessary to define "modern." Where does modern art begin? Though such decisions must always be more or less arbitrary, the answer in this case is fairly reasonable — more so than usual. Let us assume that modern art begins with the period of the French Revolution. At that period ancient beliefs, traditions and practices were ruptured and new ones started in every realm of thought including art. The break with the past has never been more complete.

The solution was novel and radical. No college had emphasized the modern period. Too often the interests of educational institutions had been "one with Nineveh and Tyre," and still are, so far as art is concerned. Yet the modern period is one of great richness and significance, and very close to our sympathies. . . . My proposal was not orthodox but it was adopted.

The "concentration plan" as I conceived it might have seemed

inexcusably ambitious considering our limited funds, for it meant nothing less than a collection of works by the foremost artists of modern times.

The first step in its execution was to compose a table of names representing the indispensable links in the development of modern art without regard to nationality — those painters and sculptors without whom the history of modern art cannot be understood. The painters who in my judgment deserved place in the list were the following, a truly awe-inspiring phalanx: Goya, Constable, David, Ingres, Gros, Géricault, Delacroix, Daumier, Corot, Millet, Courbet, Manet, Renoir, Monet or Pissarro, Gauguin, Van Gogh and Cézanne.

The project would have been less appalling had it been merely a matter of getting together a series of works of proved authenticity without regard to quality. But for our purpose quality had to be the first consideration. A weak or inferior work could only be misleading to the student. Everything in the collection must show the imaginative conception of the master who made it, must reveal something of his suppleness, strength, and beauty. And it must show his "handwriting": it must be "signed all over" with the characters that he and he alone has given the world or could give.

Our standard of excellence must, in fact, be equal to that of any museum in the world. It seemed to me, at first, that my ideals differed somewhat from those of the best museums of Europe. I was willing to acquire a *fragment* where they would not, for even a fragment may reveal the master. I would take an *unfinished work* where they would not, for such a work may convey quite as much as a finished one. But I was led to reflect that the Louvre is glad to do the same, *provided the work is old*. Their Greek marbles are badly broken. Their Botticelli frescos [*sic*] are patched and faded.... After all, I was only adopting their principles for my field....

Buildings that have housed the art collections

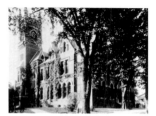

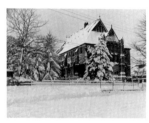

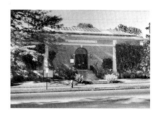

Since the opening of the College on July 14, 1875, four buildings have housed the art collections of Smith College. College Hall, by the architectural firm of Peabody and Stearns, the first College building to be erected and now the administration building, included an art gallery in its original plan. In 1877, an anonymous donor gave $2,000 to be matched by the Trustees. This allowed the College's first President, L. Clark Seelye, to buy casts of classical sculpture and reproductive prints as "models" for study. The gallery's exhibitions were open to the public from the outset.

In 1881, Winthrop Hillyer, a Northampton druggist, contributed $25,000 for the construction of a new gallery, also designed by Peabody and Stearns. In 1887, Drayton Hillyer and Sarah Hillyer Mather gave $10,000 for an addition to this building. Later, through a letter of intention honored by his brother and sister, Winthrop Hillyer left a final gift to Smith of $50,000 as an endowment for the maintenance of the Hillyer Art Gallery and for additions to the art collection. By the turn of the century, however, the collection as well as the study of art had increased to such an extent that a new gallery was deemed necessary.

In 1925, Dwight Tryon, Professor of Art from 1886 to 1923, who had chosen or approved many works of art for the College, and his wife, Alice Belden Tryon, donated $100,000 for a new gallery designed by Frederick L. Ackerman. On Tryon's death in 1926, he bequeathed an additional $300,000 for the maintenance of the new Tryon Gallery, for education and for the acquisition of works of art. In 1932, a small office wing designed by Karl Putnam was added to the southwest corner of the building. In 1950–1951, a bridge linking Tryon and the Hillyer art building was also designed by Mr. Putnam. In 1963, Charles Chetham designed an outdoor sculpture garden between the Museum and the art building.

In 1972, the new Smith College Museum of Art opened in a new Tryon Hall, four times the size of the previous building. The Museum was the work of the Andrews/Anderson/Baldwin firm of Toronto, and the principal participants in the design team were John Andrews, Brian Hunt, and Edward Galanyk, who acted as architect-in-charge. Funds for this building were raised by the alumnae of the College through the Capital Campaign of 1969–1972. Administrative offices were given by Ethelyn Atha

Chase ('44), Joanne Melniker Stern ('44), Viola Aloe Laski ('20), Isabel Aloe Baer ('24), Patricia Aloe Tucker ('24), and Sarah Prescott Michel ('30). The Doyle Gallery was given by Louise Ines Doyle ('34) in honor of the Class of 1934, the Common Room in memory of Helen Sherwood Kyle Platt ('86), the Dalrymple Gallery in honor of Bernice Barber Dalrymple ('10), the Agnes Seasongood Gallery by Agnes ('11) and Murray Seasongood, the Sabin Gallery by Dorothea Underwood Sabin ('16), and the Michigan Gallery by alumnae and friends of Smith College from the state of Michigan. The Eleanor Lamont Cunningham ('32) Print Room was given in her memory by her husband, Charles Cunningham, and her daughter, Priscilla Cunningham ('58), and the Sculpture Court was given in honor of Elizabeth Mayer Boeckman ('54). The special exhibition gallery was named in honor of Selma Erving ('27).

The new Museum building, with excellent facilities on three floors, has provided considerable impetus for the growth of the collection. It has allowed the Museum to initiate and greatly expand its own programs. These have included new and unusual educational opportunities for students at Smith, in the Five-College Consortium, and for the general public.

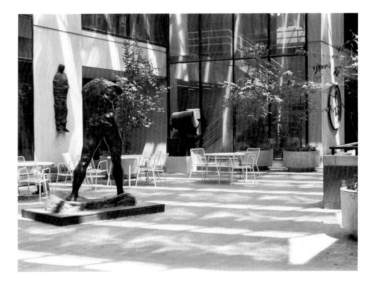

Collections

Paintings and Sculpture

Thomas Eakins's *In Grandmother's Time* (122), the first painting accessioned by the College, was one of twenty-seven oils by living American artists that President L. Clark Seelye bought in the spring of 1879. This group included works by J. G. Brown, Samuel Coleman, Winslow Homer, George Inness, Alexander Wyant, and Louis Comfort Tiffany, as well as by others whose names are less well remembered. A newspaper of the day observed that "it may well be doubted if there is as good a collection of works of American artists to be found anywhere among the same number of paintings." The first American sculpture acquired by the Museum was Daniel Chester French's *The May Queen* (121), which was donated shortly after the purchase of the first European sculpture, *Children with Lizard* (79), by Auguste Rodin. Interestingly, the first non-American paintings to be acquired were scrolls by Chinese and Japanese masters, the gifts of Charles Lang Freer, Dwight Tryon's friend and patron. It was not until 1919 that the first European painting, Georges Michel's *Landscape* was purchased.

With the College Trustees' decision to accept Alfred Vance Churchill's "Concentration Plan" (pp. 23–24), the collection's policy was expanded to include all of western art but with emphasis on the nineteenth and twentieth centuries. The successive Directors of the Museum, the Messrs. Abbott, Hartt, Schenck, Hitchcock, Parks, and Chetham, have implemented Mr. Churchill's idea. Today, of the Museum's more than 18,000 objects, 830 are paintings and 256 are sculptures. The strength of the collection continues to lie in the outstanding American and French art of the nineteenth and twentieth centuries. Among these, works by French Realists, Impressionists, Post-Impressionists, and Cubists are particularly renowned. Many fine examples of eighteenth century art are included as well, and while there are fewer works from each successively earlier century, distinguished examples of painting and sculpture are to be found. Two major collections of twentieth century art have been donated to the Museum.

THE MR. AND MRS. JOHN O. TOMB (HELEN ADELAIDE BROCK '42) COLLECTION
Between 1974 and 1978, Mr. and Mrs. John O. Tomb gave a collection of art in various media by internationally known artists. It includes work by Max Bill, Robert Indiana, Joán Miró, Barnett Newman, Jean Arp (187), Victor Vasarely, Georges

Braque, Jorge Fick, Ian Hodges, Louis Mayano, Brian Robbins, Joe Tilson, Rosalind Salzman, and Gino Lorcini, as well as others.

THE MRS. SIGMUND W. KUNSTADTER (MAXINE WEIL '24) COLLECTION

Bequeathed to the Museum in 1978, the Kunstadter Collection contains 150 works of twentieth century art in various media. The gift consists of seven paintings, twenty-one sculptures, twenty-three drawings and watercolors, fifty-four prints, portfolios, and illustrated books, as well as many posters and art publications. There are watercolors by Paul Klee, Morris Graves, and Mark Tobey (275, 276); sculptures by Jean Arp, Max Bill, José de Rivera, and George Rickey (194); and oils by Fritz Glarner (178), Robert Delaunay, and Friedrich Vordemberge-Gildewart.

Prints

An impression of the fourth state of Rembrandt van Rijn's *The Three Crosses* (213), c. 1660, was the Museum's first print acquisition, a gift of the Studio Club in 1911. From this exemplary beginning, the collection grew through gifts and purchases to the present figure of approximately seven thousand prints. Included are works from the fifteenth through the twentieth centuries. The Print Room has fine examples of the work of many master printmakers, both western and eastern: Albrecht Dürer (199, 203), Giovanni Battista Piranesi (224), Eugène Delacroix (236), Henri Daumier, Edgar Degas (242), Henri de Toulouse-Lautrec (254), Edvard Munch (262), Pablo Picasso, Henri Matisse (272), Hiroshige, and Hokusai to name only a few. The collection is notable for superb impressions as exemplified by Dürer's engraving *Adam and Eve* (199), and Rembrandt's etching of the same subject (211), by Toulouse-Lautrec's lithograph of Loie Fuller printed with gold (254), by the entire *Carceri* and *Vedute di Roma* (224) of Piranesi, and by the complete set of the first edition of Goya's *Caprichos* (228).

THE SELMA ERVING ('27) COLLECTION

During her lifetime Selma Erving regularly presented the Museum with works of art from her collection. These included nearly four hundred prints, a dozen related drawings, and over forty *livres d'artistes,* all by artists of the late nineteenth and early twentieth centuries. Sixty drawings from her collection were received as a bequest in 1984. Among these are works by

Camille Pissarro (260), Paul Gauguin, Pablo Picasso, Pierre Renoir, Henri Matisse (268, 272), Edvard Munch (246, 262), Edouard Vuillard (256) and Paul Klee.

THE PRISCILLA PAINE VAN DER POEL ('28) COLLECTION

The Van der Poel Collection of 305 works of art focuses on French art of the nineteenth and twentieth centuries. It consists primarily of works on paper and encompasses a valuable survey of printmaking and drawing from Delacroix to Cézanne. From the twentieth century are examples of Cubist, Surrealist, and Expressionist art. Mrs. Van der Poel, who taught the history of fine and decorative arts at Smith from 1934 to 1972, assembled the collection for her own pleasure and for the instruction of her students. In 1977 a second collection of forty-five prints and drawings by prominent local artists was given by Mrs. Van der Poel to the Museum.

THE MARGARET RANKIN BARKER ('08) AND ISAAC OGDEN RANKIN COLLECTION

The Isaac Ogden Rankin Collection of Japanese art includes over four hundred Japanese prints. A large number are by Hiroshige and Hokusai, but many other artists are represented. The collection was assembled at the end of the nineteenth century and the beginning of this century by Isaac Rankin, a Congregational minister, and by his daughter, Margaret Rankin Barker, who gave the collection to the Museum in her father's memory.

Drawings

The drawing collection numbers in excess of 1,500 items and spans the history of western drawing from the sixteenth century to the present, with special emphasis on the nineteenth and twentieth centuries. It contains a great many drawings of the highest quality, among them Grünewald's *Study of Drapery* (200), Dieric Bouts's *Portrait of a Young Man* (197), Pieter Brueghel's *Mountain Landscape* (206), Rosso Fiorentino's *Martrydom of Sts. Marcellinus and Mark* (204), Moreau the Younger's drawings celebrating the birth of the first Dauphin of Louis XVI (225, 226), two studies for Georges Seurat's *Grand Jatte* (247, 248), Piet Mondrian's *Chrysanthemum* (261), and Paul Klee's *Goat* (267).

THE LAMONT ENGLISH WATERCOLORS

The Lamont watercolors consist of twenty-six watercolors and drawings of the late eighteenth and nineteenth centuries collected by Mrs. Thomas W. Lamont (Florence Corliss '93) and

given to the College by her children. Among the watercolors are examples by Alexander Cozens (223), Paul Sandby, John Sell Cotman, David Cox, Thomas Rowlandson (230), and John Varley. Also in this collection is a study for Gainsborough's *The Market Cart* (227).

Photographs

The photography collection consists of over 3,600 photographic prints and gravures. The earliest acquisitions were four photographs by Luke Swank, Walker Evans (293), George Platt Lynes, and László Moholy-Nagy purchased in 1933. Following this early start (only one year after the Museum of Modern Art initiated its photographic collection), additions were sporadic until the early 1960s when photography exhibitions and the purchase of photographs became a regular part of the annual exhibition and acquisition program. By 1982, the collection had grown to approximately 1,600 items, most of which belonged to the twentieth century. In that year the Museum purchased the photographs of the Lenox Library Association, Lenox, Massachusetts. This addition of more than 2,000 prints, largely assembled by Caroline Sturgis Tappan, doubled the Museum's photography collection and added considerable depth to its nineteenth century holdings. It includes most of the major photographers of the nineteenth century, among them Julia Margaret Cameron (288), Samuel Bourne, Eadweard Muybridge (289), Josef Albert, the Fratelli Alinari, Giacchino Altobelli, Edouard-Denis Baldus, Felice A. Beato (290), Louis-August Bisson, Giacomo Brogi, Robert MacPherson, Pompeo Molins, Carlo Ponti, James Robertson, and Baron von Stillfried.

KAY BELL REYNAL (KAY BEALL '28)
The Museum owns ten portraits taken in the 1950s of artists working in New York City. Subjects portrayed are William Baziotes, Jean Dubuffet, Marcel Duchamp, Max Ernst, Hans Hoffman, Willem de Kooning, John Marin, Mark Rothko, Max Weber, and Bradley Tomlin. In addition, a still life from 1977, the year of the photographer's death, was purchased.

ALISON FRANTZ ('24)
The Museum owns 125 photographs of Minoan and Mycenaean archaeological sites and artifacts that figured in the 1968 Smith College Museum exhibition entitled *A Land Called Crete*. In 1984, sixteen additional photographs of modern as well as ancient subjects were given to the collection.

CLARENCE KENNEDY

The Museum owns 318 photographs by Clarence Kennedy from such series as the *Verrocchio Monument to Cardinal Forteguerri at Pistoia*, the *Antonio Rossellino Tomb of the Cardinal of Portugal* (294), and the *Treasury of the Siphnians at Delphi*.

EADWEARD MUYBRIDGE

The Museum owns 575 photogravures from *Animal Locomotion* (1872–1885). Four hundred seventy-nine were obtained by Henry Russell Hitchcock as a gift from the Philadelphia Commercial Museum and ninety-six were presented by Mrs. William Marseilles (Sarah Smith '27).

RALPH STEINER

The Museum now holds fifty-three photographs by Ralph Steiner through gifts of the artist, Thomas R. Schiff, and Robert Levine. Eventually the collection will have examples of Steiner's work from every phase of his career.

CAROLINE STURGIS TAPPAN COLLECTION

Many of the nineteenth century photographs purchased from the Lenox Library Association were collected by Caroline Sturgis Tappan, then a prominent member of New England's leading social circle and friend of many of the foremost intellectuals of the period. From 1855 until her death in 1888, she traveled to Europe annually and purchased photographs of European and other subjects as mementos of her trips.

Decorative Arts

The decorative arts collection of approximately 2,100 objects has been formed for the most part by gift rather than purchase, and is characterized by distinctive and often very special groups of objects, reflecting the tastes of individual collectors.

THE ADELINE ('98) AND CAROLINE ('96) WING COLLECTION

This collection of 224 embroidered pictures formed over a period of seventy years by the late Misses Adeline and Caroline Wing of New York City and Bangor, Maine, includes examples of a wide variety of embroidery techniques, materials, and subjects. It ranges historically from the seventeenth to the mid-twentieth centuries. The works are predominantly English and there are several particularly fine examples of the late seventeenth and early eighteenth centuries. American, Continental, and Hispanic work is also represented in the collection, which was bequeathed to the Museum by Caroline Wing.

THE EDDIE THORNTON WHEELER ('18) COLLECTION

This collection of over two hundred glass paperweights was bequeathed to the Museum in 1970 by Mrs. Alfred N. Wheeler. Many of the paperweights were produced by the French firms of Baccarat, Clichy, and St. Louis, while American makers are represented by Sandwich, Millville, and the New England Glass Company.

THE MARY BYERS SMITH ('08) COLLECTION

This collection consists of American furniture and decorative arts given in 1968 by Mary Byers Smith, in memory of her brother John Duke Smith. He was responsible for assembling the collection before his death in 1941. Most pieces in the collection are of New England origin and range in date from about 1720 to 1820.

Ancient Art

The collection of ancient art contains approximately 600 examples of pottery, sculpture, small bronzes, lamps, coins, and glassware. These belong to a great many cultures ranging in date from the Bronze Age to the early Christian period, but most pertain to the Graeco-Roman tradition. A few objects belong to the societies of Mesopotamia, Egypt, Cyprus, Crete, and the Cyclades.

ALISON FRANTZ ('24) COLLECTION

In 1975, Alison Frantz presented the Museum with her collection of twenty-six Greek black-slip pottery vessels. All were made in Attica and date between the close of the sixth and fourth centuries B.C.

ALFRED C. BURRAGE COLLECTION

One hundred eleven examples of ancient glassware were given to the Museum in 1954 by Mrs. Harold L. Chalifoux, daughter of the collector. The majority of these are Romano-Syrian free- and mold-blown vessels of the fourth through sixth centuries A.D., but there also are examples of Hellenistic cast bowls and Islamic blown glass.

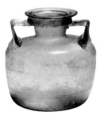

MRS. HENRY T. ROBERTSON (PAULINE MATHESIUS '37) COLLECTION

A collection of thirty-nine ancient glass vessels was presented to the Museum in 1971 by Mrs. Henry T. Robertson and her sisters in memory of their uncle, Anthony P. Mathesius. For the most part these are Romano-Syrian blown vessels of the late Imperial period.

Asian Art

Although the acquisitions policy of 1920 advocated the purchase of Western art and not the art of the Near or Far East, the Museum was nonetheless able to accept gifts of such objects. As a result, the collections in these areas have come entirely through the generosity of alumnae and friends. Included are several important collections.

THE CHARLES LANG FREER COLLECTION
In 1917, Charles Freer, friend of Dwight Tryon, presented Smith College with a number of objects from his own collection. The group contained thirteen Japanese and six Chinese paintings. In 1920, Freer donated a sizable group of nineteenth century etchings.

THE MR. AND MRS. IVAN B. HART COLLECTION
The fifty-seven archaic Chinese jades in this collection were originally acquired in the 1930s by the Dutch financier S.H. Minkenhof. The collection was expected to go to the Asiatic Museum then at the Rijksmuseum, Amsterdam, but upon Minkenhof's death in 1956 the jades were sold to Ivan B. Hart of New York City. At the urging of a Visiting Committee member, Ernest C. Gottlieb, Mr. and Mrs. Hart gave these jades to the Museum between 1959 and 1962.

THE DIANE SCHARFELD ISAACS ('61) COLLECTION
A collection of fifty-three Chinese jades and porcelains was given to the Museum in 1969 by Diane Scharfeld Isaacs in memory of Arthur W. Scharfeld, her father. Objects date from the Yin-Chou through the Ming Dynasties.

THE MAJOR AND MRS. OLIVER J. TODD COLLECTION
This collection consists of thirty-nine Chinese bronzes extending from the Chou to the Ming Dynasties. Major Todd, an American army engineer, and his wife, a medical missionary, lived in China for nearly twenty years. Their daughter, Dr. Doris T. Brown, was a member of the class of 1949.

THE MARION BROWN RAFFERTY SMITH ('26) COLLECTION
This collection contains over one hundred celadon ceramic bowls and other utensils attributed to the Ming and Sung periods. They are reported to have been excavated in the Philippines during the 1950s.

MARGARET RANKIN BARKER ('08) AND ISAAC OGDEN
RANKIN COLLECTION
In addition to the prints already mentioned, the collection contains approximately two hundred examples of Asiatic decorative arts, chiefly Japanese in origin. These include ceramics, inro, and netsuke.

THE CATHERINE ATWATER GALBRAITH ('34) COLLECTION
Between 1981 and 1982 Ambassador and Mrs. John Kenneth Galbraith gave the Museum thirty-four examples of fine Indian painting. They represent the schools of Rajasthan, Central India, and the Punjab Hills, as well as the provincial Mughal courts. With the exception of an early Jain manuscript page, most of the works date from the eighteenth and nineteenth centuries.

Art of Traditional Societies

The Museum's holdings in the art of traditional societies, most of which have been acquired through donation, contain examples from four principal regions: West Africa, the vast area of the Pacific from Hawaii to Australia, the Northwestern coast of North America, and the American Southwest. Included are ceramics, baskets, rugs, masks, headdresses, dolls, and other objects. Probably the finest is a Baluba ceremonial axe from Zaire purchased in 1939.

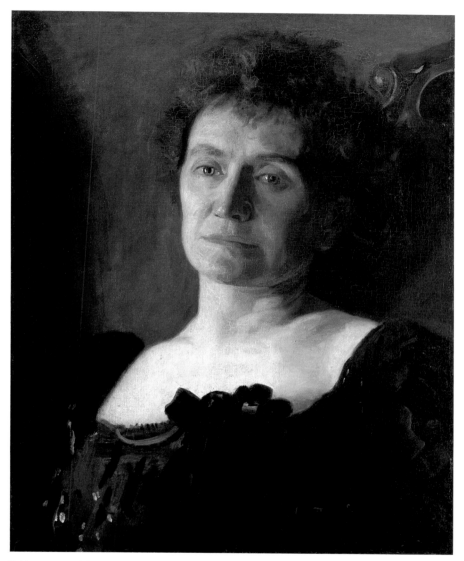

Eakins, *Mrs. Edith Mahon*, no. 135.

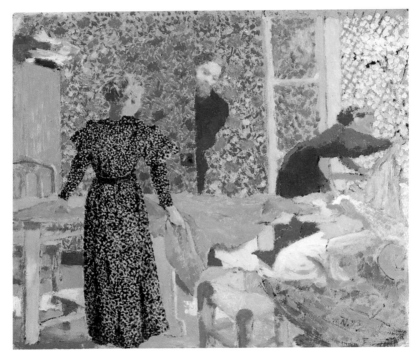

Vuillard, *The Suitor,* no. 87.

Cézanne, *A Turn in the Road at La Roche-Guyon,* no. 85.

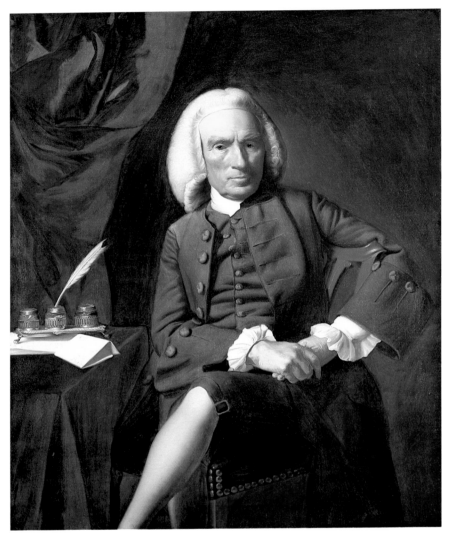

Copley, *The Honorable John Erving,* no. 102.

Moreau the Younger, *The Masked Ball*, no. 225.

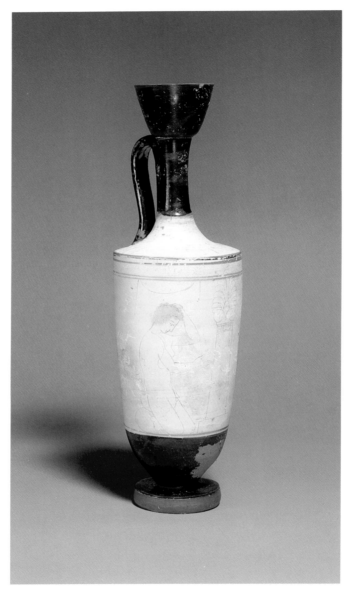

White-Ground Lekythos, no. 6.

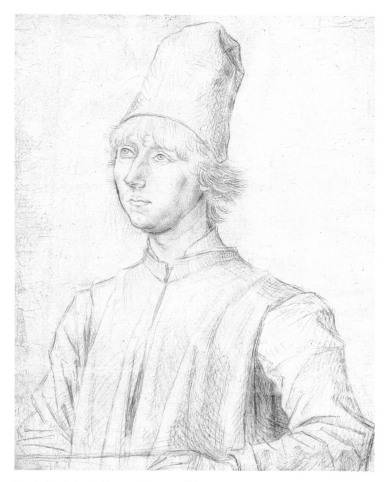

Bouts, *Portrait of a Young Man,* no. 197.

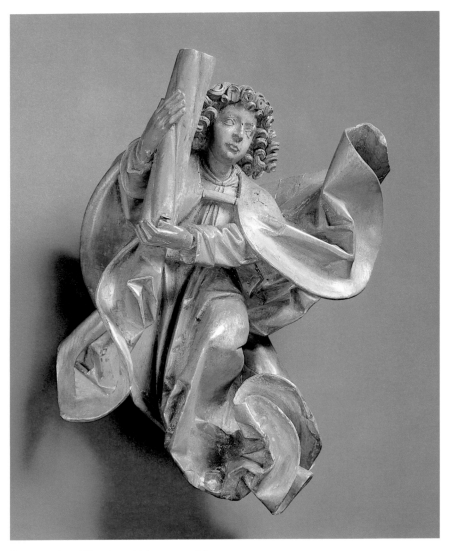

German, *Angel Bearing a Column*, no. 20.

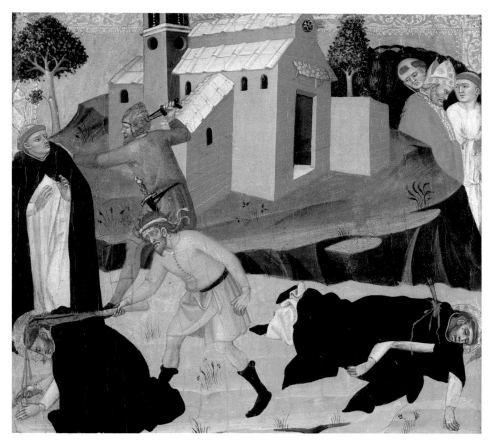

Taddeo di Bartolo, *Death of Saint Peter Martyr,* no. 22.

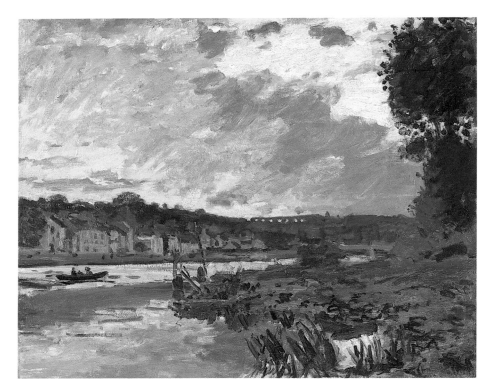

Monet, *The Seine at Bougival,* no. 71.

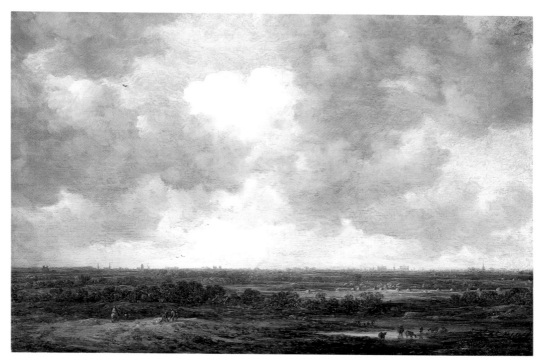

van Goyen, *View of Rijnland,* no. 39.

Degas, *The Daughter of Jephthah*, no. 68.

Courbet, *The Preparation of the Dead Girl,* no. 62.

Bonnard, *Landscape in Normandy,* no. 153.

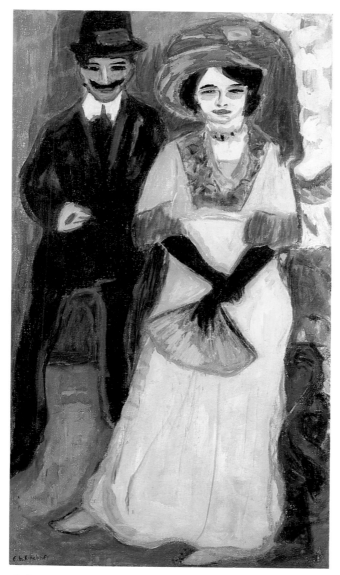

Kirchner, *Dodo and her Brother,* no. 142.

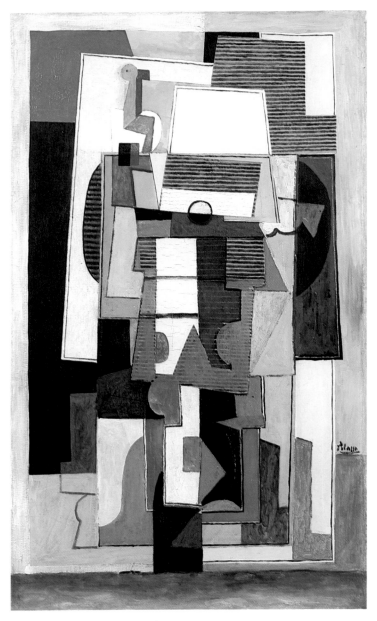

Picasso, *Table, Guitar and Bottle*, no. 151.

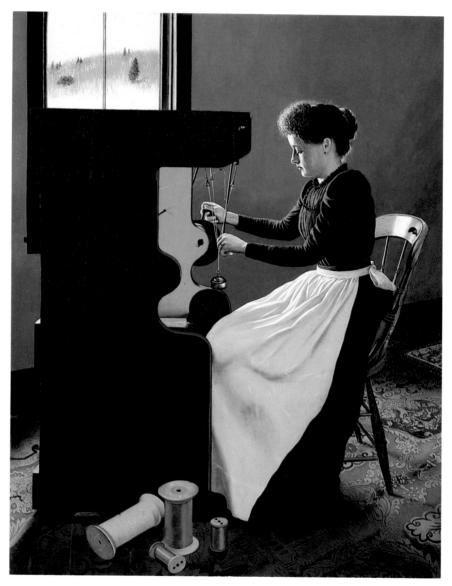

Elmer, *A Lady of Baptist Corner,* no. 131.

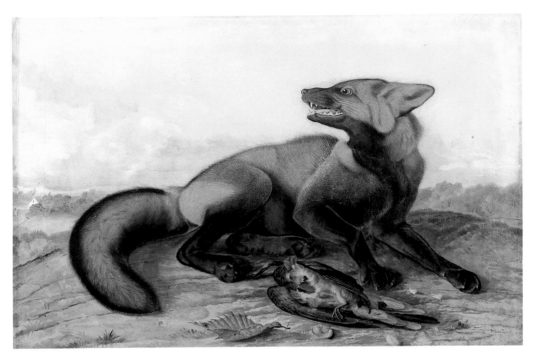

Audubon, *American Cross Fox,* no. 235.

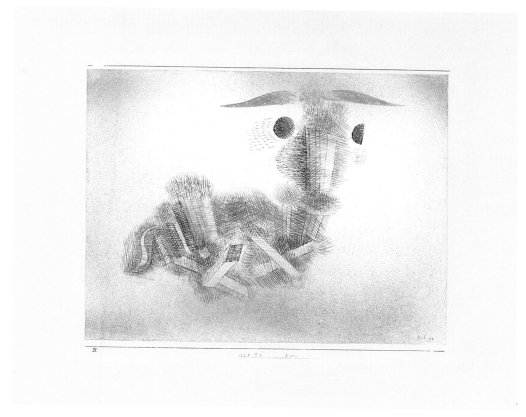

Klee, *Goat*, no. 267.

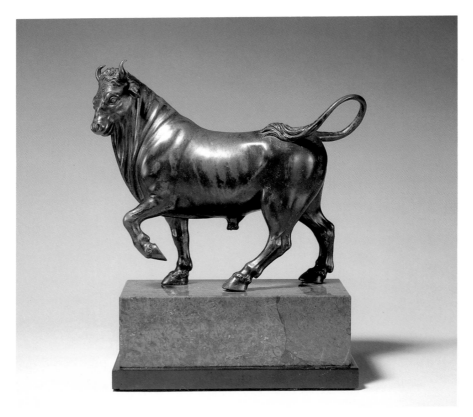

Studio of Giovanni da Bologna, *Striding Bull*, no. 27.

Sheeler, *Rolling Power,* no. 166.

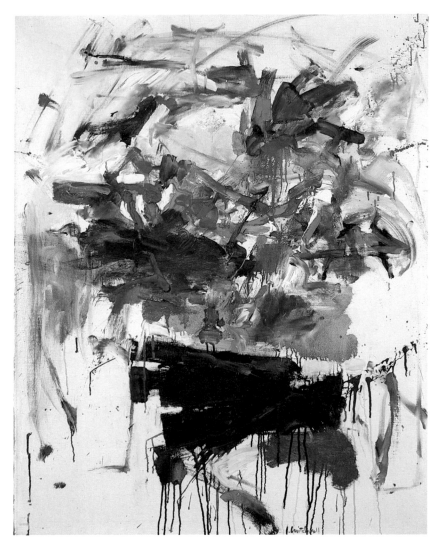

Mitchell, *Untitled*, no. 184.

Enos, *Untitled* (roses and cobra lilies), no. 301.

Feininger, *Gables I, Lüneburg*, no. 157.

Note to the reader

Objects in this handbook are arranged within eight major divisions representing the strengths of the collection. Dimensions, in inches and centimeters, are given with height preceding width preceding depth (for three-dimensional objects). Diameter measurements are cited where they occur. Titles are given in English except where translations are inappropriate. For prints and drawings the paper color is off-white or white unless otherwise stated. All works are illustrated in black and white and those also reproduced in color are so designated. Additional information on each object (documentation, provenance, exhibition history, and publication record), as well as photographs, color transparencies, and slides, can be obtained by applying to the Museum.

1
Cycladic, Bronze Age, possibly from Naxos or Paros

Female Figure, c. 2500–2400 B.C.
Marble, height 5 7/16 in.
(13.8 cm.), width 2 1/2 in.
(6.3 cm.)

Gift of Dr. and Mrs. Aron Krich in
memory of Ely Chinoy
1975:41

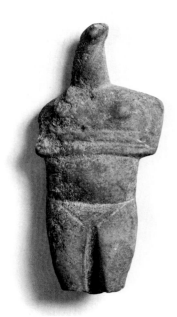

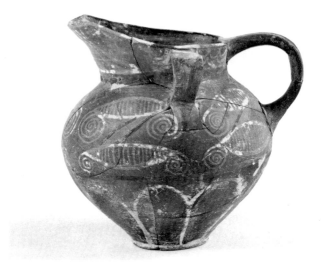

2
Minoan, Bronze Age, from Crete

Kamares Ware Jug, Middle
Minoan II, c. 1850–1700 B.C.
Earthenware with slip decoration,
height 6 1/4 in. (15.8 cm.),
maximum rim diameter 4 in.
(10.2 cm.)

Permanent loan in memory of
Harriet Boyd Hawes ('92)
EL 1:67

3
**Egyptian, New Kingdom or later
(18th–26th dynasties)**

Head of Anubis, 16th to 8th
century B.C.
Diorite, height 11 3/4 in.
(29.8 cm.), width 9 1/2 in.
(24.2 cm.)

Gift of Mr. and Mrs. Richard
Lyman (Charlotte Cabot '32)
1970:19

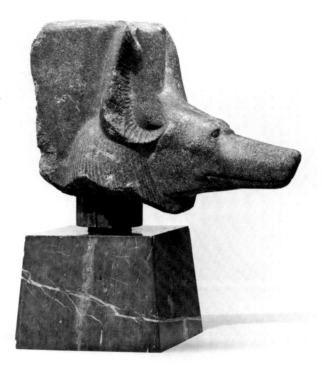

4
Greek, Archaic, from Attica

Black-Figure Panel Amphora,
c. 550 B.C.
Earthenware with slip decoration,
height 15 in. (38.1 cm.), rim
diameter 6 3/4 in. (17.1 cm.)

Purchased
1920:12

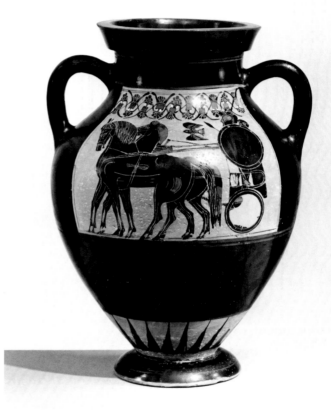

5

Greek, Late Archaic, from Attica

Red-Figure Kylix, attributed to the
Nikosthenes Painter, c. 520–500
B.C.
Earthenware with slip decoration,
height 4 15/16 in. (12.6 cm.), rim
diameter 13 3/16 in. (33.4 cm.)

Purchased
1955:45

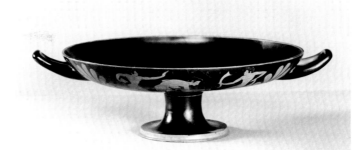

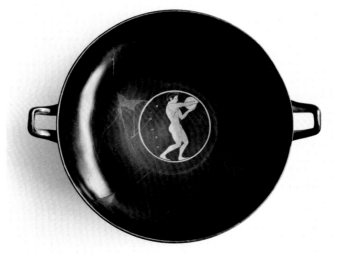

6
Greek, Classical, from Attica

White-Ground Lekythos, 440–420
B.C., near the painter of Munich
2335
Earthenware with slip decoration,
height 12 1/16 in. (30.6 cm.),
maximum diameter 2 7/16 in.
(6.3 cm.)

Purchased, Winthrop Hillyer Fund
1923:5

Color plate, page 40

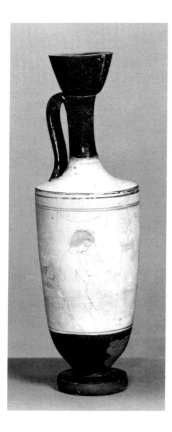

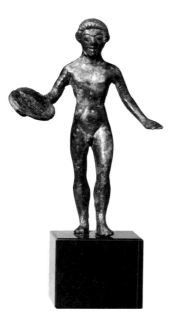

8
Greek, Hellenistic

Head of a Young Man (possibly Demetrios Poliorketes), late 4th–3rd century B.C.
Marble, height 10 1/2 in. (26.6 cm.), width 6 in. (15.2 cm.)

Purchased, Winthrop Hillyer Fund 1925:8

7
Etruscan, Late Archaic

Discus Thrower, late 6th century B.C.
Bronze, height 3 11/16 in. (9.4 cm.), width 2 7/16 in. (6.2 cm.)

Purchased with funds given by Mrs. Harold L. Chalifoux 1958:15

9
Roman, Early Imperial

Winged Torso of Eros, 1st century
A.D.
Marble, height 7 3/4 in. (19.5 cm.),
maximum width 13 1/2 in.
(34.4 cm.)

Purchased
1922:28

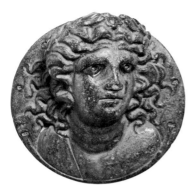

10
Roman, Early Imperial

Head of Artemis-Selene (furniture appliqué), 1st century B.C.–1st century A.D.
Bronze with silver inlaid eyes and diadem, diameter 2 1/8 in. (5.2 cm.), depth 3/4 in. (2 cm.)

Gift of Mrs. Ephraim Shorr in memory of Karl Lehmann
1961:2

11
Roman, Early Imperial, from Egypt

Mask of a Woman, 1st century A.D.
Plaster with traces of paint, height 7 3/4 in. (19.7 cm.), width 6 1/8 in. (15.5 cm.)

Gift of Mr. and Mrs. Harold Rudolph
1961:64

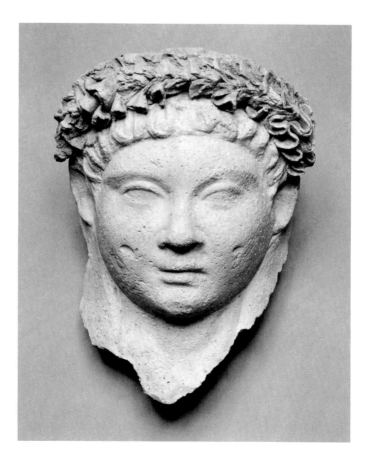

12
Roman, Early Imperial, from near Seleucia Pieria, Syria

Personification of the River Pyramos (fragment of mosaic), 2nd century A.D.
Stone tesserae, 56 x 57 in. (142.2 x 144.8 cm.)

Purchased, Drayton Hillyer Fund
1938:14

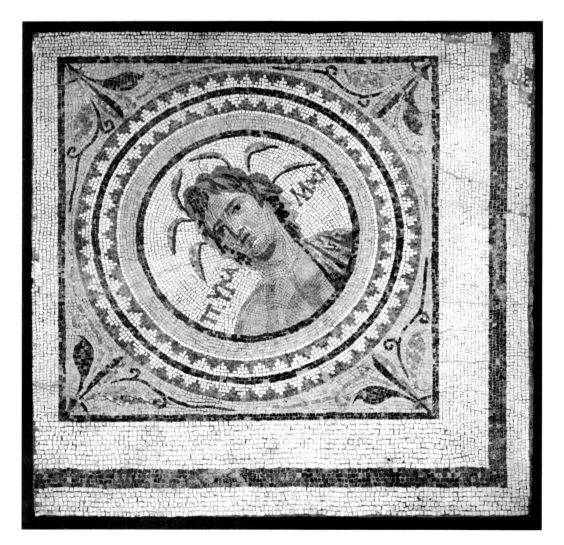

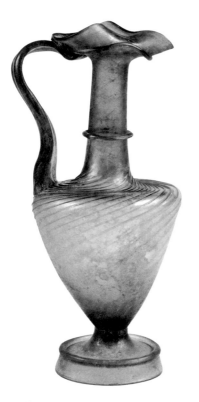

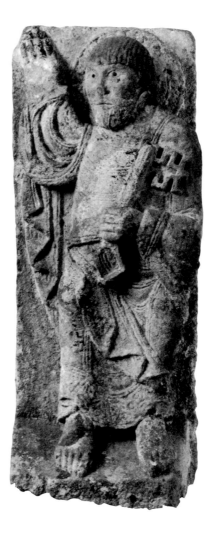

14
French, Romanesque, from the region of Sarlat

St. Peter, 2nd quarter of 12th century
Limestone, 33 x 12 x 7 in. (84 x 30.5 x 17.5 cm.)

Purchased, Tryon Fund
1937:12

13
Roman, Late Imperial, from Syro-Palestinian area

Blown Jug, c. 4th century A.D.
Glass, height 14 1/2 in. (35.7 cm.), maximum diameter 6 in. (15.2 cm.)

Acquired by exchange
1948:4

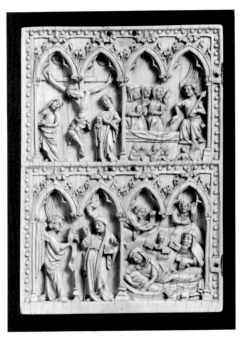

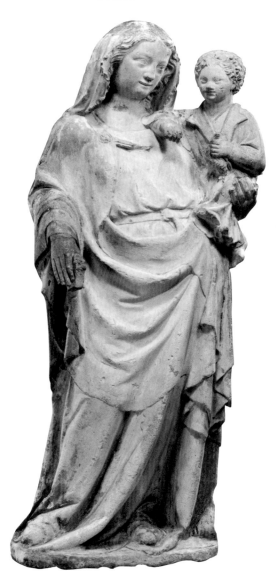

French, Gothic, from Lorraine

Madonna and Child, c. 1315
Limestone, 32 x 12 3/4 x 10 in.
(81.4 x 32.7 x 25.5 cm.)

Gift of Mrs. William Turney (Alice
Stowell '25)
1975:32

15
French, Gothic

Four Scenes from the Life of Christ
(left wing of diptych), 14th century
Ivory, 6 5/16 x 4 5/16 in. (16.1 x
11 cm.)

Purchased
1961:62

17
German, probably from Nuremberg

Kneeling Man (candleholder), 1st half of 15th century
Brass, 9 3/4 x 6 x 5 1/4 in. (24.8 x 15.2 x 13.3 cm.)

Gift of Mr. and Mrs. Stanley Marcus
1955:61

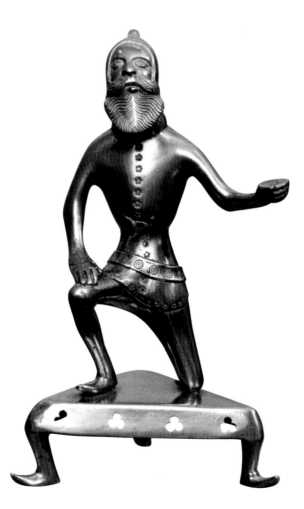

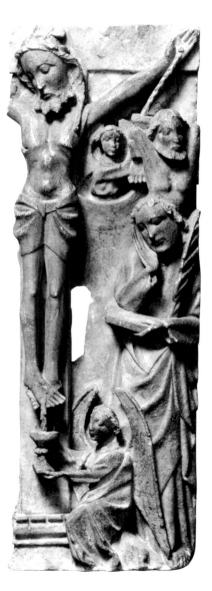

18
English School

Crucifixion, 15th century
Alabaster, 19 11/16 x 6 1/2 x 2 in.
(49.9 x 16.5 x 5.1 cm.)

Purchased
1957:34

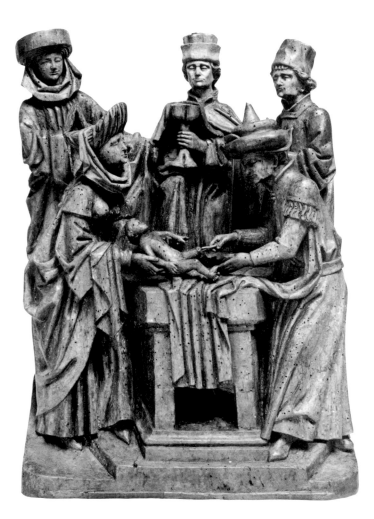

19
South Netherlands, from Brussels

The Circumcision, c. 1470
Walnut, 18 1/2 x 12 3/4 x 7 7/8 in.
(47 x 32.6 x 20 cm.)

Anonymous gift
1955:68

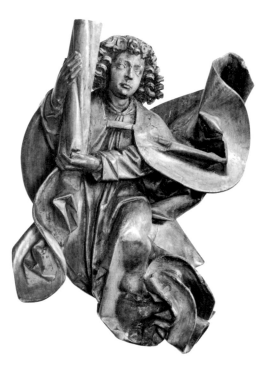

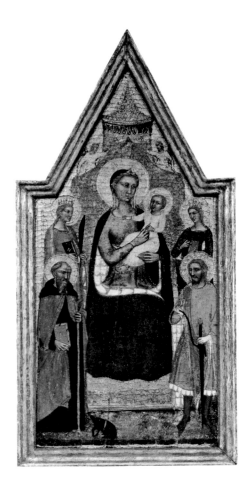

21
The Bargello Master
Italian (Florentine), active during
third quarter of 14th century

*Madonna and Child Enthroned with
Four Saints and Angels,* c. 1375
Tempera and gold leaf on panel,
19 5/16 x 9 7/16 in. (49.1 x
24.3 cm.)

Gift of Sir Joseph Duveen
1921:9

20
**German, possibly Veit Stoss
(1447–1533) or circle, from
Franconia**

Angel Bearing a Column,
15th–early 16th century
Lindenwood, 17 1/2 x 11 1/2 in.
(44.5 x 29.2 cm.)

Purchased, Winthrop Hillyer Fund
1920:26

Color plate, page 42

22
Taddeo di Bartolo
Italian (Sienese), c. 1362–1422

Death of Saint Peter Martyr,
c. 1400
Tempera and gold leaf on panel,
14 1/2 x 15 3/8 in. (36.2 x
38.6 cm.)

Purchased
1958:38

Color plate, page 43

23
Sano di Pietro
Italian (Sienese), c. 1406–1481

Madonna and Child with Saints,
c. 1450
Tempera and gold leaf on panel,
17 1/2 x 14 1/2 in. (44.5 x
36.9 cm.)

Gift of Sir Joseph Duveen
1923:3

24
Attributed to Antonio Rossellino
Italian, 1427–1479

The Madonna of the Candelabra
Polychromed stucco, 29 1/2 x
20 1/4 in. (74.9 x 51.4 cm.)

Gift of Sir Joseph Duveen
1927:2–2

25
Studio of Andrea della Robbia
Italian (Florentine), 1435–1525

Madonna and Child, 1470–1480
Glazed terracotta, diameter
17 5/16 in. (44 cm.), depth
3 1/2 in. (8.9 cm.)

Gift of Dr. and Mrs. John F.
Butterworth in honor of their
daughters Susan Butterworth Lord
('70) and Ann Butterworth Feakins
('73)
1984:28

26
Attributed to Tullio Lombardo
Italian, c. 1455–1532

Head of a Woman, c. 1490–1510
Bronze, 5 3/4 x 5 5/8 x 4 1/4 in.
(14.5 x 14.4 x 10.5 cm.)

Purchased
1960:44

27
Studio of Giovanni da Bologna
Born Flanders (Douai) 1529,
worked in Italy from 1550, died
1608

Striding Bull
Bronze, 12 3/4 x 10 1/2 x 3 in.
(32.3 x 26.6 x 7.6 cm.)

Gift of Mr. and Mrs. Ernest Gottlieb
1956:62

Color plate, page 54

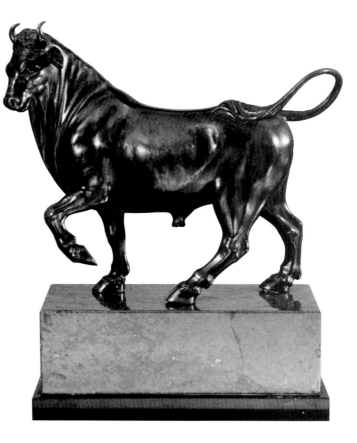

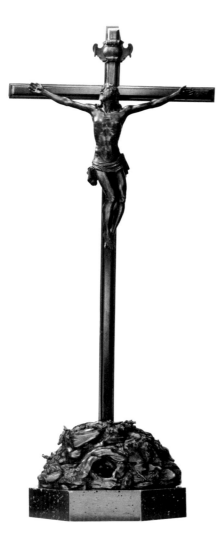

28
Antonio Susini
Italian, active 1580, died 1624

Christ on the Cross
Bronze, 31 5/8 x 13 1/4 x 4 7/8 in.
(80.3 x 33.6 x 12.4 cm.)

Gift of Mrs. Maurice van Dyck
Emetaz in memory of Mary Waring
Fitch ('93)
1966:9

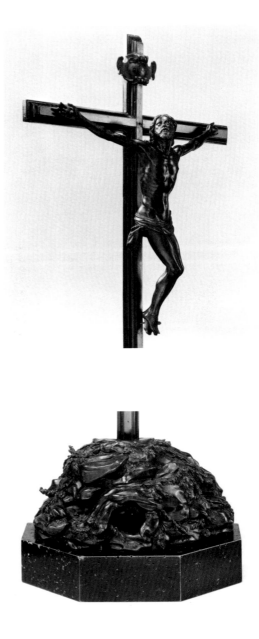

29
Italian, 17th century, after
Alessandro Algardi (Italian
1598-1654)

Saint Philip Neri
Bronze, 10 3/8 x 7 x 4 in. (25.8 x
17.8 x 10.2 cm.)

Purchased
1960:167

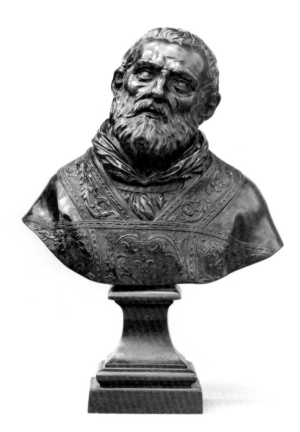

30
Pietro Longhi
Italian, 1702–1785

La Furlana
Oil on canvas, 24 3/8 x 20 1/16 in.
(61.9 x 50.9 cm.)

Purchased, Drayton Hillyer Fund
1947:2

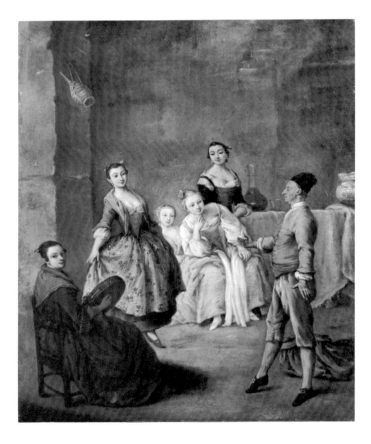

31
Lorenzo Bellotto
Italian, c. 1744–1770

View of a Palace Courtyard, 1765
Oil on canvas, 36 11/16 x
41 1/8 in. (93.2 x 104.4 cm.)

Purchased
1956:48

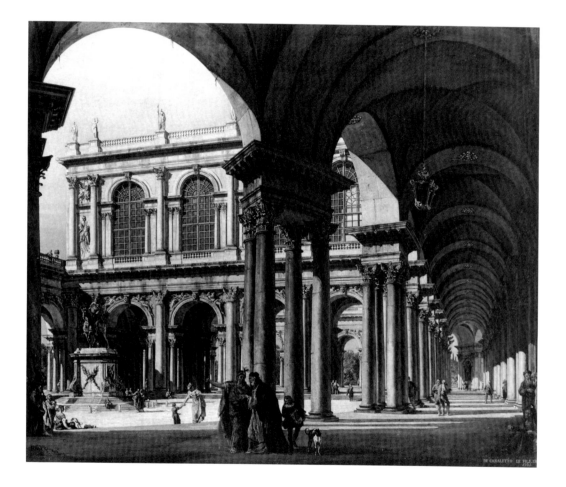

32
Giovanni Paolo Panini
Italian, 1691/92–1765

The Death Leap of Marcus Curtius
Oil on canvas, 40 x 50 in. (101.6 x
127 cm.)

Gift of Jean McLean Morron ('01)
1951:139

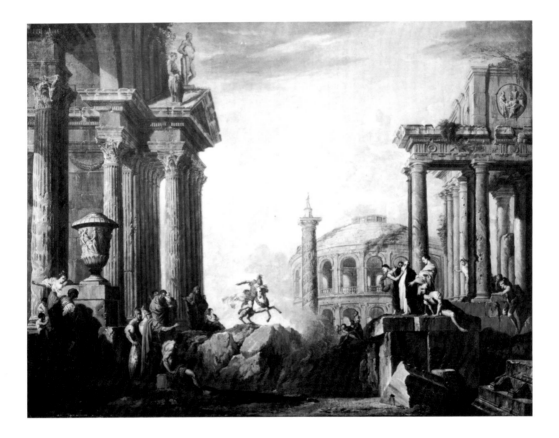

33
Ambrosius Bosschaert the Elder
Dutch, 1573–1621

Fruit Dish with Siegburger Jug,
before 1615
Oil on panel, 17 1/4 x 24 1/4 in.
(43.8 x 61.1 cm.)

Purchased with the gift of Adeline
F. Wing ('98) and Caroline R.
Wing ('96)
1963:62

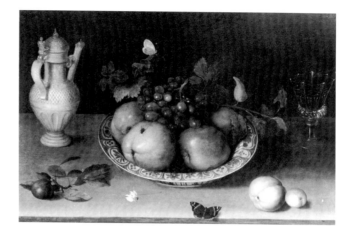

34
Joos de Momper
Flemish, 1564–1635

Alpine Landscape
Oil on panel, 18 1/2 x 27 1/4 in.
(47 x 69 cm.)

Purchased
1970:15

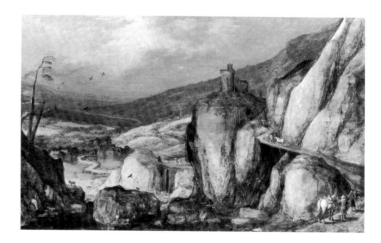

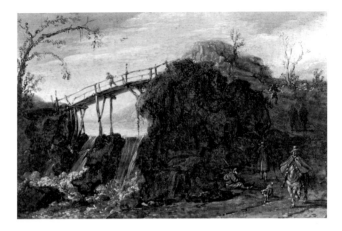

35
Esaias van de Velde
Dutch, c. 1591–1630

Bridge Over a Waterfall, 1625
Oil on panel, 5 1/2 x 8 1/8 in.
(14 x 20.7 cm.)

Purchased
1964:4

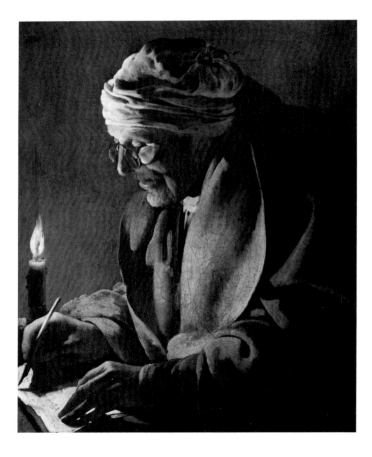

36
Hendrick Terbrugghen
Dutch, 1588–1629

Old Man Writing by Candlelight,
c. 1627
Oil on canvas, 25 7/8 x 20 3/4 in.
(65.8 x 52.7 cm.)

Purchased with the gift of Adeline
F. Wing ('98) and Caroline R.
Wing ('96)
1957:10

37
Johann König
German, c. 1586–1642

Tobias and the Angel
Oil on copper mounted on panel,
7 5/8 x 10 1/4 in. (19.4 x 26 cm.)

Gift of Mrs. Charles Lincoln Taylor
(Margaret R. Goldthwait '21)
1980:38

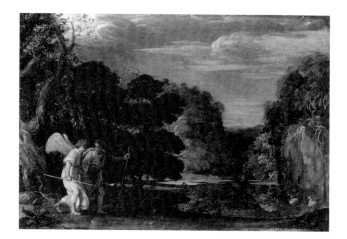

38
Attributed to Willem Kalf
Dutch, 1622–1693

Interior of a Farmhouse, c. 1645
Oil on panel, 14 1/4 x 14 1/2 in.
(36.2 x 36.8 cm.)

Purchased
1962:9

39
Jan van Goyen
Dutch, 1596–1656

View of Rijnland, 1647
Oil on panel, 16 1/4 x 24 in.
(41.3 x 61 cm.)

Purchased
1942:3

Color plate, page 45

40
Jacob van Ruisdael
Dutch, 1628/29–1682

*A Panoramic View with the Church
of Beverwijk,* 1660–1665
Oil on canvas, 12 1/2 x 16 in.
(31.8 x 40.6 cm.)

Purchased, Drayton Hillyer Fund
1943:16

41
Jan Steen
Dutch, 1626–1679

The Drinker, c. 1665
Oil on panel, 14 3/4 x 11 3/4 in.
(37.5 x 29.8 cm.)

Gift of Adeline F. Wing ('98) and
Caroline R. Wing ('96)
1957:36

42
Abraham Mignon
German, 1640–1679

Woodland Still Life, after 1660
Oil on canvas, 24 3/8 x 19 1/4 in.
(61.9 x 48.9 cm.)

Purchased, Eleanor Lamont
Cunningham ('32) Fund in memory
of Alphons P. A. Vorenkamp
1957:3

43
Sebastien Bourdon
French, 1616–1671

Landscape with a Ford (formerly
called *Laban Going into the
Desert*), before 1640
Oil on canvas, 20 x 24 1/2 in.
(50.8 x 62.3 cm.)

Purchased, Eleanor Lamont
Cunningham ('32) Fund
1961:1

44
Jean Jouvenet
French, 1644–1717

The Presentation in the Temple,
c. 1685
Oil on canvas, 50 7/8 x 38 1/2 in.
(129.3 x 97.8 cm.)

Purchased
1946:12

45
Hyacinthe Rigaud
French, 1659–1743

Victor Marie, Duc d'Estrées
(1660–1737), c. 1700
Oil on canvas, 20 1/2 x 16 1/8 in.
(52.1 x 41 cm.)

Purchased, Drayton Hillyer and
Winthrop Hillyer Funds
1947:7

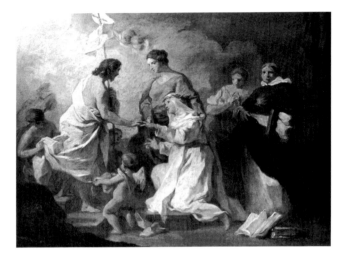

47
Pierre Subleyras
French, 1699–1749

Study for the Mystic Marriage of Saint Catherine of Ricci, 1746
Oil on canvas, 9 1/16 x 11 13/16 in. (23.1 x 30 cm.)

Purchased
1957:33

46
Attributed to Egid Quirin Asam
German, 1692–1750

Saint Benno
Terracotta, 17 1/2 x 7 5/8 x 4 3/4 in. (44.4 x 19.4 x 12.1 cm.)

Gift of Anastasia Thannhauser Dunau ('41) in gratitude to Smith College for the hospitality and help extended to the refugees from Hitler's Germany
1981:11

48
François Hubert Drouais
French, 1727–1775

Portrait of a Boy
Oil on canvas, 17 3/4 x 15 in.
(45 x 38 cm.)

Gift of Mrs. John Wintersteen
(Bernice McIlhenny '25)
1965:3

49
Hubert Robert
French, 1733–1808

Pyramids, c. 1760
Oil on panel, 24 x 28 1/2 in. (61 x
72.4 cm.)

Purchased
1950:15

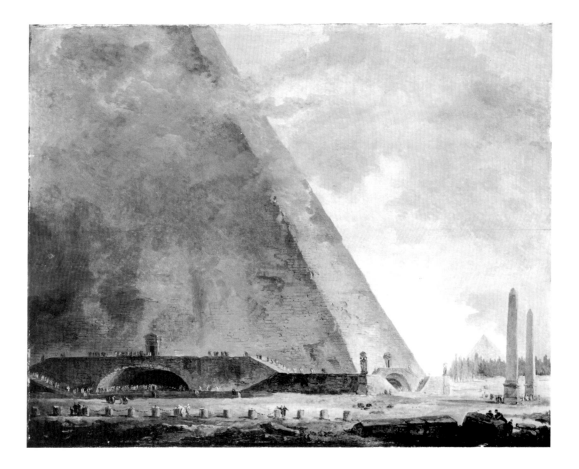

50
Jean-Baptiste Pillement
French, 1728–1808

Landscape with Figures
Oil on copper, 12 3/4 x 16 1/2 in.
(32.4 x 41.9 cm.)

Purchased
1981:6

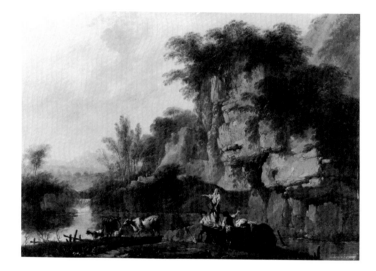

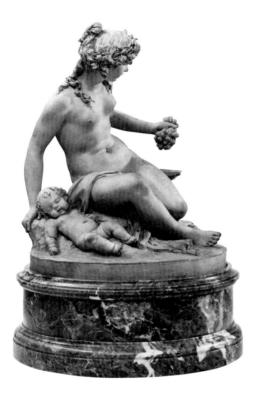

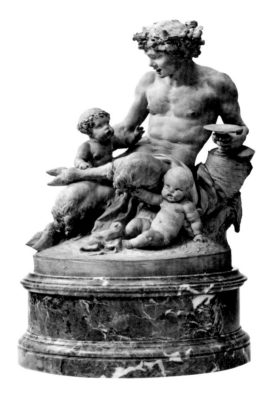

51
Clodion (Claude Michel)
French, 1738–1814

Nymph with Two Children
Terracotta on self-base, 16 1/2 x
9 1/2 x 9 1/4 in. (42 x 24.2 x
23.5 cm.)

Purchased with funds bequeathed
by Frances Ryder Walker ('30)
1973:7–1

52
Clodion (Claude Michel)
French, 1738–1814

Satyr with Two Children
Terracotta on self-base, 16 1/2 x
9 1/2 x 8 7/8 in. (42 x 24.2 x
22.6 cm.)

Purchased with funds bequeathed
by Frances Ryder Walker ('30)
1973:7–2

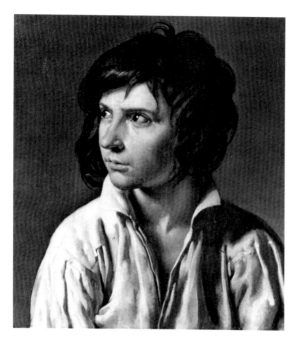

53
French, Anonymous

Portrait of a Youth, early 19th century
Oil on canvas, 17 3/4 x 14 1/4 in. (45.2 x 36.2 cm.)

Purchased, Drayton Hillyer Fund
1931:6

54
Valentin Sonnenschein
Born Stuttgart 1749, died Bern 1828

Madame Rosine-Margarethe Stantz (1749–1807), c. 1807
Terracotta on self-base, 12 x 9 x 13 in. (30.5 x 22.9 x 33 cm.)

Gift of Mr. and Mrs. Jacques Kayaloff
1972:33–8

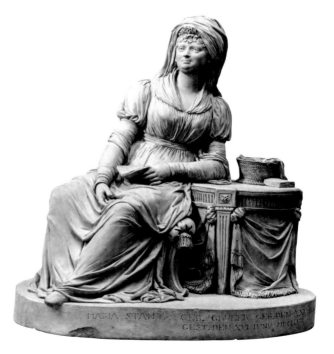

55
Jean-Auguste-Dominique Ingres
French, 1780–1867

The Death of Leonardo da Vinci,
c. 1818
Oil on canvas, 16 1/4 x 19 1/4 in.
(41.2 x 48.9 cm.)

Purchased
1950:98

56
Pierre Etienne Théodore Rousseau
French, 1812–1867

The Bridge at Moret, c. 1828–1829
Oil on canvas, 10 1/2 x 13 1/4 in.
(26.6 x 33.6 cm.)

Purchased
1957:32

58
Narcisse Virgile Diaz de la Peña
French, 1808–1876

Forest at Fontainebleau,
c. 1855–1865
Oil on panel, 19 3/16 x 24 in.
(48.8 x 61 cm.)

Gift of Mr. and Mrs. Anthony L.
Michel (Sarah Prescott '30)
1976:39

57
Jean-Baptiste Camille Corot
French, 1796–1875

Jumièges, c. 1830
Oil on canvas, 12 x 15 1/2 in.
(30.5 x 39.4 cm.)

Purchased, Winthrop Hillyer Fund
1924:15

59
Paul Flandrin
French, 1811–1902

*Mountainous Landscape with
Figures,* c. 1837–1839
Oil on canvas, oval format, 19 1/8
x 15 1/8 in. (48.5 x 38.5 cm.)

Purchased with funds given by the
Smith Club of Albany, New York,
in memory of Marian Park
Humphrey ('15)
1964:3

60
Antoine-Louis Barye
French, 1796–1875

Theseus Slaying the Centaur,
modeled 1849–1850
Bronze on self-base, 21 1/2 x 19 x
5 in. (54.6 x 48.2 x 12.7 cm.)

Purchased
1973:4

61
Jean-Baptiste Camille Corot
French, 1796–1875

La Blonde Gasconne, c. 1850
Oil on canvas, 15 3/4 x 11 7/8 in.
(40 x 30.2 cm.)

Purchased, Drayton Hillyer Fund
1934:7

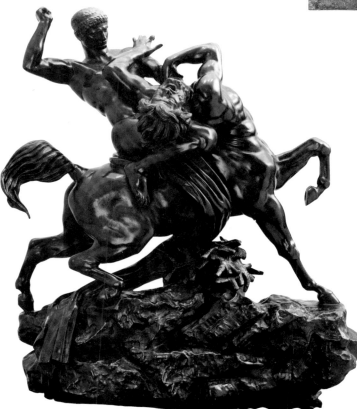

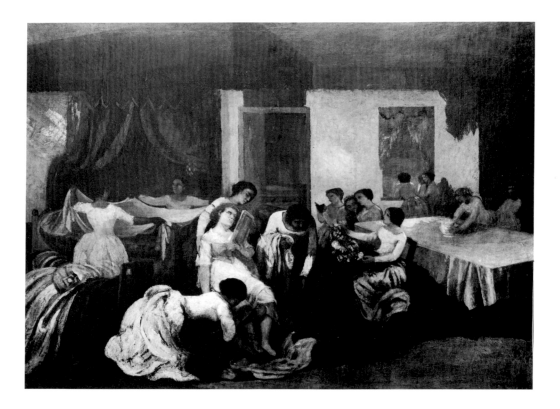

63
Gustave Courbet
French, 1819–1877

Monsieur Nodler the Elder at Trouville, 1865
Oil on canvas, 36 1/4 x 28 3/4 in. (92.1 x 73 cm.)

Purchased, Winthrop Hillyer Fund 1935:3

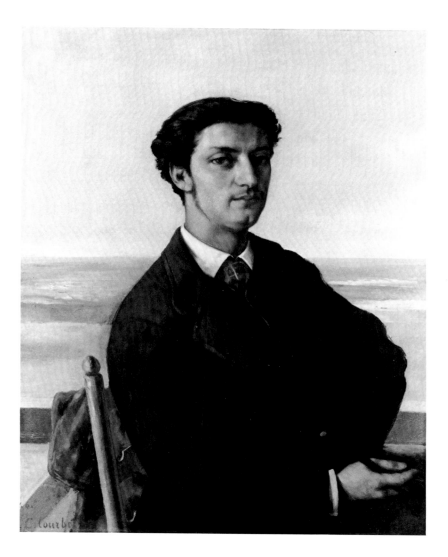

64
Eugène Boudin
French, 1824–1898

Still Life with Fish and Oysters,
c. 1853–1856
Oil on canvas, 17 3/4 x 29 1/2 in.
(45.1 x 74.9 cm.)

Purchased with the aid of funds
given by Mrs. Henry T. Curtiss
(Mina Kirstein '18)
1963:40

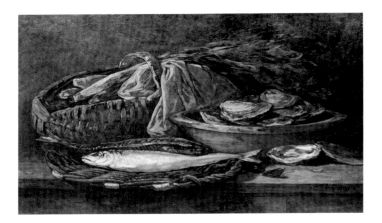

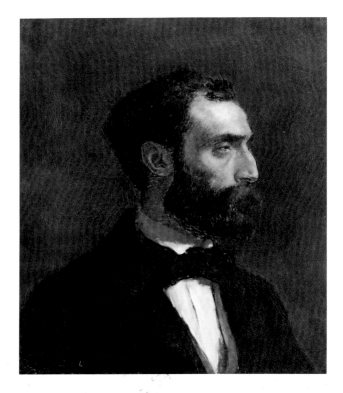

65
Jean-François Millet
French, 1814–1875

William Morris Hunt (1824–1879),
c. 1853–1855
Oil on canvas, 22 x 18 in.
(55.9 x 45.8 cm.)

Purchased
1951:291

66
Jean-François Millet
French, 1814–1875

Farm at Gruchy, 1854
Oil on canvas, 21 1/4 x 28 5/8 in.
(53.9 x 72.7 cm.)

Purchased, Tryon Fund
1931:10

67
Edgar-Hilaire-Germain Degas
French, 1834–1917

René de Gas (1845–1926), c. 1855
Oil on canvas, 36 1/2 x 29 1/2 in.
(91.5 x 74.9 cm.)

Purchased, Drayton Hillyer Fund
1935:12

68
Edgar-Hilaire-Germain Degas
French, 1834–1917

The Daughter of Jephthah,
1859–1860
Oil on canvas, 77 x 117 1/2 in.
(195.5 x 298.5 cm.)

Purchased, Drayton Hillyer Fund
1933:9

Color plate, page 46

69
Auguste Rodin
French, 1840–1917

Man with the Broken Nose,
modeled 1863–1864, this cast
c. 1900
Bronze, 12 x 7 1/2 x 6 3/4 in.
(30.5 x 19 x 17.2 cm.)

Purchased
1963:57

70
Jean-Baptiste Camille Corot
French, 1796–1875

Dubuisson's Grove at Brunoy, 1868
Oil on canvas, 18 x 21 1/2 in.
(45.8 x 54.6 cm.)

Purchased with funds given by
Louise Ines Doyle ('34)
1952:116

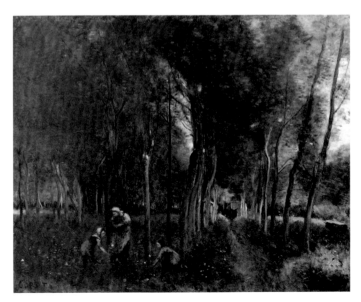

71
Claude Monet
French, 1840–1926

The Seine at Bougival, 1869
Oil on canvas, 23 5/8 x 28 7/8 in.
(60 x 73.3 cm.)

Purchased
1946:4

Color plate, page 44

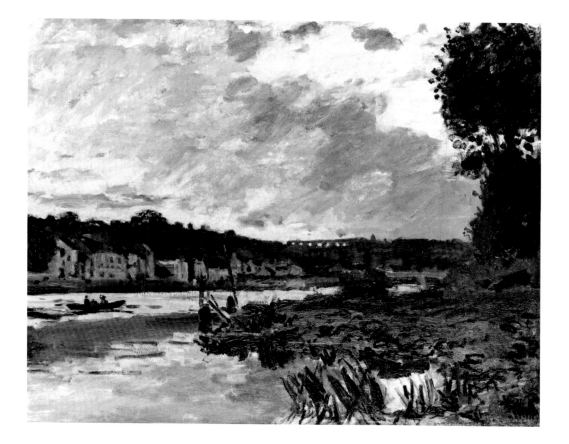

72
Pierre Auguste Renoir
French, 1841–1919

Rapha Maître (Madame Edmond Maître), 1871
Oil on canvas, 14 3/4 x 12 3/4 in.
(37.4 x 32.3 cm.)

Purchased
1924:16

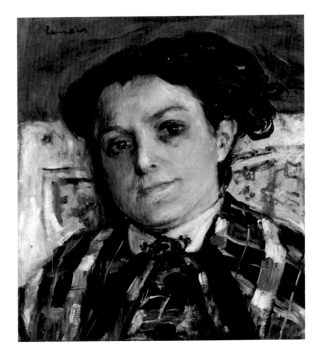

73
Edouard Manet
French, 1832–1883

Marguérite de Conflans, 1873
Oil on canvas, 21 x 17 1/2 in.
(53.3 x 44.4 cm.)

Purchased, Drayton Hillyer Fund
1945:6

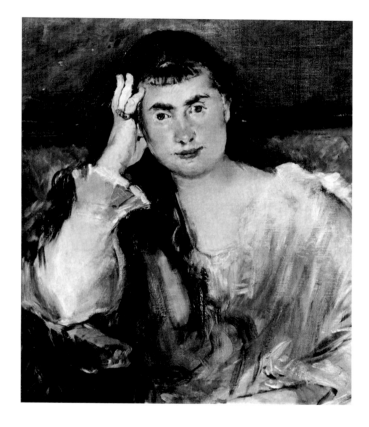

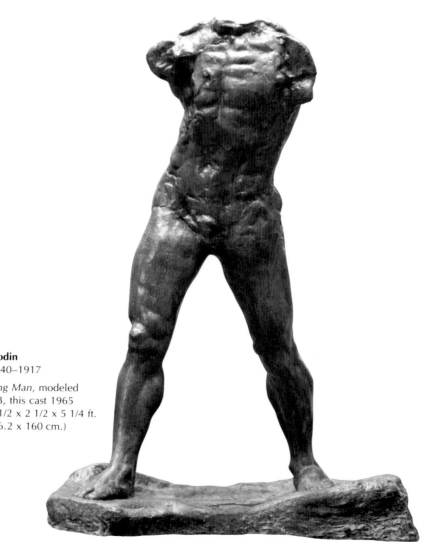

74
Auguste Rodin
French, 1840–1917

The Walking Man, modeled
1877–1878, this cast 1965
Bronze, 7 1/2 x 2 1/2 x 5 1/4 ft.
(228.6 x 76.2 x 160 cm.)

Purchased
1965:30

75
Edgar-Hilaire-Germain Degas
French, 1834–1917

Dancer on the Stage, c. 1877–1880
Oil on canvas, 36 x 46 1/2 in.
(91.5 x 118.1 cm.)

Gift of Paul Rosenberg and
Company
1955:14

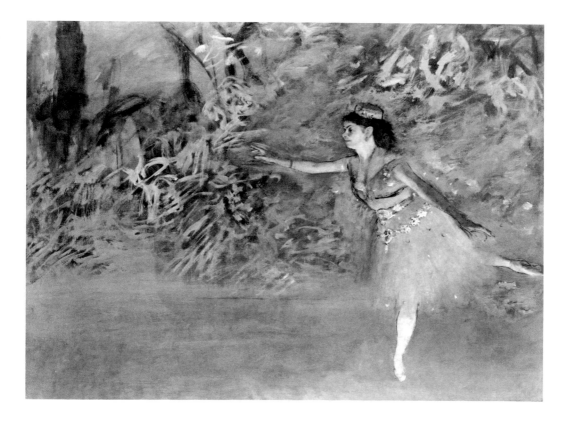

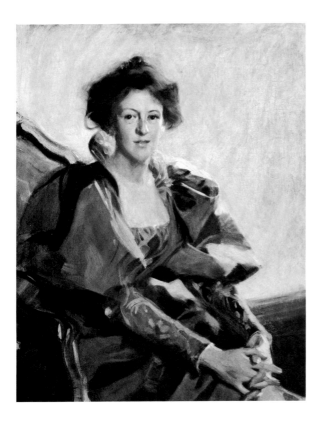

76
Anders Zorn
Swedish, 1860–1920

Susan White Hildreth (1859–1939),
1893
Oil on canvas, 40 1/8 x 30 1/16 in.
(102 x 76.4 cm.)

Gift of Dr. Erwin Saxl in memory of
Lucretia Hildreth Saxl
1981:1

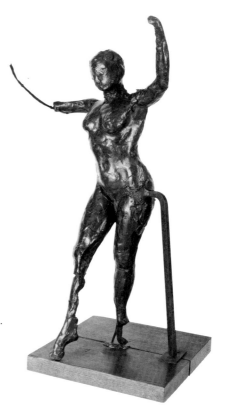

77
Edgar-Hilaire-Germain Degas
French, 1834–1917

Dancer Moving Forward,
1882–1895
Bronze, 25 x 12 5/8 x 8 1/4 in.
(63.5 x 32 x 21 cm.)

Purchased
1965:29

78
Henri Fantin-Latour
French, 1836–1904

Mr. Becker, 1886
Oil on canvas, 40 x 32 1/2 in.
(101.6 x 82.5 cm.)

Purchased
1964:33

79
Auguste Rodin
French, 1840–1917

Children with Lizard (formerly
called *Brother and Sister*), c. 1881
Bronze, 15 1/2 x 10 x 9 3/4 in.
(39.4 x 25.4 x 24.8 cm.)

Purchased from the artist, Winthrop
Hillyer Fund
1914:2

80
Anton Romako
Austrian, 1832–1889

*Girl on a Swing (Olga von
Wassermann, 1872–1944),* c. 1882
Oil on canvas, 63 x 48 in.
(160 x 121.9 cm.)

Purchased
1963:58

81
Claude Monet
French, 1840–1926

Field of Poppies, 1890
Oil on canvas, 23 1/2 x 39 1/2 in.
(59.7 x 100.3 cm.)

Gift of the Honorable and Mrs.
Irwin Untermyer in honor of their
daughter Joan L. Untermyer ('40)
1940:10

82
Alfred Sisley
French, 1839–1899

Saint-Mammès, 1886
Oil on canvas, 13 1/2 x 18 1/4 in.
(34.3 x 47 cm.)

Bequest of Mr. and Mrs. Murray
Seasongood (Agnes Senior '11)
1983:20–1

83
Camille Pissarro
French, born Virgin Islands 1830,
to France 1855, died 1903

Outskirts of Pontoise, c. 1877–1879
Oil on canvas, 19 3/4 x 24 in.
(50.2 x 61 cm.)

Purchased
1954:17

84
Claude Monet
French, 1840–1926

*Cathedral at Rouen (La Cour
d'Albane)*, 1892–1894
Oil on canvas, 36 1/2 x 29 1/16 in.
(92.7 x 73.7 cm.)

Gift of Adeline F. Wing ('98) and
Caroline R. Wing ('96)
1956:24

85
Paul Cézanne
French, 1839–1906

*A Turn in the Road at La Roche-
Guyon,* c. 1885
Oil on canvas, 25 1/4 x 31 1/2 in.
(64.2 x 80 cm.)

Purchased
1932:2

Color plate, page 37

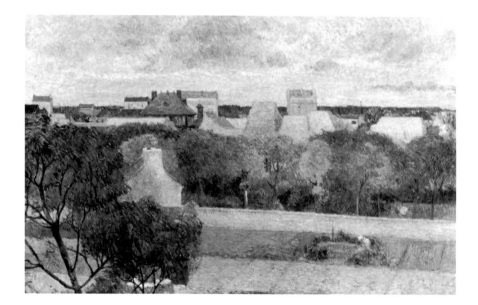

86
Paul Gauguin
French, 1848–1903

The Market Gardens of Vaugirard,
1879
Oil on canvas, 26 x 39 1/2 in.
(66 x 100.3 cm.)

Purchased
1953:55

87
Edouard Vuillard
French, 1868–1940

The Suitor (formerly called *Interior at l'Etang-la-Ville*), 1893
Oil on millboard panel, 12 1/2 x 14 15/16 in. (31.8 x 36.4 cm.)

Purchased, Drayton Hillyer Fund 1938:15

Color plate, page 36

88
Georges Seurat
French, 1859–1891

Woman with a Monkey (study for *Sunday Afternoon on the Island of La Grande Jatte*), 1884
Oil on panel, 9 3/4 x 6 1/4 in. (24.8 x 15.9 cm.)

Purchased, Tryon Fund 1934:2–1

Color plate, frontispiece

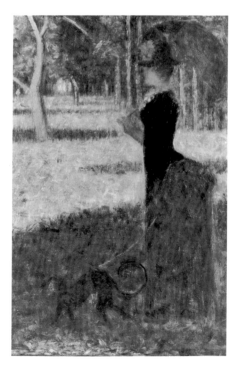

89
Pierre Bonnard
French, 1867–1947

Rooftops, c. 1897
Oil on composition board, 13 1/2 x
14 1/2 in. (34.3 x 36.9 cm.)

Gift of the Adele R. Levy Fund, Inc.
1962:23

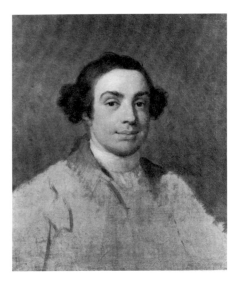

90
William Hogarth
English, 1697–1764

James Caulfield, First Earl of Charlemont (1728–1799), after 1759
Oil on canvas, 23 1/2 x 19 1/2 in. (59.7 x 49.5 cm.)

Gift of Mr. and Mrs. R. Keith Kane (Amanda Stewart Bryan '27)
1959:211

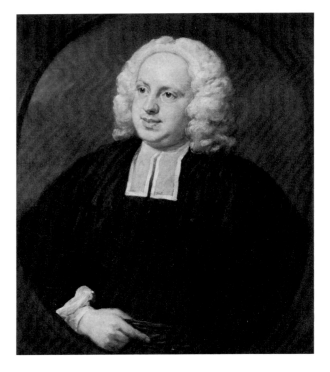

91
William Hogarth
English, 1697–1764

The Reverend John Hoadly, Chancellor of Winchester (1711–1776), 1741
Oil on canvas, 29 7/8 x 25 in. (75.9 x 63.5 cm.)

Purchased, Drayton Hillyer Fund
1948:7

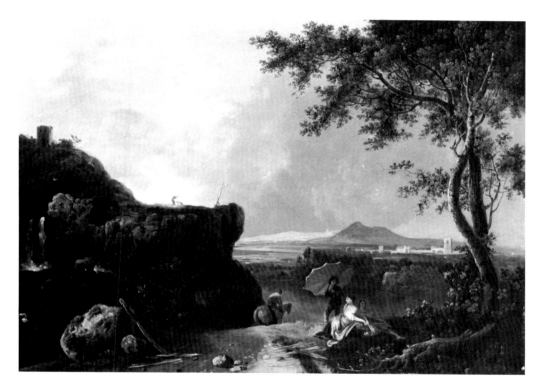

92
Richard Wilson and studio
English, 1713–1782

The White Monk, c. 1765–1775
Oil on canvas, 36 3/8 x 51 in.
(92.4 x 129.5 cm.)

Acquired by exchange
1954:63

93
Attributed to Johann Joseph Zoffany
Born Germany 1733, to London c. 1760, died 1810

The Oboe Player, c. 1780
Oil on canvas, 29 1/2 x 24 1/2 in. (74.9 x 62.2 cm.)

Gift of Mr. and Mrs. Allan D. Emil 1956:59

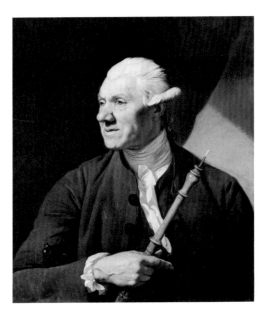

94
Henry Fuseli
Born Zurich 1741, to England 1764, died 1825

Lady Constance, Arthur, and Salisbury ("Here I and sorrow sit"), 1783
Oil on paper mounted on canvas, 25 x 21 in. (63.5 x 53.3 cm.)

Purchased with the gift of Eleanor Lamont Cunningham ('32) 1949:9

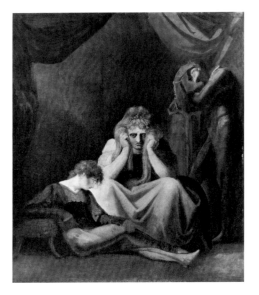

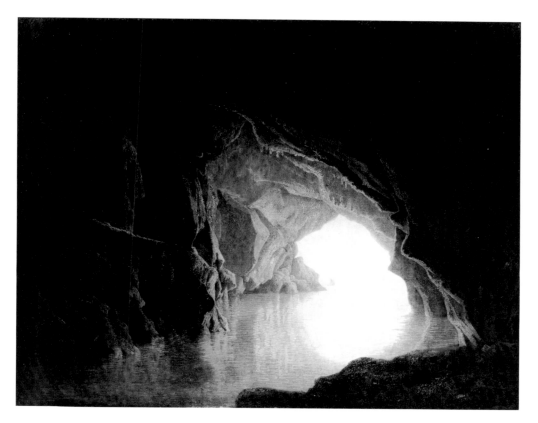

95
Joseph Wright of Derby
English, 1734–1797

A Cavern, Evening, 1774
Oil on canvas, 40 x 50 in. (101.6 x 127 cm.)

Purchased
1950:16

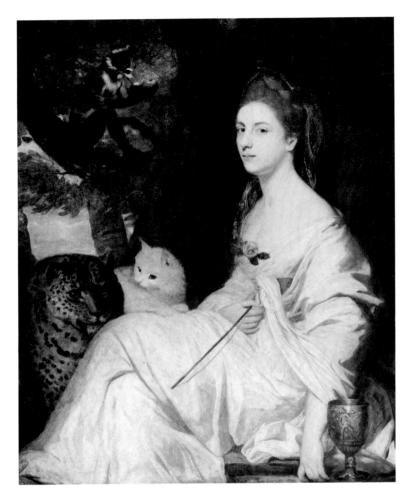

96
Sir Joshua Reynolds
English, 1723–1790

Mrs. Nesbitt as Circe, 1781
Oil on canvas, 49 1/4 x 39 1/2 in.
(125.1 x 100.3 cm.)

Gift of Dwight W. Morrow, Jr.,
Anne Morrow Lindbergh ('28), and
Constance Morrow Morgan ('35)
1958:4

97
Sir Thomas Lawrence
English, 1769–1830

Robert Burnet Jones, c. 1805–1815
Oil on canvas, 28 7/8 x 23 7/8 in.
(73.4 x 60.7 cm.)

Gift of Mrs. Curtis D. Epler
(Katherine May '26)
1973:26

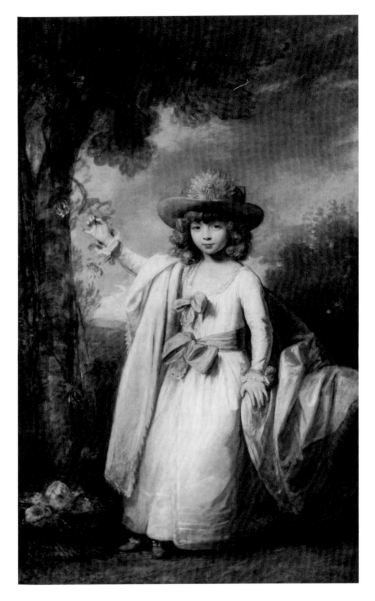

98
Gilbert Stuart
Born America 1755, worked in
England 1775–1793, died 1828

*Henrietta Elizabeth Frederica Vane
(c. 1773–1807)*, 1783
Oil on canvas, 65 7/8 x 38 5/8 in.
(167 x 98.2 cm.)

Gift in memory of Jessie Rand
Goldthwait ('90) by her husband
Dr. Joel E. Goldthwait, and
daughter Mrs. Charles Lincoln
Taylor (Margaret Rand
Goldthwait '21)
1957:39

99

Benjamin West
Born America 1738, worked in
England from 1763, died 1820

The Conversion of Saint Paul, with
Paul's Persecution of the Christians
(left) and *Restoration of Paul's Sight
by Ananias* (right), 1786
Oil on canvas, framed 56 x 54 in.
(142.3 x 137.2 cm.)

Gift of Adeline F. Wing ('98) and
Caroline R. Wing ('96)
1951:169

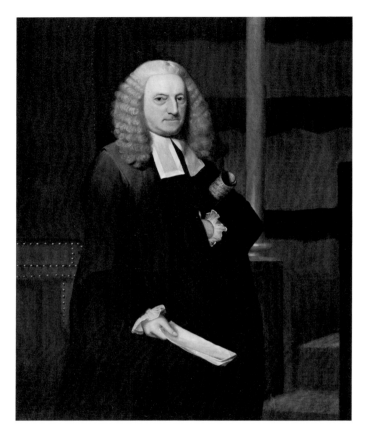

100
Ralph Earl
Born America 1751, worked in
England 1778–1785, died 1801

*A Master in Chancery Entering the
House of Lords,* 1783
Oil on canvas, 49 1/2 x 39 in.
(125.1 x 99.1 cm.)

Purchased
1956:52

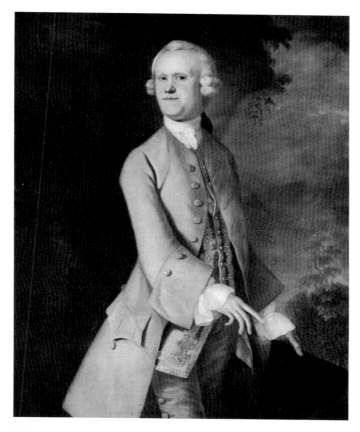

101
Joseph Blackburn
Born England, worked in America
1753/54–1763

Andrew Faneuil Phillips
(1729–1775), 1755
Oil on canvas, 50 3/8 x 40 1/2 in.
(127.9 x 102.2 cm.)

Gift of Mrs. Winthrop Merton Rice
(Helen Swift Jones '10)
1973:25

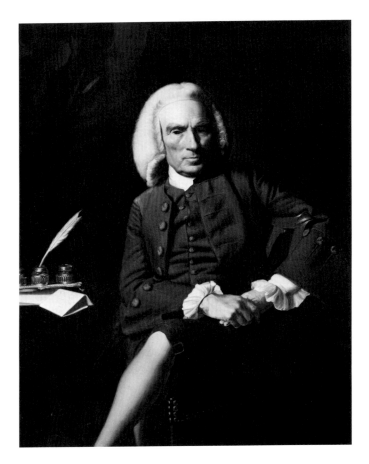

102
John Singleton Copley
Born Boston 1737, to England
1774, died 1815

*The Honorable John Erving
(1693–1786),* c. 1774
Oil on canvas, 50 1/2 x 40 1/2 in.
(128.2 x 102.9 cm.)

Bequest of Alice Rutherford
Erving ('29)
1975:52–1

Color plate, page 38

103
John Smibert
Born Scotland 1688, worked in
London 1722–1728, to America
1728, died 1751

Mrs. John Erving (Abigail Phillips,
1702–1759), c. 1733
Oil on canvas, 39 3/4 x 30 3/4 in.
(100.9 x 78.1 cm.)

Purchased with funds realized from
the estate of Maxine Weil
Kunstadter ('24)
1981:12

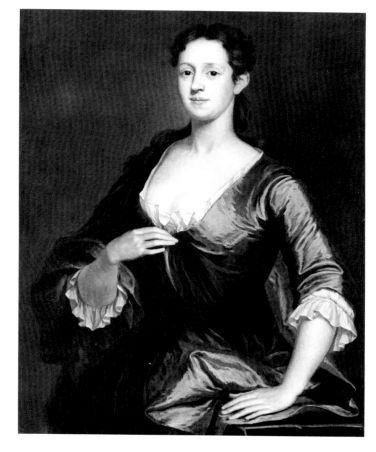

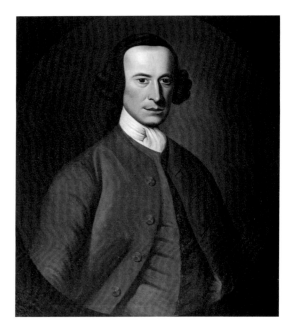

104
Thomas McIlworth
Born Scotland (?), active
1757–1769

Dr. William Samuel Johnson
(1727–1819), 1761
Oil on canvas, 31 1/2 x 26 1/4 in.
(80 x 66.7 cm.)

Purchased, Eleanor Lamont
Cunningham ('32) Fund
1955:4

105
William Jennys
American, active c. 1795–1810

*Lieutenant David Billings
(1730–1810),* c. 1800
Oil on canvas, 30 x 24 7/8 in.
(76.2 x 63.2 cm.)

Gift of H. Louisa Billings ('05) and
Marian C. Billings ('01)
1972:41–1

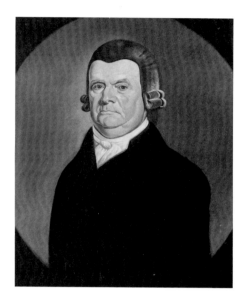

106
William Jennys
American, active c. 1795–1810

Mabel Little Billings (1744–1815),
c. 1800
Oil on canvas, 30 x 24 7/8 in.
(76.2 x 63.2 cm.)

Gift of H. Louisa Billings ('05) and
Marian C. Billings ('01)
1972:41–2

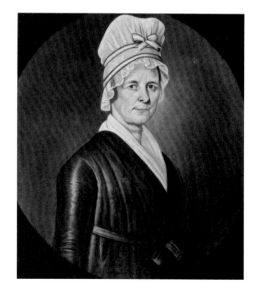

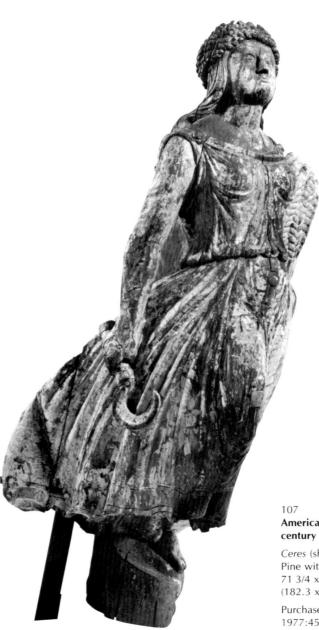

107
American, late 18th–early 19th century

Ceres (ship's figurehead)
Pine with traces of gesso and paint,
71 3/4 x 24 1/2 x 25 1/2 in.
(182.3 x 62.3 x 64.8 cm.)

Purchased
1977:45

108
American, late 18th-early 19th century

Eagle (architectural ornament), c. 1790–1820
Pine with gilt and gesso, 37 x 26 1/2 x 60 in. (94 x 152.5 x 67.3 cm.)

Gift of Dorothy C. Miller '25 (Mrs. Holger Cahill)
1969:83

109
Margaretta Angelica Peale
American, 1795–1882

Still Life with Watermelon and Peaches, 1828
Oil on canvas, 13 x 19 1/8 in.
(33 x 48.5 cm.)

Purchased with funds given anonymously by a member of the Class of 1952
1952:53

110
Alonzo Blanchard
American, active 1822–1863

George Washington (portion of stove), design patented 1843
Cast iron, 47 x 12 3/4 x 8 in. (119.5 x 32.3 x 20.3 cm.)

Purchased
1980:24

111
George Inness
American, 1825–1894

Along the Delaware, 1878
Oil on canvas, 16 x 24 in. (40.6 x
61 cm.)

Purchased
1951:193

112
Thomas Chambers
Born England 1808, to United
States 1832, died after 1866

Looking North to Kingston, c. 1850
Oil on canvas, 22 1/2 x 30 1/2 in.
(57.1 x 76.2 cm.)

Purchased, Annie Swan Coburn
(Mrs. Lewis Larned Coburn) Fund
1942:9

113
**Lilly Martin Spencer (born
Angeline Marie Martine)**
Born England 1824, to United
States 1829, died 1902

Reading the Legend, 1852
Oil on canvas, 50 3/8 x 38 in.
(127.9 x 96.5 cm.)

Gift of Adeline F. Wing ('98) and
Caroline R. Wing ('96)
1954:69

114
William Matthew Prior
American, 1806–1873

Mount Vernon and the Tomb of Washington, after 1852
Oil on canvas, 18 3/4 x 28 3/4 in. (47.7 x 73 cm.)

Purchased
1950:72

115
Asher B. Durand
American, 1796–1886

Woodland Interior, c. 1854
Oil on canvas, 23 1/2 x 16 3/4 in. (59.6 x 42.6 cm.)

Purchased
1952:107

116
William Stanley Haseltine
American, 1835–1900

Natural Arch, Capri, c. 1855–1876
Oil on canvas, 15 x 23 in.
(38.2 x 58.4 cm.)

Gift of Helen Haseltine Plowden
(Mrs. Roger H. Plowden)
1952:4

117
Francis Shedd Frost
American, 1825–1902

*South Pass, Wind River Mountains,
Wyoming,* 1860
Oil on canvas, 28 1/2 x 50 1/8 in.
(71.5 x 127.2 cm.)

Gift of Margaret Richardson
Gallagher ('06)
1951:278

118
Albert Bierstadt
Born Germany 1830, to United
States 1831, died 1902

Echo Lake, Franconia Mountains,
New Hampshire, 1861
Oil on canvas, 25 x 39 1/8 in.
(63.5 x 99.3 cm.)

Purchased with the aid of funds
given by Mrs. John Stewart
Dalrymple (Bernice Barber '10)
1960:37

119
Thomas Charles Farrer
Born England 1839, worked in
United States c. 1858–1872, died
1891

View of Northampton from the
Dome of the Hospital, 1865
Oil on canvas, 28 1/8 x 36 in.
(73.9 x 91.5 cm.)

Purchased
1953:96

Color plate, page 10

120
Winslow Homer
American, 1836–1910

Shipbuilding at Gloucester, 1871
Oil on canvas, 13 1/2 x 19 3/4 in.
(34.2 x 50.2 cm.)

Purchased
1950:99

121
Daniel Chester French
American, 1850–1931

The May Queen, 1875
Marble, 16 x 14 x 7 1/2 in.
(40.7 x 35.6 x 19.1 cm.)

Gift of Dr. and Mrs. Joel E.
Goldthwait (Jessie Rand '90)
1915:8

122
Thomas Eakins
American, 1844–1916

In Grandmother's Time, 1876
Oil on canvas, 16 x 12 in.
(40.6 x 30.5 cm.)

Purchased from the artist
1879:1

123
William Morris Hunt
American, 1824–1879

Niagara Falls, 1878
Oil on canvas, 28 x 24 in.
(71.1 x 61 cm.)

Purchased
1950:24

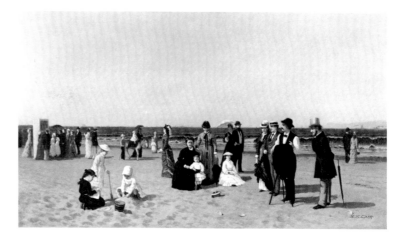

124
Samuel S. Carr
Born England 1838, to United
States 1863, died 1908

Beach Scene, c. 1879
Oil on canvas, 12 x 20 in.
(30.5 x 50.8 cm.)

Bequest of Annie Swan Coburn
(Mrs. Lewis Larned Coburn)
1934:3–10

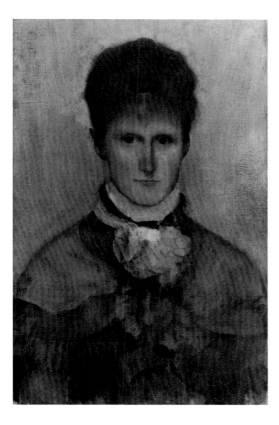

125
James Abbott McNeill Whistler
American, born 1834, to England
1860, died 1903

*Mrs. Lewis Jarvis (Ada Maud Vesey-
Dawson Jarvis, died 1919)*, 1879
Oil on canvas, 25 x 16 in.
(63.5 x 40.7 cm.)

Purchased, Winthrop Hillyer Fund
1908:2

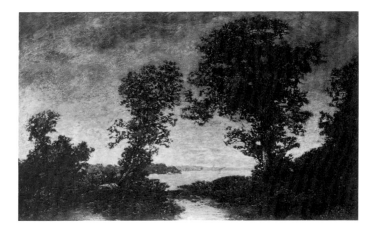

126
Ralph Albert Blakelock
American, 1847–1919

Outlet of a Mountain Lake, c. 1887
Oil on canvas, 16 x 24 in.
(40.2 x 61 cm.)

Purchased, Winthrop Hillyer Fund
1914:1

127
John Singer Sargent
American, born Italy 1856, worked
in Paris 1874–1884, died London
1925

My Dining Room, c. 1883–1886
Oil on canvas, 29 x 23 3/4 in.
(73.7 x 60.4 cm.)

Purchased with funds given by Mrs.
Henry T. Curtiss (Mina Kirstein '18)
in memory of William Allan
Neilson
1968:10

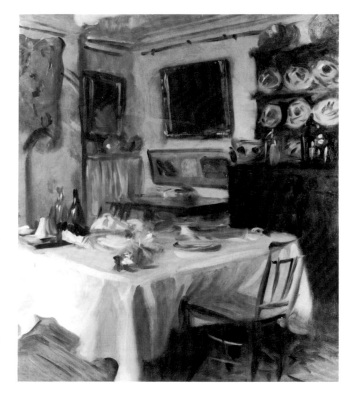

128
William Merritt Chase
American, 1849–1916

Woman in Black, c. 1890
Oil on panel, 15 1/4 x 9 7/8 in.
(38.7 x 25.1 cm.)

Purchased
1900:16

129
Albert Pinkham Ryder
American, 1847–1917

Perrette, c. 1890
Oil on canvas mounted on wood,
12 3/4 x 7 5/8 in. (32.3 x 19.3 cm.)

Purchased, Winthrop Hillyer Fund
1893:1

130
Edwin Romanzo Elmer
American, 1850–1923

Mourning Picture, 1890
Oil on canvas, 28 x 36 in.
(71.1 x 91.5 cm.)

Purchased
1953:129

131
Edwin Romanzo Elmer
American, 1850–1923

A Lady of Baptist Corner, Ashfield,
Massachusetts (the artist's wife),
1892
Oil on canvas, 33 x 24 7/8 in.
(83.8 x 63.2 cm.)

Gift of E. Porter Dickinson
1979:47

Color plate, page 51

132
Childe Hassam
American, 1859–1935

*Cab Stand at Night, Madison
Square, New York,* 1891
Oil on panel, 8 1/4 x 13 3/4 in.
(21 x 34.9 cm.)

Bequest of Annie Swan Coburn
(Mrs. Lewis Larned Coburn)
1934:3–2

133
Childe Hassam
American, 1859–1935

*White Island Light, Isles of Shoals,
at Sundown,* 1899
Oil on canvas, 27 x 27 in.
(68.6 x 68.6 cm.)

Gift of Mr. and Mrs. Harold D.
Hodgkinson (Laura White
Cabot '22)
1973:51

134
Augustus Saint-Gaudens
American, 1848–1907

Diana of the Tower, 1899
Bronze on self-base, 36 x 14 1/4 x
11 in. (91.4 x 36.2 x 28 cm.)

Purchased, Winthrop Hillyer Fund
1900:22

135
Thomas Eakins
American, 1844–1916

Mrs. Edith Mahon, 1904
Oil on canvas, 20 x 16 in.
(50.8 x 40.7 cm.)

Purchased, Drayton Hillyer Fund
1931:2

Color plate, page 35

136
Rockwell Kent
American, 1882–1971

Dublin Pond, 1903
Oil on canvas, 28 x 30 in.
(71.1 x 76.2 cm.)

Purchased, Winthrop Hillyer Fund
1904:2

137
Alfred Henry Maurer
American, born 1868, worked in
France 1897–1914, died 1932

Le Bal Bullier, c. 1901–1903
Oil on canvas, 28 1/2 x 36 1/2 in.
(72.4 x 92.7 cm.)

Purchased
1951:283

138
John Frederick Peto
American, 1854–1907

Discarded Treasures, c. 1904
Oil on canvas, 22 x 40 in.
(55.9 x 101.6 cm.)

Spurious signature of W. M.
Harnett over traces of Peto
signature

Purchased, Drayton Hillyer Fund
1939:4

139
Piet Mondrian
Dutch, born 1872, worked in Paris
1919–1938, worked in United
States from 1940, died 1944

Trees by the River Gein,
c. 1902–1905
Oil on canvas, 12 1/8 x 18 1/8 in.
(30.8 x 46 cm.)

Gift of Mrs. John W. O'Boyle
(Nancy Millar '52)
1975:23

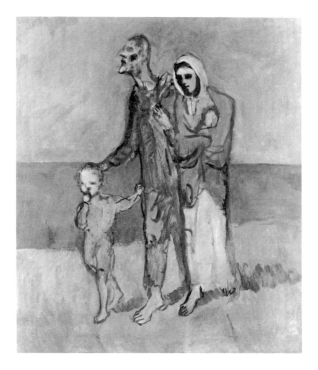

140
Pablo Picasso
Spanish, born 1881, worked in
France from 1904, died 1973

*Figures by the Sea (Les Misérables
au bord de la mer)*, 1903
Oil on canvas, 23 1/2 x 19 1/2 in.
(61.6 x 50.5 cm.)

Gift of Jere Abbott
1965:33

141
Henri Rousseau
French, 1844–1910

Banks of the Oise, c. 1905
Oil on canvas, 18 x 22 in.
(45.7 x 55.9 cm.)

Purchased, Drayton Hillyer Fund
1939:7

142
Ernst Ludwig Kirchner
German, 1880–1938

Dodo and her Brother, 1908–1920
Oil on canvas, 67 1/8 x 37 7/16 in.
(170.5 x 94.1 cm.)

Purchased
1955:59

Color plate, page 49

143
Wilhelm Lehmbruck
German, born 1881, worked in
Paris 1910–1914, died 1919

Torso of the Pensive Woman,
1913–1914
Cast in concrete by the artist, on
self-base, 50 7/8 x 18 x 13 1/8 in.
(129.3 x 45.7 x 33.3 cm.)

Purchased, Winthrop Hillyer Fund
1922:19

144
Gaston Lachaise
American, born France 1882, to
United States 1906, died 1935

*Woman with Beads (La Force
éternelle),* 1913–1917
Bronze, 12 1/4 x 4 x 5 1/2 in.
(31.1 x 10.2 x 14 cm.)

Gift of Stephan Bourgeois
1923:6–1

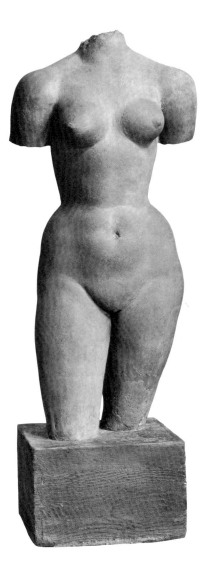

145

Juan Gris

Spanish, born 1887, worked in
France from 1906, died 1927

Still Life, the Bottle of Rum,
December 1913–January 1914
Oil on canvas, 13 5/8 x 8 5/8 in.
(34.6 x 21.9 cm.)

Gift of Joseph Brummer
1923:2–2

146

Elie Nadelman

American, born Poland 1882,
worked in Paris 1904–1914, to
United States 1914, died 1946

Resting Stag, c. 1915
Bronze, 14 3/8 x 20 1/2 x 10 in.
(36.5 x 52 x 25.4 cm.)

Purchased with income from the
Hillyer, Tryon, and Mather Funds
and funds given by Bernice
Hirschman Tumen ('23) in honor of
the Class of 1923
1983:24

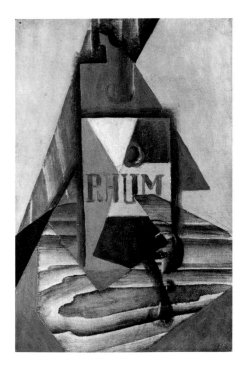

147
Juan Gris
Spanish, born 1887, worked in
France from 1906, died 1927

Glasses and Newspaper, May 1914
Gouache, conté crayon and chalk
on paper mounted on canvas,
24 x 15 in. (61 x 38 cm.)

Gift of Joseph Brummer
1921:8–2

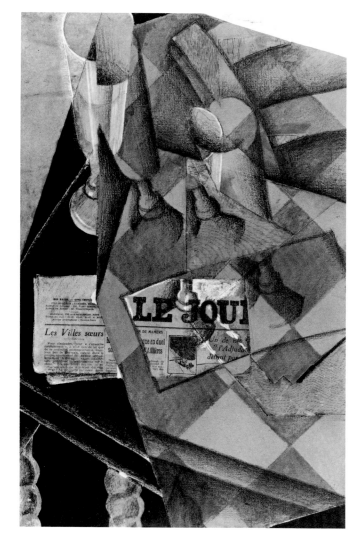

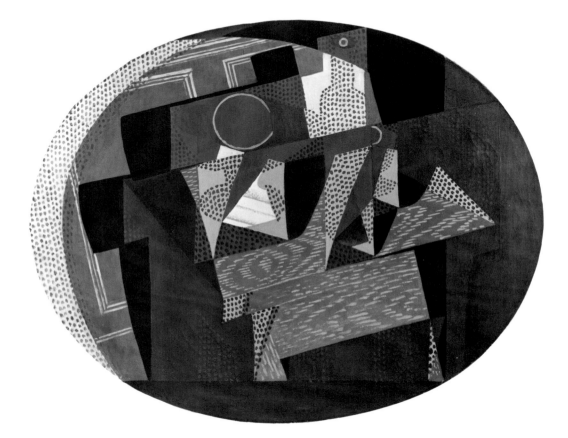

148
Juan Gris
Spanish, born 1887, worked in
France from 1906, died 1927

Fruit Dish and Bottle, March 1916
Oil on canvas, oval format,
25 5/8 x 31 7/8 in. (65.1 x
80.6 cm.)

Gift of Joseph Brummer
1921:8–4

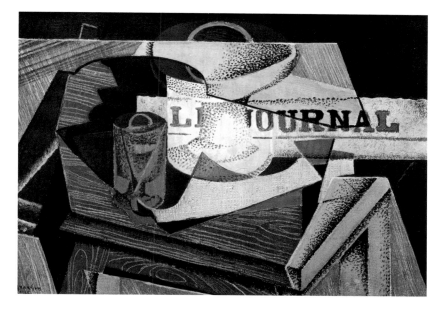

149
Juan Gris
Spanish, born 1887, worked in
France from 1906, died 1927

Fruit Dish, Glass, and Newspaper,
1916
Oil on canvas, 13 x 18 1/4 in.
(33 x 46.3 cm.)

Gift of Joseph Brummer
1923:2–1

150
Kurt Schwitters
German, 1887–1949

Kynast-Fest, 1919
Collage of colored and printed
papers, 11 1/16 x 8 9/16 in. (28.1 x
21.7 cm.)

Purchased, Eleanor Lamont
Cunningham ('32) Fund
1959:65

151
Pablo Picasso
Spanish, born 1881, worked in
France from 1904, died 1973

Table, Guitar, and Bottle (La Table),
1919
Oil on canvas, 50 x 29 1/2 in.
(127 x 74.9 cm.)

Purchased, Sarah J. Mather Fund
1932:15

Color plate, page 50

153
Pierre Bonnard
French, 1867–1947

Landscape in Normandy (formerly
Paysage du Midi), begun 1920
Oil on canvas, 24 5/8 x 32 in.
(62.6 x 81.3 cm.)

Purchased, Drayton Hillyer Fund
1937:8

Color plate, page 48

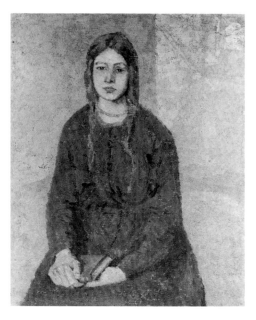

152
Gwen John
English, born 1876, worked in
France from 1903, died 1939

Seated Girl Holding a Book,
c. 1922
Oil on canvas, 17 1/2 x 13 1/2 in.
(44.5 x 34.4 cm.)

Anonymous gift
1972:47

154
Florine Stettheimer
American, 1871–1944

*Henry McBride, Art Critic
(1868–1962)*, 1922
Oil on canvas, 30 x 26 in.
(76.2 x 66 cm.)

Gift of Ettie Stettheimer
1951:198

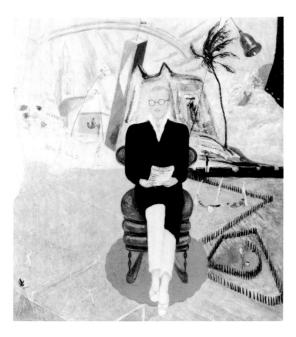

155
László Moholy-Nagy
American, born Hungary 1895,
worked in Germany 1921–1935, to
United States 1937, died 1947

K¹, 1922
Oil on canvas, 30 x 37 1/2 in.
(76.2 x 95.2 cm.)

Gift of Sibyl Moholy-Nagy
1951:126

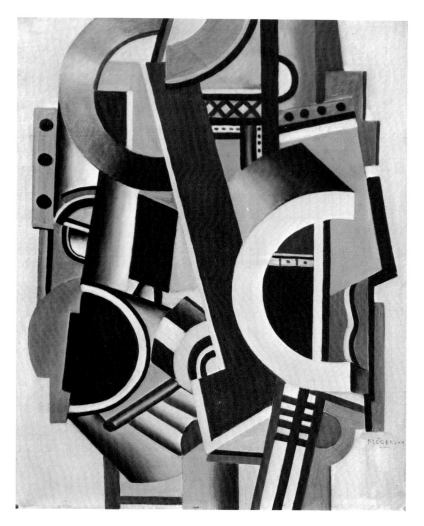

156
Fernand Léger
French, 1881–1955

Mechanical Element I, 1924
Oil on canvas, 25 1/2 x 20 in.
(64.8 x 50.8 cm.)

Purchased, Joseph Brummer Fund
1954:75

157
Lyonel Feininger
American, born 1871, worked in
France and Germany 1887–1937,
died 1956

Gables I, Lüneburg, 1925
Oil on canvas, 37 3/4 x 28 1/2 in.
(95.9 x 72.4 cm.)

Gift of Nanette Harrison Meech
('38) in honor of Julia Meech-
Pekarik ('63)
1985:20

Color plate, page 58

158
César Domela (born César Domela Nieuwenhuis)
Dutch, born 1900, worked in Germany 1927–1933, to Paris 1933

Neo-plastic Relief No. 9, 1929
Oil on panel with overlays of painted wood, glass and metal elements, 22 x 18 1/4 in. (55.9 x 46.4 cm.)

Purchased from the artist, Director's Purchase Fund
1935:7

159
Jacob Epstein
English, born United States 1880, to England 1905, died 1959

Paul Robeson (1898–1976), 1928
Bronze, 13 x 8 5/8 x 12 1/2 in. (33 x 22 x 31.8 cm.)

Purchased, Drayton Hillyer Fund
1933:5

160
Gaston Lachaise
American, born France 1882, to
United States 1906, died 1935

Torso, 1933
Marble, 11 3/4 x 12 x 9 in. (29.8 x
30.5 x 22.9 cm.)

Anonymous gift
1935:6

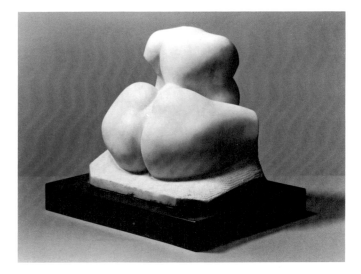

161
Alexander Calder
American, 1898–1976

Mobile, c. 1934
Nickel-plated wood, wire, and
steel, height 42 1/2 in. (107.9 cm.),
base diameter 11 7/8 in. (30.2 cm.)

Purchased, Director's Purchase
Fund
1935:11

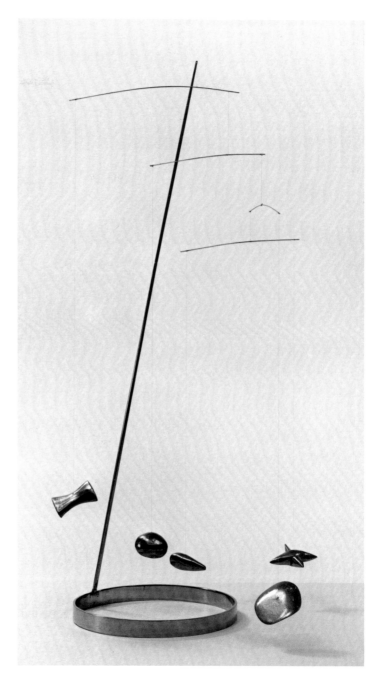

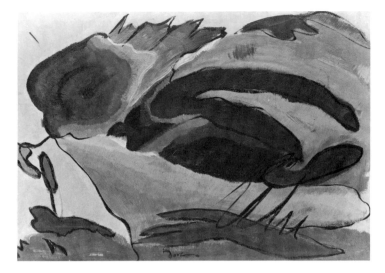

162
Arthur Dove
American, 1880–1946

Happy Landscape, 1937
Oil on canvas, 10 x 13 15/16 in.
(25.4 x 35.4 cm.)

Gift of Dr. and Mrs. Douglas
Spencer (Daisy Davis '24)
1982:33

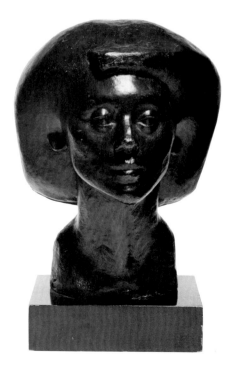

163
Alberto Giacometti
Swiss, born 1901, worked in
France from 1922, died 1966

Head of Isabel (Isabel Rawsthorne),
1936
Bronze, 11 1/2 x 8 5/8 x 9 5/8 in.
(29.2 x 21.9 x 24.5 cm.)

Purchased
1984:12

164
American, Anonymous

The Duke and Duchess of Windsor,
c. 1937
Polychromed wood, 19 3/4 x
10 1/2 x 5 5/8 in. (50.3 x 26.1 x
14.3 cm.)

Purchased
1978:53

165
Yves Tanguy
American, born France 1900, to
United States 1939, died 1955

Movements and Acts, 1937
Oil on canvas, 25 1/2 x 20 3/4 in.
(64.7 x 52.7 cm.)

Gift of the estate of Kay Sage
Tanguy
1964:45

166
Charles Sheeler
American, 1883–1965

Rolling Power, 1939
Oil on canvas, 15 x 30 in.
(38.1 x 72.6 cm.)

Purchased, Drayton Hillyer Fund
1940:18

Color plate, page 55

167
Charles Despiau
French, 1874–1946

*Anne Morrow Lindbergh (born
1906),* 1939
Bronze, 14 x 8 1/4 x 9 1/2 in.
(36 x 21 x 24 cm.)

Gift of A. Conger Goodyear
1940:22

168
Diego Rivera
Mexican, 1886–1957

Self-portrait, January 1941
Oil on canvas, 24 x 16 7/8 in.
(61 x 43 cm.)

Gift of Irene Rich Clifford
1977:63–1

169
Jacques Lipchitz (born Chaim Jacob Lipchitz)
American, born Lithuania 1891, to Paris 1909, to United States 1941, died 1973

Barbara, 1942
Gilded bronze, 15 5/8 x 8 x 8 3/4 in. (39.8 x 20.3 x 22.2 cm.)

Gift of Philip L. Goodwin
1948:9

170
Marsden Hartley
American, 1877–1943

Sea Window, Tinker Mackerel,
1942
Oil on masonite, 40 x 30 in.
(101.6 x 76.2 cm.)

Purchased, Sarah J. Mather Fund
1947:8

171
Robert Motherwell
American, born 1915

Collage, 1947
Oil and paper on academy board,
26 1/4 x 18 3/4 in.
(66.7 x 47.7 cm.)

Acquired by exchange
1950:81

172
Kay Sage
American, 1898–1963

Remote Control, 1951
Oil on canvas, 10 1/4 x 12 in.
(26 x 30.5 cm.)

Gift of the estate of the artist
1964:43

173
Ben Nicholson
English, 1894–1982

Still Life (West Penwith), October
30, 1949
Oil and graphite on canvas, 46 7/8
x 72 3/16 in. (119 x 183.4 cm.)

Purchased, Eleanor Lamont
Cunningham ('32) Fund
1955:15

174
Henry Moore
British, 1898–1986

Working Model for Time-Life Screen, modeled 1952
Bronze, 14 7/8 x 39 1/8 x 3 in.
(37.8 x 99.4 x 7.6 cm.)

Purchased from the artist
1953:114

175
Marino Marini
Italian, 1901–1980

*Head of Igor Stravinsky
(1882–1971),* 1951 (second version)
Bronze, 11 3/4 x 7 x 8 1/8 in.
(29.8 x 17.8 x 20.6 cm.)

Purchased with funds given by Mrs.
John Wintersteen (Bernice
McIlhenny '25)
1953:90

176
Jean Arp
French, 1887–1966

Torso, 1953
Marble, 31 1/4 x 14 1/2 x
13 3/8 in. (79.4 x 36.8 x 33.9 cm.)

Gift of Mr. and Mrs. Ralph F. Colin
(I. Georgia Talmey '28)
1956:13

177
Giorgio Morandi
Italian, 1890–1964

Still Life, 1954
Oil on canvas, 14 x 18 1/4 in.
(35.6 x 46.4 cm.)

Purchased from the artist
1954:62

178
Fritz Glarner
American, born Switzerland 1899,
worked in United States 1936–
1971, died Switzerland 1972

Relational Painting, Tondo #33,
1954
Oil on masonite, diameter 25 in.
(63.5 cm.)

Gift of the estate of Mrs. Sigmund
W. Kunstadter (Maxine Weil '24)
1978:56–14

179
Josef Albers
American, born Germany 1888, to
United States 1933, died 1976

Homage to the Square: Layers,
1958
Oil on board, 24 x 24 in.
(60.9 x 60.9 cm.)

Gift of Mr. and Mrs. John R.
Jakobson (Barbara Petchesky '54)
1964:40

180
Franz Kline
American, 1910–1962

Rose, Purple, and Black, 1958
Oil on canvas, 45 x 36 in.
(114.3 x 91.5 cm.)

Gift of Mrs. Sigmund W. Kunstadter
(Maxine Weil '24)
1965:27

181
Lee Bontecou
American, born 1931

Untitled, 1959
Canvas and metal, 20 5/8 x 20 5/8
x 7 3/4 in. (52.4 x 52.4 x 19.7 cm.)

Purchased with a gift from the
Chace Foundation, Inc.
1960:14

182
Loren MacIver
American, born 1909

Subway Lights, 1959
Oil on canvas, 50 x 35 in.
(127 x 89 cm.)

Purchased with funds given by
friends of the artist
1973:11

183
Mary Bauermeister
American, born Germany 1934, to
United States 1962

Eighteen Rows, 1962–1968
Pebbles and epoxy on linen-
covered board, 17 5/8 x 17 3/4 x
2 7/8 in. (44.6 x 45.1 x 7.4 cm.)

Gift of Dorothy C. Miller '25 (Mrs.
Holger Cahill)
1972:42–1

184
Joan Mitchell
American, born 1926

Untitled, c. 1960
Oil on canvas, 50 x 38 in.
(127 x 96.5 cm.)

Purchased with funds given by Mrs.
John W. O'Boyle (Nancy Millar
'52)
1981:30

Color plate, page 56

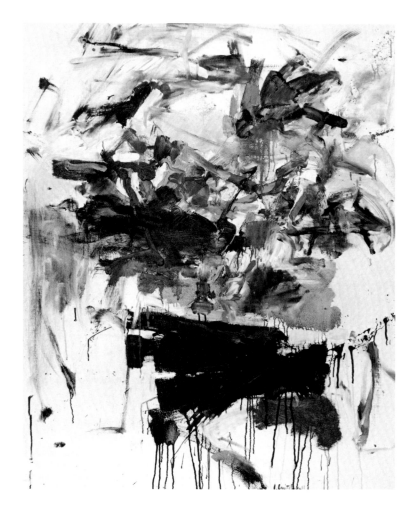

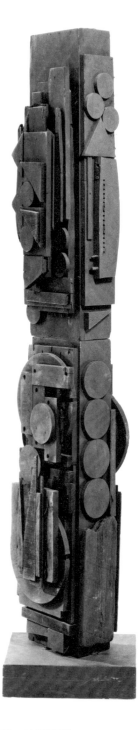

185
Louise Nevelson
American, born Russia 1899, to
United States 1905

Distant Column, 1963
Painted wood, 80 x 15 x 12 1/2 in.
(203.2 x 38.1 x 31.7 cm.)

Purchased with funds given by
Donald Millar in honor of his
daughters Brenda M. Baldwin
(Brenda Millar '49) and Mrs. John
W. O'Boyle (Nancy Millar '52)
1972:10

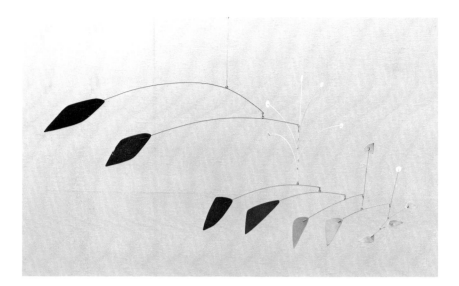

186
Alexander Calder
American, 1898–1976

White Spray, 1964
Painted metal, 34 x 73 x 40 1/2 in.
(86.5 x 185.4 x 102.8 cm.)

Purchased with funds given by the
estate of Mrs. Chapin Riley (Mary
Alexander '30)
1965:9

187
Jean Arp
French, 1887–1966

Birdlike, 1965
Bronze, 13 1/2 x 12 x 5 3/8 in.
(34.3 x 30.5 x 13.7 cm.)

Gift of Mr. and Mrs. John O. Tomb
(Helen Adelaide Brock '42)
1975:62–1

188
Claes Oldenburg
American, born Sweden 1929

Soft Fan, 1965
Enamel on wood, paper, and rope,
19 5/8 x 22 1/8 x 21 3/8 in.
(49.8 x 56.2 x 54.2 cm.)

Purchased
1979:49

189
Mark Rothko
American, 1903–1970

Untitled, 1968
Acrylic on paper mounted on
masonite, 24 1/16 x 18 3/16 in.
(61.2 x 46.2 cm.)

Gift of The Mark Rothko
Foundation, Inc.
1986:3–2

190
Willem de Kooning
American, born The Netherlands
1904

Woman in Landscape X, 1968
Oil on paper mounted on canvas,
23 1/4 x 18 1/2 in. (59 x 47 cm.)

Gift of the artist in memory of
Louise Lindner Eastman ('33)
1969:84

191
Larry Bell
American, born 1939

Untitled, 1969
Vacuum-plated glass with chrome
binding, 18 1/4 x 18 1/4 x
18 1/4 in. (46.4 x 46.4 x 46.4 cm.)

Purchased
1972:7

192
Frank Stella
American, born 1936

Damascus Gate (Variation III), 1969
Polymer and fluorescent polymer
paint on canvas, 10 x 40 ft.
(304.8 x 1219.2 cm.)

Gift of the artist
1969:76

193
Michael de Lisio
American, born 1911

Shakespeare and Company,
1970–1973
Bronze with oak base (figures
various sizes), 13 7/16 x 30 1/8 x
48 in. (34.2 x 76.5 x 121.9 cm.)

Purchased
1979:15

194
George Rickey
American, born 1907

Forty-three Squares Vine Variation,
1974
Stainless steel, irregular 28 x 11 x
9 in. (71.1 x 27.9 x 22.8 cm.)

Gift of the estate of Mrs. Sigmund
W. Kunstadter (Maxine Weil '24)
1978:56–31

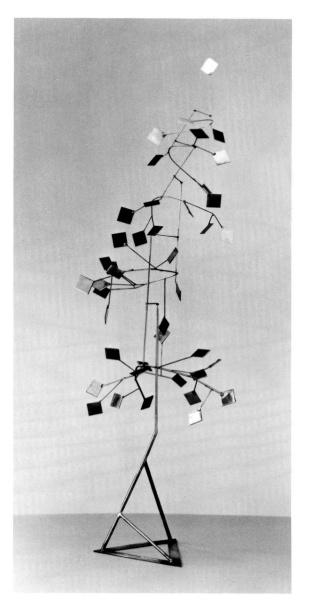

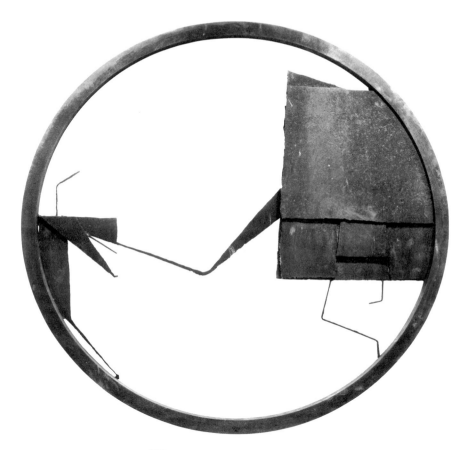

195
Richard Stankiewicz
American, 1922–1983

Untitled, 1975
Steel, diameter 64 3/8 in. (163.5
cm.), depth 2 in. (5.1 cm.)

Purchased with funds given in
honor of Mildred and Frederick
Mayer by their daughter, Elizabeth
Mayer Boeckman ('54)
1977:22

196
Sol LeWitt
American, born 1928

*Cube Structure Based on Nine
Modules (Wall/Floor Piece #2),*
1976–1977
Painted birch, 43 x 43 x 43 in.
(109.2 x 109.2 x 109.2 cm.)

Purchased
1977:64

197
Dieric Bouts
Flemish, c. 1410–1475

Portrait of a Young Man, c. 1467
Silverpoint on prepared paper,
5 7/16 x 4 3/8 in. (14 x 10.7 cm.)

Purchased, Drayton Hillyer Fund
1939:3

Color plate, page 41

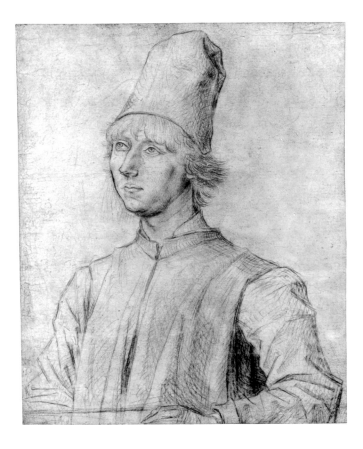

198
Martin Schongauer
German, c. 1430–1491

The Flight into Egypt, c. 1475–1480
Engraving, sheet (trimmed within
platemark) 10 1/8 x 6 11/16 in.
(25.6 x 16.9 cm.)

Gift of Mrs. Charles Lincoln Taylor
(Margaret Rand Goldthwait '21) in
honor of the Class of 1921
1971:17

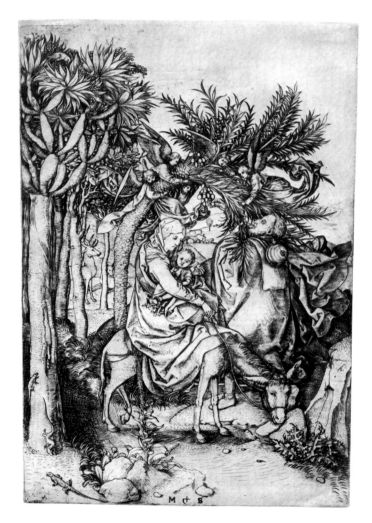

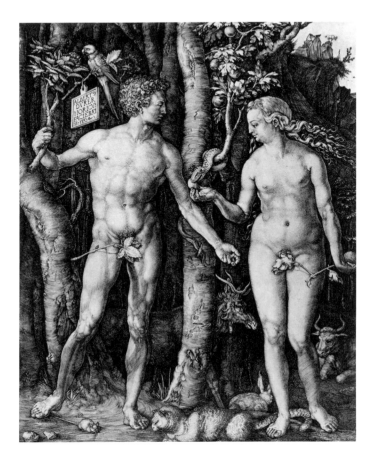

199
Albrecht Dürer
German, 1471–1528

Adam and Eve, 1504
Engraving, sheet (trimmed within
platemark) 9 7/8 x 8 5/8 in.
(25.1 x 21.9 cm.)

Bequest of Mr. and Mrs. Murray
Seasongood (Agnes Senior '11)
1983:20–4

200
Grünewald (Mathis Gothardt Neithardt)
German, c. 1465–1528

Study of Drapery, c. 1512
Black chalk, 5 3/16 x 7 3/16 in.
(13.1 x 18.2 cm.)

Inscribed in pencil by a later hand:
A. Durer [*sic*]

Anonymous gift in honor of the
Class of 1898
1958:3

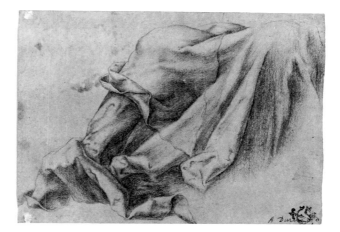

201
Erhard Altdorfer or school
German, active 1512–1561

Beheading of St. John the Baptist,
c. 1512–1514
Pen and brown ink, 8 9/16 x
6 1/4 in. (21.7 x 15.8 cm.)

Purchased
1957:31

202
Fra Bartolommeo (Baccio della Porta)
Italian, 1472–1517

A View of the Monastery of Santa Maria Maddalena at Caldine, c. 1512–1516
Pen and brown ink, 11 1/16 x 8 7/16 in. (28.1 x 21.5 cm.)

Purchased
1957:59

203
Albrecht Dürer
German, 1471–1528

St. Jerome in his Study, 1514
Engraving, fifth state of six, sheet (trimmed to platemark) 9 11/16 x 7 7/16 in. (24.6 x 18.9 cm.)

Bequest of Henry L. Seaver
1976:54–48

204

Rosso Fiorentino (Giovanni Battista di Jacopo)
Italian, 1495–1540

Martyrdom of Saints Marcellinus and Mark, 1535–1536
Red and black chalk, squared for transfer, 9 5/16 x 8 1/4 in. (23.7 x 21 cm.)

Purchased with the gift of Mrs. Stanley Keith (Helen May Shedd '05)
1959:32

205
Attributed to Jan or Lucas van Duetecum, after Pieter Brueghel the Elder (Flemish c. 1525/30–1569) Dutch, active second half of 16th century

The Fair on St. George's Day (The Kermess of St. George), c. 1553
Etching, first state of two, sheet (trimmed within platemark)
13 1/8 x 20 3/4 in. (33.3 x 52.7 cm.)

Purchased
1973:12–1

206
Pieter Brueghel the Elder
Flemish, c. 1525/30–1569

*Mountain Landscape with Four
Travelers,* 1560
Pen and light brown ink, 5 1/2 x
7 7/16 in. (14 x 18.9 cm.)

Purchased
1958:39

207
Federico Barocci
Italian, c. 1535–1612

Head of a Woman, c. 1574
Black and colored chalks on grey
paper (faded from blue), 13 1/8 x
9 5/8 in. (33.3 x 24.4 cm.)

Purchased
1960:99

208
Anthony van Dyck
Flemish, 1599–1641

Justus Susterman (1597–1681),
c. 1627–1632
Etching, first state of five, sheet
(trimmed within platemark) 9 5/8 x
6 7/16 in. (24.5 x 16.4 cm.)

Purchased with funds donated by
Priscilla Cunningham ('58)
1973:12–2

209
Hendrik Goltzius, after
Bartolomaeus Spranger (Flemish,
1546–1611)
Dutch, 1558–1617

*The Body of Christ Supported by an
Angel,* 1587
Engraving, sheet (trimmed within
platemark) 13 5/8 x 9 3/4 in.
(34.6 x 24.8 cm.)

Purchased
1976:16–2

210
Bartolomaeus Spranger
Flemish, 1546–1611

Mars and Venus, c. 1597
Brown-black ink, grey wash, and
white gouache, 10 1/4 x 8 1/4 in.
(26 x 20.9 cm.)

Purchased
1963:52

211
Rembrandt van Rijn
Dutch, 1606–1669

Woman Kneeling in Prayer,
c. 1640–1641
Pen and brown ink, 3 1/4 x
3 3/8 in. (8.3 x 8.6 cm.)

Gift of Mr. and Mrs. Richard C.
Harrison (Ruth Leonard '10)
1959:161

212
Rembrandt van Rijn
Dutch, 1606–1669

Adam and Eve, 1638
Etching, second state of two,
plate 6 3/8 x 4 9/16 in. (16.2 x
11.5 cm.), sheet 7 x 5 5/16 in.
(17.8 x 13.5 cm.)

Purchased
1981:5

213
Rembrandt van Rijn
Dutch, 1606–1669

The Three Crosses (first state 1653),
c. 1660
Etching, engraving, and drypoint,
fourth state of five, sheet (trimmed
within platemark) 15 1/8 x
17 3/4 in. (38.3 x 45.1 cm.)

Gift of the Studio Club and Friends
1911:2

214
Jan Lievens
Dutch, 1607–1674

Road with Trees and a Horse-drawn Wagon near a Village
Pen and brown ink with brown wash, 9 9/16 x 15 1/4 in.
(24.3 x 38.7 cm.)

Purchased
1960:91

215
Jacob van Ruisdael
Dutch, 1628/29–1682

The Little Bridge, c. 1650–1660
Etching, second state of two or
three, sheet (trimmed within
platemark) 7 7/16 x 10 5/8 in.
(18.9 x 26.9 cm.)

Gift of A. V. Galbraith in memory
of Helen McIntosh Galbraith ('01)
1959:94

216
Giovanni Paolo Panini
Italian, 1691–1764

The Death Leap of Marcus Curtius,
c. 1730–1740
Graphite, 11 x 13 7/8 in.
(28 x 35.3 cm.)

Purchased with funds given by
Frances Converse Powers ('23)
1959:67

217
William Hogarth
English, 1697–1764

Strolling Actresses Dressing in a Barn, 1738
Etching and engraving, second state of four, image 16 5/8 x 21 1/8 in. (42.2 x 53.6 cm.), sheet (trimmed within plate mark) 17 1/8 x 21 3/4 in. (43.8 x 55.2 cm.)

Gift of Dr. and Mrs. William Norton Bullard
1923:7–56

218
Charles Joseph Natoire
French, 1700–1777

Study of a Faun, c. 1747
Red chalk heightened with white on brown paper, 14 3/8 x 9 3/16 in. (36.5 x 23.4 cm.)

Gift of Philip Hofer
1951:270

219
Giovanni Battista Tiepolo
Italian, 1696–1770

Rinaldo and Armida, c. 1740–1750
Pen and brown ink wash over
black chalk, 16 11/16 x 11 1/2 in.
(42.4 x 29.2 cm.)

Purchased in honor of Clarence
Kennedy with funds given by Mr.
and Mrs. Edwin Land
1960:43

220
Jean-Honoré Fragonard
French, 1732–1806

Sacrifice of Noah, c. 1750–1759
Black crayon, 7 7/8 x 11 5/8 in.
(20 x 29.5 cm.)

Purchased
1957:8

221
Louis-Marin Bonnet, after François
Boucher (French, 1703–1770)
French, 1736–1793

The Sleep of Venus, 1771
Crayon manner engraving on blue
paper mounted on cream paper
with engraved border and
inscription, image 10 7/16 x
13 15/16 in. (26.4 x 35.4 cm.),
plate 14 1/8 x 16 1/4 in. (35.9 x
41.3 cm.), sheet 15 x 17 15/16 in.
(38.2 x 45.1 cm.)

Purchased
1964:8

222
François Boucher
French, 1703–1770

*Juno Inducing Aeolus to Loose the
Storm on Aeneas,* c. 1769
Pen and brown ink with grey-blue
wash on brown paper, 9 1/2 x
13 1/4 in. (24.2 x 33.5 cm.)

Purchased with funds from the
Theodore T. and Hilda Rose
Foundation, Linda C. Rose ('63),
President
1975:26–1

223
Alexander Cozens
English, c. 1717–1786

Lake in the Hills
Brush and ink wash over graphite
on ochre-toned paper, 5 7/8 x 8 in.
(14.9 x 20.3 cm.)

Gift of the children of Mrs. Thomas
W. Lamont (Florence Corliss '93)
1953:21

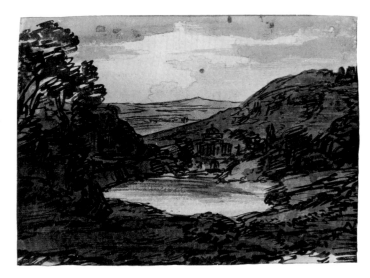

224

Giovanni Battista Piranesi
Italian, 1720–1778

*The Colosseum, Bird's-eye View
(Veduta dell'Anfiteatro Flavio detto
il Colosseo) from Vedute di Roma,
1776*
Etching, second state of four, plate
19 5/8 x 28 3/8 in. (49.8 x
72.1 cm.), sheet 21 3/4 x 29 1/2 in.
(54 x 74.9 cm.)

Gift of Mrs. Herman G. Matzinger
1951:145–2

225
Jean Michel Moreau the Younger
French, 1741–1814

The Masked Ball, c. 1782
Pen and grey-brown ink wash,
10 3/4 x 10 1/4 in. (27.3 x 26 cm.)

Purchased
1973:13–1

Color plate, page 39

226
Jean Michel Moreau the Younger
French, 1741–1814

The Royal Festival, c. 1782
Pen and grey ink wash, 10 3/4 x
10 1/4 in. (27.3 x 26 cm.)

Purchased
1973:13–2

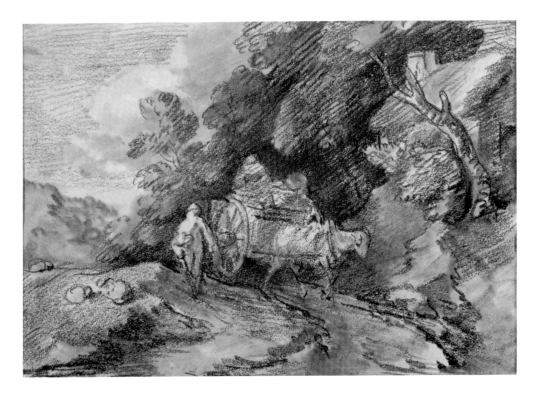

227
Thomas Gainsborough
English, 1727–1788

Study for *The Market Cart,*
c. 1785–1790
Black chalk with stumping and grey
wash, 10 15/16 x 14 3/4 in. (27.7 x
37.5 cm.)

Gift of the children of Mrs. Thomas
W. Lamont (Florence Corliss '93)
1953:28

Se repulen

228
Francisco Goya
Spanish, 1746–1828

They Spruce Themselves Up (Se repulen) from *Los Caprichos,* first edition, plate 51, 1799
Etching, burnished aquatint, and burin, plate 8 1/4 x 5 3/4 in. (21 x 14.6 cm.), sheet 11 3/4 x 8 1/4 in. (29.8 x 21 cm.)

Purchased with funds given by Albert H. Gordon
1964:34–51

229
William Alfred Delamotte
English, 1775–1863

Men and Dogs Resting under a Tree from *Specimens of Polyautography,* 1802
Lithograph, sheet (trimmed to image) 9 1/8 x 12 13/16 in. (23.2 x 32.5 cm.)

Purchased
1960:32

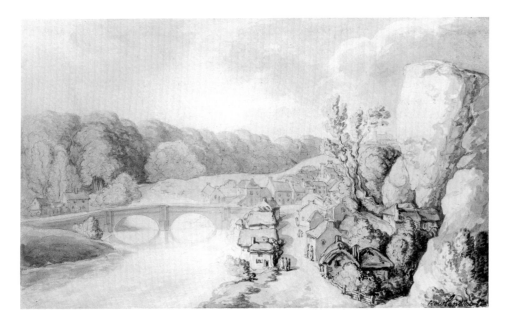

230
Thomas Rowlandson
English, 1756–1827

Knaresborough, Yorkshire, 1803
Watercolor and graphite, 9 3/4 x
15 1/4 in. (24.7 x 38.7 cm.)

Gift of the children of Mrs. Thomas
W. Lamont (Florence Corliss '93)
1953:26

231
Théodore Géricault
French, 1791–1824

Landscape with Stormy Sky; verso:
A Courtyard in Montmartre,
c. 1813–1814
Pen, brown ink, blue and green
washes, heightened with white
gouache; verso: graphite, pen, and
brown ink, image 6 1/4 x
8 1/4 in.(15.6 x 20.3 cm.), sheet
8 7/16 x 11 1/4 in. (21.4 x
28.6 cm.)

Purchased
1960:92

232
Jean-Auguste-Dominique Ingres
French, 1780–1867

*The Architects Achille Leclère and
Jean Louis Provost,* 1812
Graphite on thin tissue mounted on
paper, 12 3/8 x 9 5/8 in. (31.4 x
24.5 cm.)

Purchased, Drayton Hillyer Fund
1937:5

233
Théodore Géricault
French, 1791–1824

Horses Going to a Fair, 1821
Lithograph, image 10 x 14 in.
(25.4 x 35.6 cm.), sheet 11 1/2 x
15 3/16 in. (29.2 x 38.6 cm.)

Purchased
1929:9

234
William Sawrey Gilpin
English, 1762–1843

View in Downton Park,
Herefordshire
Watercolor over graphite,
15 13/16 x 11 7/16 in. (40.2 x
29 cm.)

Purchased
1952:38

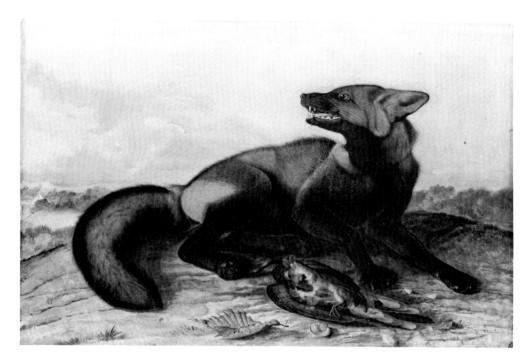

235
John James Audubon
American, born Haiti 1785, to
United States 1806, died 1851

American Cross Fox, c. 1841
Watercolor, oil, and graphite,
21 1/2 x 31 1/2 in. (54.6 x
77.5 cm.)

Purchased
1952:108–1

Color plate, page 52

236
Eugène Delacroix
French, 1798–1863

The Blacksmith, 1853
Aquatint and etching, fourth state
of four, image 6 3/8 x 3 13/16 in.
(16.2 x 9.7 cm.), plate 9 x
6 3/8 in.(22.9 x 16.2 cm.), sheet
21 15/16 x 14 7/8 in. (55.7 x
37.7 cm.)

Purchased with funds given by Mrs.
Sigmund W. Kunstadter (Maxine
Weil '24)
1959:48

237
Edgar-Hilaire-Germain Degas
French, 1834–1917

Boy Leading a Horse, c. 1860
Graphite on oatmeal paper,
12 1/4 x 9 5/8 in. (31.3 x 24.5 cm.)

Purchased, Winthrop Hillyer Fund
1934:1

238
Francisco Goya
Spanish, 1746–1828

Extravagant Folly (Disparate Ridiculo) from *Los Disparates,* first edition, 1864, plate 3, c. 1816–1823
Etching and aquatint, image 8 3/8 x 12 3/4 in. (21.2 x 32.2 cm.), plate 9 11/16 x 13 7/8 in. (24.6 x 35.2 cm.), sheet 13 x 19 9/16 in. (33 x 49.7 cm.)

Purchased
1964:25–3

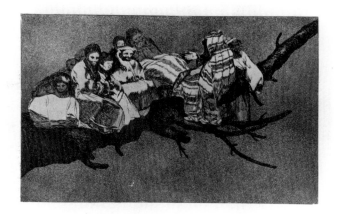

239
Edouard Manet
French, 1832–1883

The Execution of the Emperor Maximilian, c. 1867–1868
Lithograph on chine appliqué, image 13 1/16 x 17 15/16 in. (33.2 x 43.1 cm.), sheet 18 5/8 x 22 1/4 in. (47.4 x 56.5 cm.)

Purchased
1980:10

240
James Jacques Joseph Tissot
French, 1836–1902

Young Lady in a Rocking Chair
(study for *The Last Evening*),
c. 1873
Gouache and watercolor over
graphite on grey-blue paper,
9 7/8 x 15 1/2 in. (25.1 x 39.4 cm.)

Purchased
1967:2

241
Edouard Manet
French, 1832–1883

The Raven by Edgar Allan Poe,
Stéphane Mallarmé translation
(Richard Lesclide, Paris, 1875)

Livre d'artiste containing 4 transfer
lithographs *hors texte* printed in
black, plus lithographed cover and
ex-libris printed in black on
parchment, page size 21 x 15 in.
(53.3 x 38.1 cm.)

Purchased in honor of Elizabeth
Mongan (LHD '85)
1985:1

242
Edgar-Hilaire-Germain Degas
French, 1834–1917

Woman Bathing, c. 1878–1885
Monotype, image 8 1/2 x 6 3/8 in.
(21.6 x 16.2 cm.), sheet 9 13/16 x
7 3/4 in. (24.9 x 18.8 cm.)

Purchased
1979:24

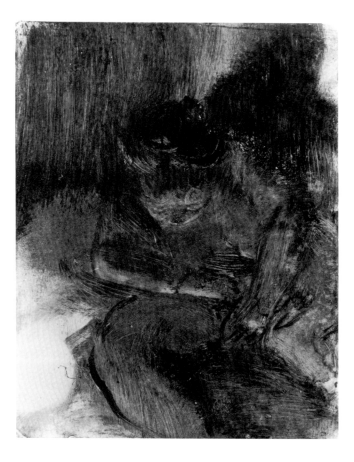

243
Paul Cézanne
French, 1839–1906

Village Cottages in Provence; verso:
Study of an Armchair,
c. 1879–1882
Watercolor over graphite on buff
paper; verso: watercolor, 12 7/8 x
19 11/16 in. (32.7 x 49.9 cm.)

Bequest of Charles C. Cunningham
in memory of Eleanor Lamont
Cunningham ('32)
1980:22–1

244
William Stanley Haseltine
American, 1835–1900

*Study of Snow Mountains in the
Eighties,* 1880–1890
Graphite and colored wash on blue
paper, 15 1/8 x 20 3/4 in. (38.4 x
52.7 cm.)

Gift of Helen Haseltine Plowden
(Mrs. Roger H. Plowden)
1952:9

245
Vincent van Gogh
Dutch, 1853–1890

Old Man with Walking Stick, 1882
Charcoal and graphite, 19 x
10 1/4 in. (48.2 x 26 cm.)

Purchased
1984:11

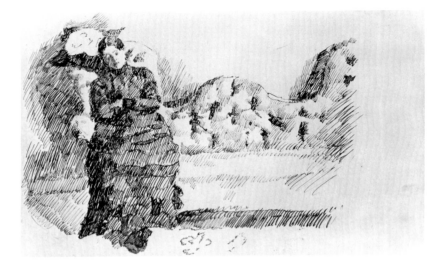

246
Edvard Munch
Norwegian, 1863–1944

Aunt Karen Bjølstad, 1883
Brown ink, 5 7/16 x 8 5/8 in.
(13.8 x 21.9 cm.)

Bequest of Selma Erving ('27)
1984:10–43

247
Georges Seurat
French, 1859–1891

Head of a Woman (study for
*Sunday Afternoon on the Island of
La Grande Jatte),* c. 1884–1885
Conté crayon, 11 3/4 x 8 1/2 in.
(29.8 x 21.6 cm.)

Purchased, Tryon Fund
1938:10–1

248
Georges Seurat
French, 1859–1891

Three Women (study for *Sunday Afternoon on the Island of La Grande Jatte*), c. 1884–1885
Conté crayon, 9 1/4 x 12 in. (23.5 x 30.5 cm.)

Purchased, Tryon Fund
1938:10–2

249
Henri Fantin-Latour
French, 1836–1904

Homage to Berlioz, 1886
Crayon on tracing paper mounted
on card, 23 13/16 x 19 in. (60.7 x
48.2 cm.)

Gift of Mrs. Henry T. Curtiss (Mina
Kirstein '18)
1965:13

250
Odilon Redon
French, 1840–1916

Profile of a Woman
Black chalk, 19 7/16 x 14 1/4 in.
(49.3 x 36.2 cm.)

Bequest of Selma Erving ('27)
1984:10–54

251
Mary Cassatt
American, born 1844, worked in
France from 1866, died 1926

The Fitting, 1891
Color aquatint, soft-ground etching,
and drypoint, fifth state of five,
plate 14 3/4 x 10 in. (37.5 x
25.5 cm.), sheet 17 x 12 5/8 in.
(43.2 x 32 cm.)

Purchased
1950:14

252
Adolf Menzel
German, 1815–1905

Old Man with Glass, 1890
Black chalk, 4 7/8 x 8 in.
(12.5 x 20.4 cm.)

Purchased with funds given by the
Beech Corporation
1963:48

254
Henri de Toulouse-Lautrec
French, 1863–1901

Loie Fuller (1869–1928), 1892
Lithograph printed in color with
added gold, image 14 5/16 x
10 1/4 in. (36.4 x 26 cm.), sheet
15 x 11 1/8 in. (38.1 x 28.2 cm.)

Gift of Selma Erving ('27)
1978:1–45

253
Henri de Toulouse-Lautrec
French, 1863–1901

Henri-Gabriel Ibels (1867–1936),
1893
Black ink and gouache on tracing
paper, 16 1/8 x 12 5/8 in. (40.8 x
32 cm.)

Gift of Mr. and Mrs. Ernest Gottlieb
1965:64

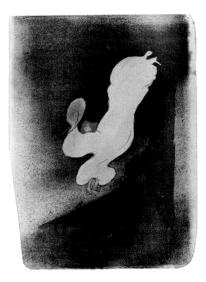

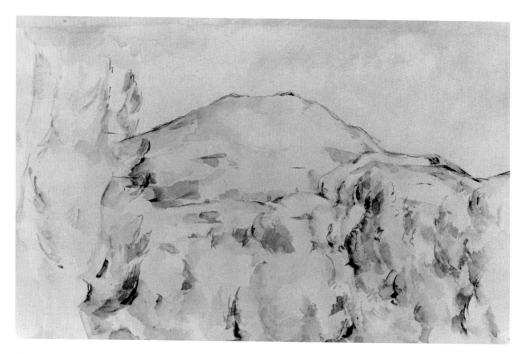

255
Paul Cézanne
French, 1839–1906

Mont St. Victoire; verso: *Landscape Study,* c. 1890–1892
Watercolor and gouache over graphite; verso: graphite, 12 1/4 x 18 5/8 in.
(31.1 x 47.2 cm.)

Bequest of Charles C. Cunningham in memory of Eleanor Lamont Cunningham ('32)
1980:22–2

256
Edouard Vuillard
French, 1868–1948

The Seamstress, c. 1894
Lithograph printed in color with
additional hand coloring and pencil
overdrawing, proof between states
two and three of four, sheet
(trimmed to image) 9 7/8 x 6 5/8 in.
(25.1 x 16.8 cm.)

Gift of Selma Erving ('27)
1976:18–78

257
Paul Signac
French, 1863–1935

St. Tropez II, 1894
Lithograph printed in color, image
10 7/8 x 14 1/2 in. (27.6 x
36.8 cm.), sheet 17 x 23 11/16 in.
(43.3 x 60.2 cm.)

Purchased with funds from the
Chace Foundation, Inc.
1957:51

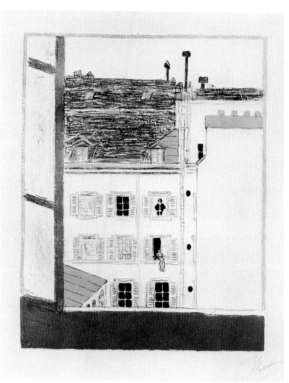

259
Maurice Prendergast
American, 1859–1924

South Boston Pier, 1896
Watercolor over graphite, 18 1/8 x
13 5/16 in. (46.1 x 35.4 cm.)

Purchased, Charles B. Hoyt Fund
1950:43

258
Pierre Bonnard
French, 1867–1947

House in the Court, 1895–1899,
from *Quelques aspects de la vie de
Paris,* 1899
Transfer lithograph printed in color,
image 13 3/4 x 10 3/16 in. (34.9 x
25.8 cm.), sheet 21 1/8 x 16 in.
(53.6 x 40.6 cm.)

Gift of Selma Erving ('27)
1978:1–7

260
Camille Pissarro
French, 1830–1903

Place du Havre, Paris, c. 1897
Lithograph on light purple paper
mounted on white paper, image
5 5/8 x 8 3/8 in. (14.2 x 21.2 cm.),
sheet 10 13/16 x 14 3/8 in. (27.5 x
36.5 cm.)

Gift of Selma Erving ('27)
1972:50–84

261
Piet Mondrian
Dutch, born 1872, worked in Paris
1919–1938, worked in United
States from 1940, died 1944

Chrysanthemum; verso: *Young
Woman*, c. 1908–1909
Black conté crayon with graphite,
charcoal, brown crayon on grey
paper; verso: black conté crayon
and charcoal, 24 3/4 x 15 1/8 in.
(62.9 x 38.4 cm.)

Purchased
1963:51

262
Edvard Munch
Norwegian, 1863–1944

Woman in Black, 1912
Woodcut on brown paper, proof,
image 21 3/4 x 13 3/4 in. (55.2 x
35 cm.), sheet 26 1/8 x 17 1/4 in.
(66.3 x 43.8 cm.)

Gift of Selma Erving ('27)
1972:50–75

263
Edward Hopper
American, 1882–1967

The Evening Wind, 1921
Etching, plate 6 15/16 x 8 1/4 in.
(17.6 x 21 cm.), sheet 13 5/8 x
15 15/16 in. (34.7 x 40.5 cm.)

Gift of Mr. and Mrs. Malcolm P.
Chace, Jr. (Beatrice Ross
Oenslager '28)
1975:66–2

264
Charles Burchfield
American, 1893–1967

Freight Cars, 1919
Watercolor, 11 3/4 x 20 in. (29.8 x
50.9 cm.)

Gift of Mr. and Mrs. Alfred Barr, Jr.
in honor of Jere Abbott
1970:13

265
Wassily Kandinsky
Born Russia 1866, worked in
Germany and France, died 1944

Small Worlds VII, 1922
Lithograph printed in color, image
10 3/4 x 9 1/8 in. (27.2 x
23.2 cm.), sheet 14 x 11 3/16 in.
(35.6 x 28.3 cm.)

Gift of Priscilla Paine Van der
Poel ('28)
1977:32–165

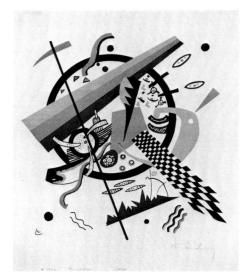

266
Yasuo Kuniyoshi
American, born Japan 1893, to
United States 1906, died 1953

Three Cows and One Calf, 1922
Pen and India ink, 15 1/2 x
22 1/2 in. (39.4 x 57.1 cm.)

Gift of Philip L. Goodwin
1953:6

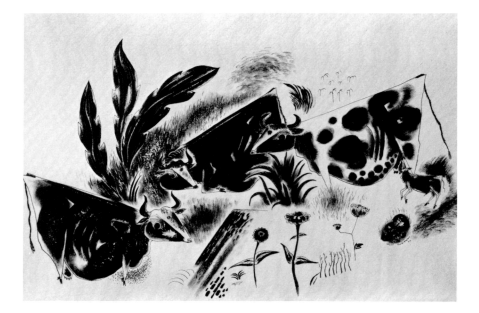

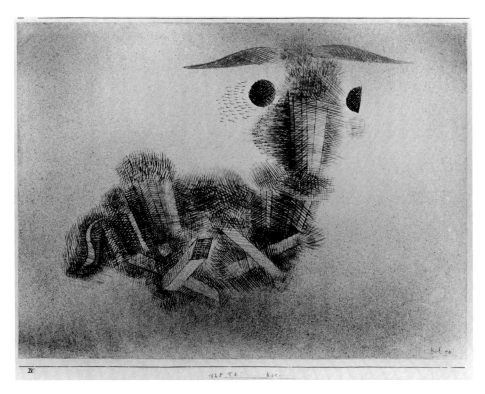

267
Paul Klee
Swiss, 1879–1940

Goat, 1925
Pen and colored inks, 8 5/8 x
11 1/16 in. (21.8 x 28.1 cm.)

Gift of Jere Abbott
1976:23

Color plate, page 53

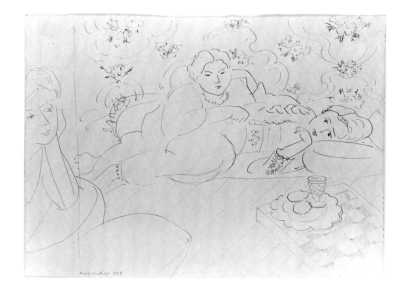

268
Henri Matisse
French, 1869–1954

Odalisque, 1928
Pen and ink, 14 3/8 x 20 in.
(36.6 x 50.8 cm.)

Bequest of Selma Erving ('27)
1984:10–38

269
John Marin
American, 1870–1953

*Sand Dunes and Sea, Small Point,
Maine,* 1917
Watercolor and black chalk,
16 1/4 x 18 1/2 in. (41.2 x 47 cm.)

Gift of the estate of Mary Virginia
Carey (MSS '42)
1972:16–2

270
Raoul Dufy
French, 1877–1953

The Duomo, Florence
Watercolor over graphite, 19 3/4 x
25 1/2 in. (50 x 64.6 cm.)

Gift of Priscilla Paine Van der
Poel ('28)
1985:32–2

271
Alice Neel
American, 1900–1984

Peggy, 1943
Graphite, 13 1/2 x 10 1/2 in.
(34.3 x 26.5 cm.)

Purchased with the aid of funds
from the National Endowment for
the Arts
1979:39

272
Henri Matisse
French, 1869–1954

Poèmes by Charles d'Orléans
(Tériade, Paris, 1950)

Livre d'artiste containing 54
lithographs printed in color, with
lithographed text in artist's hand
printed in black within lithographed
borders in color, plus lithographed
covers printed in color, page size
16 x 10 3/4 in. (40.5 x 26.5 cm.)

Gift of Selma Erving ('27)
1976:18–125

273
Willem de Kooning
American, born The Netherlands 1904

Woman, 1948
Graphite, 7 9/16 x 12 in.
(19.2 x 30.4 cm.)

Gift of Mrs. Richard L. Selle (Carol Ann Osuhowski '54)
1969:46

274
Barnett Newman
American, 1905–1970

Black and White, 1948
Black ink, 24 x 16 5/8 in.
(61 x 42.2 cm.)

Gift of Philip Johnson
1952:105

275
Mark Tobey
American, 1890–1976

Pacific Slopes, 1954
Tempera, 17 13/16 x 12 in.
(45.3 x 30.5 cm.)

Gift of the estate of Mrs. Sigmund
W. Kunstadter (Maxine Weil '24)
1978:56–42

276
Mark Tobey
American, 1890–1976

Echo, 1954
Tempera, 17 3/4 x 11 5/8 in.
(45.2 x 29.5 cm.)

Gift of the estate of Mrs. Sigmund
W. Kunstadter (Maxine Weil '24)
1978:56–40

277
Joán Miró
Spanish, 1893–1983

Pierrot the Clown, 1964
Lithograph printed in color, 35 3/8
x 23 7/8 in. (89.9 x 60.7 cm.)

Gift of Mr. and Mrs. John O. Tomb
(Helen Adelaide Brock '42)
1976:52–1

278
Jasper Johns
American, born 1930

Gray Alphabets, 1968
Lithograph printed in color, image
51 1/4 x 34 1/4 in. (127.6 x
87 cm.), sheet 60 x 41 3/4 in.
(152.4 x 106.1 cm.)

Purchased
1974:5–2

279
Sol LeWitt
American, born 1928

Alternate Broken and Not-Straight Lines, Horizontal, 1972
Ink, 14 1/2 x 14 1/2 in.
(36.9 x 36.9 cm.)

Gift of Mrs. Richard L. Selle (Carol Ann Osuhowski '54) in memory of Rosamond Bennett Kramer ('48)
1978:35

280
Brenda Miller
American, born 1941

"A" Drawing, 1973
Graphite with blue pencil on graph paper, 9 9/16 x 8 5/8 in.
(24.3 x 21.7 cm.)

Gift of Angela Westwater ('64)
1979:34–1

281
Robert Cottingham
American, born 1935

Hot, 1973
Lithograph printed in color, image
21 x 20 7/8 in. (53.3 x 53.1 cm.),
sheet 23 x 22 13/16 in. (58.3 x
58 cm.)

Purchased with funds given by Mr.
and Mrs. Sigmund W. Kunstadter
(Maxine Weil '24)
1973:38–3

282
Dotty Attie
American, born 1937

Pierre and Lady Holland (series of 140 drawings, individually mounted and framed), 1975
Graphite and colored pencils, each drawing 4 1/2 x 4 1/2 in. (11.4 x 11.4 cm.)

Purchased from the artist with the aid of funds from the National Endowment for the Arts
1980:27–1 through 140

283
Donald Judd
American, born 1928

Stack Drawing, 1974
Graphite, 30 3/4 x 22 3/4 in.
(78.2 x 57.8 cm.)

Purchased with the aid of funds
provided by the National
Endowment for the Arts
1980:3

284
Helen Frankenthaler
American, born 1928

East and Beyond, 1973
Woodcut printed in color, image
23 5/8 x 17 3/4 in. (60 x 45.1 cm.),
sheet 31 3/4 x 22 1/4 in. (80.7 x
56.5 cm.)

Purchased with funds given by Mr.
and Mrs. Sigmund W. Kunstadter
(Maxine Weil '24)
1973:38–5

285
William Henry Fox Talbot
English, 1800–1877

The Open Door, 1843
Calotype, image 5 11/16 x 7 3/4 in.
(14.5 x 19.7 cm.), mount 7 3/8 x
9 in. (18.7 x 22.9 cm.)

Gift of Dr. and Mrs. Perry W.
Nadig in honor of their daughter
Claudia Nadig ('85)
1985:14–1

286
Attributed to Benjamin D. Maxham Studio
American, 19th century

Helen Thoreau (1812–1849), 1849
Daguerreotype, image 2 11/16 x
2 3/16 in. (6.8 x 5.6 cm.), case
3 3/4 x 3 1/4 in. (9.4 x 8.1 cm.)

Gift of Dr. J. L. Huntington
1950:75

287
Nadar (Gaspard Félix Tournachon)
French, 1820–1910

Gustave Doré from *Galerie
Contemporaine, Littéraire,
Artistique,* c. 1880
Woodburytype surrounded by a
wood engraving by Gustave Doré
(French, 1832–1883), oval format
photograph 4 1/4 x 3 1/2 in (10.8 x
8.9 cm.), wood engraving 11 1/8 x
8 5/8 in. (28.2 x 22 cm.), sheet
13 3/4 x 10 5/8 in. (36.9 x 27 cm.)

Purchased
1976:45–2

288
Julia Margaret Cameron
English, 1815–1879

Florence Fisher, September 1872
Albumen print, image 14 1/8 x
10 7/8 in. (35.9 x 27.6 cm.), mount
23 1/8 x 18 5/16 in. (58.7 x
46.6 cm.)

Purchased
1982:38–1

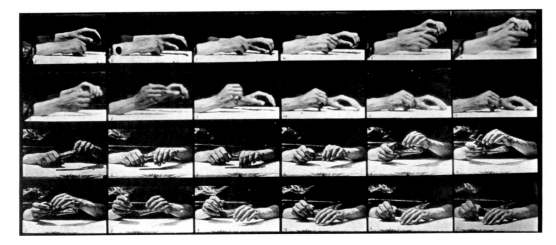

289
Eadweard Muybridge
Born England 1830, to United
States c. 1852, died England 1904

Untitled (Thomas Eakins' hands)
from *Animal Locomotion*, 1887,
plate 536
Photogravure, image 7 1/8 x
15 13/16 in. (18.1 x 40.1 cm.),
sheet 18 1/2 x 24 in. (47 x 61 cm.)

Gift of the Philadelphia
Commercial Museum
1950:53–536

290
Felice A. Beato
Born Italy, worked in the Middle
and Far East, died 1903

Barbers, from an album of 50
photographs of Japan, 1868
Albumen print with hand coloring,
image 9 11/16 x 8 3/4 in. (24.6 x
22.2 cm.), sheet 18 13/16 x
13 9/16 in. (47.8 x 34.5 cm.)

Purchased
1982:38–2(28)

291
Katherine E. McClellan
American, 1859–1918

Henry James (1843–1916), 1905
Sepia-toned silver print, image
13 7/16 x 10 1/16 in. (34.1 x
25.5 cm.), mount 17 1/8 x
13 3/8 in. (43.5 x 34 cm.)

Gift of William Allan Neilson
Library, Smith College
1976:21–5

292
Ralph Steiner
American, 1899–1896

Rural American Baroque, 1929
Silver print, image 8 x 10 in. (20.3
x 25.4 cm.), mount 8 1/4 x
10 1/8 in. (20.9 x 25.6 cm.)

Gift of Thomas R. Schiff
1983:43–5

293
Walker Evans
American, 1903–1975

Maine Pump, 1933
Silver print, image 8 x 5 7/8 in.
(20.3 x 14.9 cm.), mount 17 3/4 x
13 13/16 in. (45.2 x 36.1 cm.)

Purchased
1933:43

294
Clarence Kennedy
American, 1892–1972

Detail, Hands of the Cardinal, from
*The Tomb by Antonio Rossellino
for the Cardinal of Portugal at San
Miniato in Florence,* 1934
Silver print, image 6 5/8 x
10 3/8 in. (16.8 x 26.3 cm.), mount
13 1/16 x 19 1/16 in. (33.2 x
48.4 cm.)

Gift of Mrs. Lester A. Talkington
(Melinda Norris Kennedy '45) in
honor of Clarence Kennedy
1967:72–16

295
Berenice Abbott
American, born 1898

Warehouse, Lower Manhattan,
1930–1940
Silver print, image 15 3/8 x
19 1/2 in. (39.1 x 49.5 cm.), mount
22 x 27 7/8 in. (56 x 70.8 cm.)

Purchased with a gift from the Class
of 1972
1973:15–1

296
Charles Sheeler
American, 1883–1965

Drive Wheels, 1939
Silver print, image 6 11/16 x
9 11/16 in. (17 x 24.6 cm.), mount
17 5/16 x 13 1/2 in. (44 x
34.3 cm.)

Gift of Dorothy C. Miller '25 (Mrs.
Holger Cahill)
1978:34

297
Ansel Adams
American, 1902–1984

Death Valley from Zabriskie Point,
1942
Silver print, image 9 9/16 x
7 9/16 in. (24.3 x 19.2 cm.), mount
17 x 13 in. (43.2 x 33.1 cm.)

Gift of Mr. and Mrs. Beaumont
Newhall (Nancy Parker '30)
1951:189

298
Harry Callahan
American, born 1912

Grasses in Snow, Detroit, 1943
Silver print, image 6 3/4 x 8 3/8 in.
(17.1 x 21.3 cm.), sheet 13 7/8 x
10 15/16 in. (35.3 x 27.8 cm.)

Purchased
1977:29–4

299
Paul Caponigro
American, born 1932

Stonehenge, Salisbury Plain, England
Silver print, 12 3/4 x 19 15/16 in.
(32.4 x 50.7 cm.)

Purchased from the artist
1969:56

300
Minor White
American, 1908–1976

*Mausoleum and Apartment
Buildings,* 1973
Silver print, image 11 5/8 x
9 3/8 in. (29.5 x 23.8 cm.), sheet
13 7/8 x 10 15/16 in. (35.8 x
27.8 cm.)

Purchased
1977:4–4

301
Chris Enos
American, born 1944

Untitled (roses and cobra lilies)
from the *Flower* series, 1981
Color polaroid (Polacolor III),
image 25 x 20 5/8 in. (63.5 x
52.4 cm.), sheet 28 1/2 x 22 in.
(72.4 x 55.9 cm.)

Purchased with funds given by
Shirle N. Westwater in honor of her
daughter Angela ('64)
1983:32

302
Robert Mapplethorpe
American, born 1946

Mary Maples Dunn, 1985
Gelatin-silver print, image 14 7/8 x
14 7/8 in. (37 x 37 cm.), sheet 20 x
16 in. (50.8 x 40.7 cm.)

Purchased with funds from Museum
Members, Smith College Museum
of Art
1985:18–1

Index

Artists represented in the collection

The following list contains two parts. The first gives the names of all artists whose works are included in the major areas of our collection. Painters, sculptors, printmakers, draughtsmen, and photographers are to be found here.

The second portion includes the names of artists who have worked *after* other artists.

The following abbreviations have been used: Ptg.: painting; S.: sculpture; D.: drawing; Wclr.: watercolor; Pr.: print; and Ph.: photograph.

Livre d'artiste indicates a book illustrated with original graphic work, conceived and (usually) executed by an artist known primarily as a painter or sculptor. "Book" includes all other volumes.

In the decorative arts where the bulk of the work is anonymous (to us at least) and in the Lenox Library Photography Collection including the Caroline Tappan collection, the names of several hundred nineteenth-century photographers are not given. This latter list, still in preparation, will be printed as a supplement to this guide.

A

Abbott, Berenice — Ph.
Abbott, Jere — D., Ms. (Russian Diary), Ph.
Abbott, John White — D.
Abbott, Mary Ogden — Pr.
Abeles, Sigmund — Pr.
Abraham, Tancrède — Pr.
Accard, Eugène — Ptg.
Acconci, Vito — Pr.
Acht, René-Charles — Pr.
Adam, Benno — Ptg.
Adam, Henri-Georges — Pr.
Adam, Patrick William — Ptg.
Adams, Ansel — Ph.
Adler, Jankel — Wclr.
van Aelst, Willem — Ptg.
Afro (Afro Basaldella) — Ptg., D., Wclr., Pr.
Agam, Yaacov — S.
Akersloot, Willem Outgersz. — Pr.
Alberka, Gabriel — Wclr.
Albers, Anni — Pr.
Albers, Josef — Ptg., Pr., Book

Albert, Calvin — S., D.
Aldegrever, Heinrich — Pr.
Aldrich, Adolph — Pr.
Aldus (Aldo Pio Manuzio) — Pr.
Alexander, Francis — D.
Alexandroff, G. W. — Ph.
Alken, Henry T. — Pr.
Allard-Cambray — Pr.
Allen, Louise — S.
Alma-Tadema, Lawrence — Pr.
Altdorfer, Albrecht — Pr.
Altdorfer, Erhard (school of) — D.
Ames, Ezra — Ptg.
Amidar, Gertrude — S.
Anderegg, Jim — Pr.
Anderson, John — Ptg.
Anderson, William — Wclr.
Andre, Carl — S.
Andreani, Andrea — Pr.
Angelo, Valenti — Pr.
van d'Anthonissen, Hendrick — Ptg.
Anuszkiewicz, Richard — Pr.
Appel, Karel — D., Pr.
Appian, Adolphe — Pr.
Arakawa, Shusaku — D.
Arbus, Diane — Ph.
Arman (Armand Fernandez) — Pr.

Armington, Caroline — Pr.
Arms, John Taylor — Pr.
Arnaud, Marcel — Wclr.
Arnold, Bill — Ph.
Arp, Jean — S., Pr., Livre d'artiste
Artschwager, Richard — Ptg., S.
Artzybasheff, Boris — Pr.
Atget, Eugène — Ph.
Atlan, Jean — Pr.
Attie, Dotty — D.
Audubon, John James — Wclr., Pr.
Austin, Darrel — Ptg.
Avapoff, Alexis — D., Wclr.
Avati, Mario — Pr.
Avery, Milton — Ptg., Pr.
Aviline, F. (see Hogarth, William)
Ay-o — Ptg.
Ayers, Gillian — Pr.

B

Bacher, Otto Henry — Pr.
Bachiloff, Michel — Pr.
Bacon, Peggy — D.
Baldridge, Cyrus LeRoy — Pr.
van Balen, Hendrick — Ptg.
Balen, P. — Pr.
Ball, Thomas — S.
de Balleroy, Albert — Pr.
Baltard, Louis-Pierre — Pr.
Baltard, Victor — Pr.
Bannard, Walter Darby — Ptg.
le Barbier, Jean-Jacques François —
 D.
Bargello Master — Ptg.
Bargheer, Eduardo — Pr.
Barlach, Ernst — Pr.
Barlow, Thomas Oldham — Pr.
Barney, Tina — Ph.
Barocci, Federico — D.
Barr, Victoria — Ptg.
Barron, Ros — Pr.
Barron, Susan — Ph.
Barrymore, Lionel — Pr.
Bartlett, Richard C. — Pr.
Bartolommeo, Fra (Baccio della
 Porta) — D.
Barye, Antoine-Louis — S.
de Bas, R. — Pr.
Baskin, Leonard — S., D., Pr.,
 Livre d'artiste
Basq, Carlos — Ptg.

Bassano, Giovanni (attributed to) —
 Ptg.
Batchelder, David — Ph.
Bauchant, André — Ptg.
Baudin, Eugène and Vernay,
 François (attributed to) — Ptg.
Bauer, Marius A. — Pr.
Bauermeister, Mary — S., D., Pr.
Baumeister, Willi — D.
Bawden, Edward — D.
Bayer, Herbert — Ptg.
Bazaine, Jean — Pr.
Beardsley, Aubrey — D.
Beatrizet, Nicolas — Pr.
Beauchamp, Robert — Ptg.
Beaufrère, Adolphe-Marie-Timothée
 — Pr.
Beauverie, Charles-Joseph — Pr.
Beaux, Cecilia — Ptg.
Becher, Hilla and Bernhard — Ph.
Bechtle, Robert — Pr.
Beck, Gustav K. — Pr.
Beckmann, Max — Pr.
Beckwith, James Carroll — Ptg.
Begay, Harrison — D.
Beham, Barthel — Pr.
Beham, Hans Sebald — Pr.
Behmer, Marcus — Pr.
von Behr, Hans — Ph.
Belcher, William — Ptg.
Bell, Kay — Ph.
Bell, Larry — S.
Bella, Stefano della — Pr.
Bellangé, Hippolyte — Pr.
Bellotto, Lorenzo — Ptg.
Bellows, George — Pr.
Benanteur, Abdallah — Livre
 d'artiste
Benrimo, Thomas — D.
Ben-shmuel, Ahon — S.
Benson, Frank Weston — D.
Benson, Richard — Ph.
Benton, Thomas Hart — Wclr., Pr.
Berard, Christian — D.
Berchem, Nicolas — Pr.
Berger, Jason — D.
Berman, Eugene — Ptg.
Bernard, Emile — Livre d'artiste
Berthélémy, Pierre-Emile — Pr.
Bertman, Claude — D.
Bervic, Charles Clement — Pr.
Besnard, Paul Albert — Pr.

Besner, Jacques J. — S.
Beurdeley, Jacques — Pr.
Bewick, Thomas — Pr.
Bibiena, Giuseppe Galli da — D.
Bicknell, William Henry Warren —
 Pr.
Biddle, George — Wclr.
Bien, Ania — Ph.
Biermann, Pierre — Pr.
Bierstadt, Albert — Ptg.
Bill, Max — S.
Binning, Bertram Charles — Ptg.
Binyon, Caroline — Pr.
Bischof, Werner — Ph.
Bishop, Isabel — Ptg., Pr.
Blackburn, Joseph — Ptg.
Blaine, Nell — D.
Blake, William — D., Pr.
Blakelock, Ralph Albert — Ptg.
Blampied, Edmund — Pr.
Blanch, Arnold — Pr.
Blanchard, Alonzo — S.
Blehr, A. O. — Pr.
Bloom, Hyman — Ptg.
Blow, Sandra — Pr.
Blume, Peter — D.
Blumenfeld, Erwin — Ph.
Boardman, Seymour — Ptg.
Boccacci, Marcello — Ptg.
de Bock, Théophile — Ptg.
Bodmer, Walter — Pr.
Boel, Coryn — Pr.
Boilly, Louis-Léopold — D., Pr.
du Bois, Guy Pène — Ptg.
Boitard, François (attributed to) —
 D.
Bonasone, Giulio — Pr.
Bone, Muirhead — D., Pr.
Bonheur, Rosa — Ptg.
Bonington, Richard Parkes — Ptg.
 (attributed to), Wclr., Pr.
Bonnard, Pierre — Ptg., D., Pr.,
 Livre d'artiste, Book
Bonnefoy, Yves — Livre d'artiste
Bonnet, Louis-Marin — Pr.
Boon, James — Pr.
Bontecou, Lee — S., D., Pr.
Boret, Charles-Amédée de — Pr.
van der Borght, A. — Ptg.
Borie, Adolphe — Ptg.
Boris, Bessie — Ptg.

Boscoli, Andrea — D.
Bosschaert the Elder, Ambrosius — Ptg.
Bosse, Abraham — Pr.
Both, Jan — Pr.
Botkin, Henry Gilbert — Ptg.
Bouchene, Dimitri — Ptg.
Boucher, François — D.
Boucher-Desnoyer, Louis-Auguste — Pr.
Boudin, Eugène — Ptg., D., Pr.
Bouguereau, Adolphe William — Ptg.
Bourdon, Sebastien — Ptg., Pr.
Bourke-White, Margaret — Ph.
Bouts, Dieric — D.
Bowen, Denis — Pr.
Boyd, Fiske — Pr.
Boydell, John and Josiah, publishers — Pr.
Boyer, Helen King — Pr.
Boys, Thomas Shotter — Book
Brach, Paul — Ptg.
Bracquemond, Félix Auguste Joseph — Pr.
Bradford, Howard — Pr.
Bradshaw, David — S.
Brandi, Giacinto — Ptg.
Brangwyn, Frank — Pr.
Braque, Georges — D., Pr., Livre d'artiste
Braun, Adolphe — Ph.
Bravo, Manuel Alvarez — Ph.
Breer, Robert — Pr.
Brendel, Albert-Henrick — Pr.
Bresdin, Rodolphe — D., Pr.
Breverman, Harvey — Pr.
Brewster, Earl H. — Ptg.
Briend, Alfred — Pr.
Briggs, Eleanor — Ph.
Brockhurst, Gerald Leslie — Pr.
van Brockhusen, Theo — Pr.
Brockman — Wclr.
Broedelet, J. — Pr.
Brook, John — Ph.
Brown, Bolton — Pr.
Brown, Carlyle — Ptg.
Brown, Jacqueline J. — Ptg.
Brown, Robert — Ph.
Brown, Sylvia Arthur — Ph.
Brown, William H. — Pr.
Bruce, Edward — Ptg.

Brueghel the Younger, Jan (attributed to) — D.
Brueghel the Elder, Pieter — D.
Bruehl, Anton — Ph.
Brunif, R. — Pr.
Brus, Günter — Pr.
Brush, George de Forest — Ptg.
Bruyn the Elder, Bartholomaeus — Ptg.
Buchler, F. — Pr.
Buck, Adam (attributed to) — Pr.
Buck, John — Pr.
Buffet, Bernard — Pr.
Buhot, Félix Hilaire — Pr.
Bullard, Otis A. — Ptg.
Bullock, Wynn — Ph.
Buncho — Ptg.
Bundy, Horace — Ptg.
Bunney, John Wharlton — D.
Burchfield, Charles — Wclr.
van Buren, Richard — S.
Burgess, H. W. — D.
Burgkmair, Hans — Pr.
Bürkel, Heinrich — Ptg.
Burleigh Sr., Charles C. — Ptg.
Burne-Jones, Edward — D.
Burnett, Virgil — Pr.
Burnham, Frank — Ptg.
Burr, George Elliot — Pr.
Burrage, Mildred — Collage
Burri, Alberto — Ptg.
Burroughs, Bryson — D.
Busa, Peter — Ptg.
Butler, James D. — Pr.
Butler, Reginald — S.
Butts, Thomas — Pr.
Byer, Alexander — Ptg.

C

Cadmus, Paul — D.
van Calcar, Jan Stephan (attributed to) — Pr.
Calder, Alexander — S., Livre d'artiste
Callahan, Harry — Ph.
Callot, Jacques — Pr.
Callow, William — Wclr.
Cals, Adolphe Félix — Ptg.
Cameron, David Young — Pr.
Cameron, Julia Margaret — Ph.
Campagnola, Domenico (attributed to) — D.

Campendonk, Mathias Heinrich Ernst — Pr.
Campigli, Massimo — Ptg., Pr., Livre d'artiste
Canaletto (Antonio Canale) — Pr.
Cantagallina, Remigio — D.
Cantarini, Simone — Ptg., Pr.
Caples, Barbara Barrett — Pr.
Capogrossi, Giuseppe — Pr.
Caponigro, Paul — Ph.
Carlsen, Emil — Ptg.
Caroff, Peter — Ph.
Carolus — Pr.
Carpeaux, Jean-Baptiste — S.
da Carpi, Ugo — Pr.
Carr, Samuel S. — Ptg.
Carracci, Agostino — Pr.
Carracci, Agostino or Annibale (attributed to) — D.
Carracci, Annibale — Pr.
Carrier-Belleuse, Albert-Ernest — S.
Carrière, Eugène — Pr.
Cartotto, Ercole — D.
Caruso, Bruno — D.
Casarella, Edmond — Pr.
Casorati, Felice — Pr.
Cassatt, Mary — D., Pr.
Castel, Moshe — Ptg.
Cattermole, George — Wclr.
Cawood, John — Pr.
Celmins, Vija — Pr.
Cemehob, S. — Pr.
Ceruti, Giacomo Antonio (attributed to) — Ptg.
Cesar — Pr.
Cesari, Giuseppe (Il Cavaliere d'Arpino) — D.
Cézanne, Paul — Ptg., Wclr., Pr., Book
Chadwick, Lynn — S.
Chagall, Marc — D., Pr., Livre d'artiste, Book
Chahine, Edgar — Pr.
Chaigneau, J.-F. — Pr.
Cham (Amédée-Charles-Henri de Noé) — Pr.
Chamberlain, John — Pr.
Chamberlain, Samuel — D., Pr.
Chambers, Thomas — Ptg.
de Champaigne, Philippe (attributed to) — D.
Champney, Benjamin — Ptg.

Champney, James Wells — Ptg.,
 D., Wclr.
Chao Meng-fu (attributed to) — Ptg.
Chaplin, Charles — Pr.
Charlet, Nicolas-Toussaint — Pr.
Charlot, Jean — D., Pr., Livre
 d'artiste
Chase, William Merritt — Ptg.
Chassériau, Théodore — Ptg., Pr.
Chauvel, Théophile — Pr.
Cheffetz, Asa — Pr.
Chen Pan Ch'ao — Pr.
Chen Ting-shih — Ptg., Pr.
Chen Yung Ch'ih — Ptg.
Cherbuin, L. — Pr.
Chéret, Jules — D., Pr.
Chetham, Celia — Collage
Cheyne, Ian Alec Johnson — Pr.
Chiarenza, Carl — Ph.
Chichester, Cecil — Ptg.
Chifflart, François-Nicolas — Pr.
Childs, Bernard — Pr.
Chinnery, George — D.
de Chirico, Giorgio — Ptg.
Choffard, Pierre Philippe — Pr.
Christensen, Dan — Ptg., Wclr.
Christo (Christo Javacheff) — D.,
 Pr.
Christoforou, John — Pr.
Chryssa, Varda — S.
Chu Fu Tz — Pr.
Church, Frederic Edwin — Ptg.
Church, Frederick Stuart — Pr.
Churchill, Alfred Vance — Ptg.,
 D., Pr.
Cigoli (Lodovico Cardi) — D.
Cikovsky, Nicolai — Ptg., Pr.
Cima da Conegliano, Giovanni
 Battista — Ptg.
Citron, Minna — Pr.
Clarke, Geoffrey — Pr.
Claude Lorrain (Claude Gelée) —
 Pr.
Clave, Antoni — Pr.
Clays, Paul J. — Ptg.
Clint, George (see Turner, J. M.
 W.)
Clivettette, Merton — D.
Clodion (Claude Michel) — S.
Closson, William Baxter — Ptg.,
 D., Wclr.

Cochin, Charles Nicolas — D.
Cocteau, Jean — D., Pr.
Coggeshall, Calvert — Ptg.
Cohen, George — Ptg., D., Pr.
Cohen, Joan Lebold — Ph.
Cohn, Marjorie B. — Pr.
Coindre, Gaston — Pr.
Cole, J. Foxcroft — Pr.
Cole, Thomas — Ptg.
Cole, Walter — Pr.
Coles, Mary Drake — Wclr.
Colescott, Warrington — Pr.
Collaert, Adriaen — Pr.
Colman, Samuel — D., Pr.
Colquhoun, Robert and MacBryde,
 Robert — Collage
Conarroe, George W. — Ptg.
Conner, Bruce — Pr.
Consagra, Pietro — S., D.
Constable, John — Wclr.
Constable, Lionel Bicknell — Ptg.
Constant, George — Pr.
Constantin, Auguste — Pr.
Cook, Howard Norton — Pr.
Cook, Peter G. — Ptg.
Cooney, Gabriel Amadeus — Ph.
Cooper, Margaret — Ptg.
Cope, Leslie — Pr.
Coplans, John — Pr.
Copley, John Singleton — Ptg., D.
Le Corbusier (Charles Edouard
 Jeanneret) — Livre d'artiste
Cordes, Paul — Ph.
Corinth, Lovis — D., Pr.
Coriolano, Bartolomeo — Pr.
Corneille, Cornelis van Beverloo —
 Pr.
Corneille de Lyon — Ptg.
Cornell, Thomas B. — Pr.
Cornoyer, Paul — D.
Cornu, Eugène — S.
Corot, Jean-Baptiste Camille —
 Ptg., Pr.
Costigan, John E. — Pr.
Cotman, John Sell — Wclr.
Cottin, Pierre — Pr.
Cottingham, Robert — Pr.
Coué, Françisque — Pr.
Coughlin, Jack — Pr.
Courbet, Gustave — Ptg.
Courtry, Charles J. L. — Pr.
Covan, Nell — Pr.

Cowley, Edward — Ptg.
Cox the Elder, David — Wclr.
Coypel, Antoine — Pr.
Cozens, Alexander — D., Pr.
Cozens, John Robert — Pr.
Craig, Edward Gordon — Pr.
Cranch, Christopher Pearse — Ptg.
Crome, John — Wclr., Pr.
Cropsey, Jasper Francis — Ptg.
Cross, Henri-Edmond — D., Pr.
Cruchet, Jean-Denis — S.
Cruikshank, George — Pr.
Cruikshank, Isaac — Wclr.
Cucchi, Enzo — D.
Cuevas, José Luis — Pr.
Cuisin, Charles-Emile — Pr.
Cunningham, Imogen — Ph.
Currier, Nathaniel — Pr.
Currier and Ives, publishers — Pr.
Curry, John Steuart — Pr.
Curtis, Edward S. — Ph.

D

Dali, Salvador — Pr.
Dallin, Cyrus E. — S.
Dananche, Xavier de — Pr.
Danby, Francis — Wclr.
Daniele da Volterra (attributed to)
 — D.
Dansaert, Léon — Pr.
Daphnis, Nassos — Ptg.
Darboven, Hanne — D.
Darjou, Alfred — Pr.
Darr, William — Wclr.
Dater, Judy — Ph.
Daubigny, Charles-François — D.,
 Pr.
Daumier, Honoré — S., D., Pr.
Dauzats, Adrien — Pr.
David, Jacques-Louis — D.
David d'Angers, Pierre-Jean — S.
Davidson, J. — Pr.
Davie, Alan — Pr.
Davies, Arthur B. — D., Wclr., Pr.
Davies, Hanlyn — Pr.
Davis, Ron — S., Pr.
Davis, Stuart — Pr.
Dawe, Henry (see Turner, J. M.
 W.)
Day, Worden — S.
Dayes, Edward — Wclr.
Dean, Walter Lofthouse — Ptg.

Debucourt, Philibert-Louis — Pr.
De Faune, Georges — Pr.
Degas, Edgar-Hilaire-Germain —
 Ptg., S., D., Pr.
Dehn, Adolf — Pr.
Delacroix, Eugène — Ptg.
 (attributed to), D., Pr.
Delamotte, William A. — Pr.
Delaunay, Robert — Ptg., Pr., Livre
 d'artiste
Delaune, Etienne — Pr.
Del Deo, Romolo — Ptg.
Del Deo, Salvatore — Ptg.
Delff, Willem Jacobsz. — Ptg.
de Lisio, Michael — S.
Delteil, Loys — Pr.
De Maria, Walter — Pr.
Demarteau, Gilles — Pr.
Demarteau the Younger, Gilles
 Antoine — Pr.
Denis, Maurice — D., Pr.
Dente da Ravenna, Marco — Pr.
Derain, André — Ptg., Wclr., Pr.,
 Book
Desboutin, Marcellin Gilbert —
 Ptg.
Desbrosses, Léopold — Pr.
Deshaies, Arthur — Pr.
Despiau, Charles — S., D.
Detaille, Jean Baptiste Edouard —
 Pr.
Deveria, Achille — D.
Dewing, Thomas Wilmer — Ptg.
De Wint, Peter — Wclr.
Dey, Mukul — Pr.
Diaz de la Peña, Narcisse Virgile
 — Ptg., D.
Dickinson Brothers, Publishers —
 Pr.
Dickinson, Preston — Ptg., Wclr.
Didier, Jules — D.
Diebenkorn, Richard — D., Pr.
Dielman, Frederick — Pr.
van Diepenbeck, Abraham
 (attributed to) — Ptg.
Dietz, Donald — Ph.
Dignimont, André — Pr.
Dilley, Clyde H. — Ph.
Dine, Jim — Pr.
Disney Studio — D.
Di Suvero, Mark — S., Pr.
Dix, Otto — Wclr., Pr.

Dobois, R. A. — Pr.
Dodd, Marion — Ph.
Doisneau, Robert — Ph.
Dole, William — Collage
Domela, César — S.
Dominquez, Oscar — Pr.
Donaldson, Elise — D., Pr.
van Dongen, Kees — D., Pr.
Donoho, Ruger — Ptg.
Door, Edward — Ptg.
Dorazio, Piero — Pr.
Doré, Gustave — Ptg., Pr.
Dorr, Nell — Ph.
Dougherty, Paul — D.
Doughty, Thomas — Ptg.
Douglas, Conrad — Pr.
Dove, Arthur — Ptg., Wclr.
Downing, Joe — S.
Downman, John — Wclr.
Dows, Olin — Ptg.
Drewes, Werner — Pr.
Drouais, François Hubert — Ptg.
Drouyn, Léo — Pr.
Dubuffet, Jean — Pr.
Duchamp, Marcel — Book
Duetecum, Jan or Lucas (attributed
 to) — Pr.
Dufy, Raoul — D., Wclr., Pr.,
 Livre d'artiste, Book
Dujardin, Karel — Pr.
Dujarric, Pierre-Lucien Faure — Pr.
Dumoustier, Daniel — D.
Dunoyer de Segonzac, André —
 D., Livre d'artiste
Dupray, Henry Louis — Pr.
Duran, Robert — Ptg.
Durand, Asher B. — Ptg.
Dürer, Albrecht — Pr.
Duveneck, Frank — Ptg.
van Dyck, Anthony — Pr.
Dyf, Marcel — Ptg.

E

Eakins, Thomas — Ptg.
Earl, Ralph — Ptg.
Eaton, Dorothy — Ptg.
Eaton, Wyatt — Ptg.
Eby,Kerr — Pr.
Eckmair, Frank C. — Pr.
Edelinck, Gerard — Pr.
Edwards, Edward — Pr.
Eeckhout, Jakob Joseph — Ptg.

Egeli, Peter — Ptg.
Eggleston, William — Ph.
Ehret, Elizabeth — Wclr.
Eichenberg, Fritz — Pr.
Eilshemius, Louis Michel — Ptg.,
 D.
Eishi, Chobunsai — Pr.
Eishi, Hosada — Pr.
Eisho, Chokosai — Pr.
Elias, Arthur — Ptg.
Elmer, Edwin Romanzo — Ptg., D.
van Elten, H. D. K. — Pr.
Elwes, Simon — Ptg.
Emmett, Lydia Field — Ptg.
Emmons, Alexander H. — Ptg.
Enos, Chris — Ph.
Enos, Henry — D.
Ensor, James — Pr.
Epstein, Jacob — S.
Epting, Marion A. — Pr.
Erlanger, Elizabeth — Pr.
Erni, Hans — D., Pr., Livre d'artiste
Ernst, Max — Pr., Livre d'artiste,
 Book
Erwitt, Elliott — Pr.
Escobedo, Jésus — Pr.
Estes, Richard — Pr.
Etty, William — D.
Evans, Frederick H. — Ph.
Evans, John William — Pr.
Evans, Walker — Ph.
van Everdingen, Allaert — D., Pr.
Evergood, Philip — Ptg.
Eversley, Frederick J. — S.
van Eyck, Gaspard — Ptg.

F

Faber Jr., John — Pr.
Faggi, Alfeo — Wclr.
Fahlström, Oyvind — Pr.
Fairclough, W. — Pr.
Falda, Giovanni Battista — Pr.
Falguière, Jean-Alexandre Joseph —
 S.
Fantin-Latour, Henri — Ptg., D.,
 Pr.
Farb, Oriole — Pr.
Farber, Daniel — Ph.
Farber, Henry — Pr.
Farrer, Thomas Charles — Ptg.
Fauchery, Auguste — Pr.
Faulkner, Frank — Ptg.

Fausett, Dean — Ptg.
Feininger, Lux — Ph.
Feininger, Lyonel — Ptg., D., Ph.
 (attributed to)
Feininger, Lyonel and Lux — Ph.
Ferry, Isabelle — Ptg.
Fesenmaier, Helene — D.
Fett, William F. — Wclr.
Feuchère, Jean-Jacques — Pr.
Feyen-Perrin, Auguste — Pr.
Fick, Jorge — Ptg.
Field, Erastus Salisbury — Ptg.
Fielding, Copley — Ptg., D.
Fiene, Ernest — Ptg., Pr.
Fine, Perle — Ptg.
Fink, Herbert L. — Pr.
Fischer, Hans Erich — Pr.
Fish, Janet — Pr.
Fisher, Joel — Pr.
Fitton, Hedley — Pr.
Flagg, Charles Noel — Ptg.
Flamen, Albert — Pr.
Flameng, Leopold — Pr.
Flamm, Roy — Ph.
Flandrin, Paul — Ptg.
Flannagan, John — S.
Flavin, Dan — S., Pr.
Flaxman, John — D.
Flint, William Russell — D.
Floch, Joseph — Ptg.
Florsheim, Lillian — S.
Fock, Harmanus — Pr.
Foegele, Paul — Pr.
Fokke, Simon — Pr.
Fontaine, Pierre (see Percier,
 Charles)
Forain, Jean-Louis — D., Pr., Livre
 d'artiste
Forest, E. — D.
Forsberg, James-Alfred — Pr.
Forsyth, William — Ptg.
Fortess, Karl E. — Ptg.
Fortuny y Carbo, Mariano — Pr.
Fougeron, André — Pr.
Fournier, Gabriel — Livre d'artiste
Fowle, Isaac (workshop of) — S.
Foy, Gray — D.
Fragonard, Jean Honoré — D., Pr.
Franceschini, Marc Antonio
 (attributed to) — D.
Francis, Sam — Pr.
Frankenthaler, Helen — Pr.
Frantz, Alison — Ph.

Frasconi, Antonio — Pr.
Frapié — Ptg.
Fraser, Louatt — Pr.
Fraser, Laura Gardin — S.
Frazer, James — Ph.
Freed, Hermine — Videotape
Freeth, H. W. — Pr.
Frélaut, Jean — Pr.
French, Daniel Chester — S.
French, Frank — Pr.
Frère, Edouard — Pr.
Friedlander, John — Pr.
Fries, Janet — Ph.
Friesz, Emile-Othon — D.
Frink, Elizabeth — S., Livre
 d'artiste
Frober, Johann — Pr.
Frost, Arthur Burdett — Wclr.
Frost, Francis Shedd — Ptg.
Fry, Roger — Pr.
Fuller, George — Ptg., D.
Fuller, Sue — S., Pr.
Fuseli, Henry — Ptg.
Fyt, Jan — D.

G

Gabriel, Justin-J. — Pr.
Gag, Wanda — D., Wclr.
Gaillard, Claude-Ferdinand — D.,
 Pr.
Gakutei, Yashima — Pr.
Gandini the Elder, Antonio — D.
Ganso, Emil — D., Pr.
Garrett, Edmund Henry — Pr.
Garsoian, Inna — Ptg.
Garuther, Geoffrey — Pr.
Gaspard, Leon — Ptg.
Gassies, Jean-Baptiste-Georges —
 Pr.
Gatch, Lee — Ptg.
Gaucherel, Léon — Pr.
Gaug, Margaret Ann — Pr.
Gaugengigl, Ignaz Marcel — Pr.
Gauguin, Paul — Ptg., D., Pr.
Gaul, August — Pr.
Gautherin, Jean — S.
Gavarni, Paul — Pr.
Gay, Edward — Ptg.
Gay, Walter — Ptg.
Gaylor, Samuel Wood — Ptg.
Gaywood, Richard — Pr.
Gear, William — Ptg.

Geiger, Edith R. — Ptg.
Genoves, Juan — Pr.
Genthe, Arnold — Ph.
Gentilini, Franco — Pr.
Geoffrey, T. Igbal — Pr.
Georoy — Ptg.
Gerardia, Helen — Ptg.
Gerdes, Ingeborg — Ph.
Géricault, Théodore — D., Wclr.,
 Pr.
Géricault, Théodore and Lami,
 Eugène — Pr.
Géricault, Théodore and Volmar,
 Joseph Simon — Pr.
Gérôme, Jean Léon — D.
Gerry, Samuel Lancaster — Ptg.
Gessner, Johann Conrad — Pr.
Gessner, Salomon — Pr.
Getman, William — Collage
Getsuzo — Pr.
Giacometti, Alberto — S., Pr.
Gibson, Ralph — Ph.
Gifford, Robert Swain — Ptg., Pr.
Gifford, Sanford Robinson — Ptg.
Gignoux, Régis-François — Ptg.
Giles, Howard — D.
Gilioli, Emile — S.
Gill, Eric — Pr.
Gill, Margery — Pr.
Gillespie, Gregory — Ptg., Pr.
Gilpin, Laura — Ph.
Gilpin, William Sawrey — Wclr.
Ginsberg, Yacob — Pr.
Giovanni da Bologna — S.
Girolamo di Benvenuto — Ptg.
Girodet de Roucy-Trioson, Anne-
 Louise — D.
Giroux, André (attributed to) —
 Ptg.
Glarner, Fritz — Ptg., Pr., Livre
 d'artiste
Gleichmann, Otto — Pr.
Gleizes, Albert — Pr.
Goeneutte, Norbert — Pr.
Goerg, Edouard — Pr.
van Gogh, Vincent — D.
de Gogorza, Maitland — D., Pr.
Goist — Pr.
Goldensky, Elias — Pr.
Goldthwait, Margaret R. — D.
Goltzius, Hendrik — Pr.
Gongora, Leonel — D.
Goode, Joe — Pr.

Gooden, Stephen — Pr.
Goodman, Sidney — Pr.
Goodnough, Robert — Ptg.
Goodrich and Silliman, publishers — Book
Goodwin, Arthur C. — D.
Goodyear, Anne Dixon — Ptg.
Goodyear, John — Pr.
Gorbaty, Norman — Pr.
Gosminski, Richard — Ptg.
Gottlieb, Adolph — Ptg.
Gottachald, Michael — Pr.
Goubie, Jean Richard — D.
Goudt, Hendrik — Pr.
Gowin, Emmet — Ph.
van Goyen, Jan — Ptg., D.
Grabach, John — Ptg.
Graham, Robert — S., Pr.
de Grailly, Victor — Ptg.
Granaud — Pr.
Grandville, Jean Ignace — Pr.
Grandville, Jean Ignace and Raffet, Auguste — Pr.
Granell, Eugenio — Ptg.
Grant, Campbell — Pr.
Grant, Duncan — Wclr.
Gravelot, Hubert-François — D.
Graves, Morris — D.
Gray, Ned — Ph.
Gray, Ruth — Ph.
Green, Samuel M. — D.
Green, Valentine — Pr.
Greenwood, Marion — Ptg.
Greuze, Jean-Baptiste — Pr.
Griggs, Frederick Landseer — Pr.
Grignioni, Charles (see Hogarth, William)
Grillo, John — Ptg.
Grimaldi, Giovanni Francesco — Pr.
Gris, Juan — Ptg., D., Pr.
Grooms, Red — Pr.
Gropper, William — D., Pr.
Gros, Antoine-Jean — Pr.
Gros, Antoine-Jean (school of) — Ptg.
Gross, Anthony — Pr.
Gross, Chaim — D.
Grossman, Rudolph — Pr.
Grosz, George — D., Pr.
Grueningerx — Pr.
Grunbaum, Marian Hettner — Ptg.

Grünewald (Mathis Gothardt Neithardt) — D.
de Gryef, Adriaen — Ptg.
Guardi, Francesco — D.
Guerard, Henri — Pr.
Guerin, A. M. — Ptg.
Guercino (Giovanni Francesco Barbieri) — D.
Gugell, Gwen — D.
Guiramand, Paul — Pr.
Gulliver, Mary — Ptg.
Guttuso, Renato — D.
Guys, Constantin — D.

H

Haacke, Hans — Pr.
de Haas, Maurits F. H. — Pr.
Haas, Richard — Pr.
Haden, Francis Seymour — Pr.
Hadzi, Dimitri — S., D., Wclr., Pr.
Haese, Günter — S.
Hahn, John — Pr.
Hajdu, Étienne — S., Pr., Livre d'artiste
Hale, Lillian Westcott — D., Pr.
Hale, Philip Leslie — Ptg., D., Pr.
Haley, Patience E. — D., Wclr.
Hall, Kleber — Pr.
Hall, Oliver — Pr.
Haller, Vera — Ptg.
Hallowell, George H. — Wclr.
Halsman, Philippe — Ph.
Hamaguchi, Yozo — Pr.
Hanfstaengl, Franz Seraph — Pr.
Hankins, A. P. — Pr.
Hansen, Armin — Pr.
Hanusi, Saidi (Mtwara-Makode tribe) — S.
Hardie, Martin — Pr.
Harding, George Perfect — Wclr.
Harding, James Duffield — Pr.
Hardy, Beulah Greenough — Ptg.
Hare, John — Wclr.
Harlamoff, Alexei Alexeievich — Ptg.
Harmar, Thomas — Pr.
Harpignies, Henri-Joseph — D.
Harris, Philip Spooner — Ptg.
Hart, George ("Pop") — Wclr.
Hart, William — Ptg.
Hartgen, Vincent A. — Wclr.

Hartigan, Grace — Ptg.
Hartley, Marsden — Ptg.
Hartung, Hans — Pr.
Hartung, Willi — Wclr.
Harunobu, Suzuki — Pr.
Haseltine, William Stanley — Ptg., D.
Haskell, Ernest — Pr.
Hassam, Childe — Ptg., Pr.
Hasui — Pr.
Hatcher, Keith — Pr.
van Hattick, Petrus — Ptg.
Hawkins, Dennis — Pr.
Hayter, Stanley William — Pr.
Hayward, George — Wclr.
Heade, Martin Johnson — Ptg.
Hearne, Thomas — Wclr.
Heath, Charles — Livre d'artiste
Heckel, Erich — D., Pr.
Heideman, Susan — Ptg.
Heinecken, Robert — Collage, Ph.
Heintzelman, Arthur William — Pr.
Heiss, Gottlieb I. — D.
Helleu, Paul-César François — Pr.
van der Helst, Bartholomeus (attributed to) — Ptg.
Henri, Robert — D.
Hepworth, Barbara — S.
Hereau, Jules — Pr.
Herold, Jacques — Ptg.
Heron, Patrick — Ptg., Pr.
Herring Sr., John Frederick — Ptg.
Hervier, Adolphe-Louis — Pr.
Heseltine, John Postle — Pr.
Hesse, Eva — S.
von Heyden, Auguste — Pr.
Hidai, Nankoku — D.
Higgins, Eugene — Pr.
Highmore, Anthony — D.
Hill, David Octavius — Ph.
Hill, David — D.
Hill, Edward J. — D., Pr. and copper plate, Livre d'artiste, Ph.
Hills, Laura Coombs — D.
Hinckley, Thomas — Ptg.
Hine, Lewis — Ph.
Hinman, Charles — Ptg., Pr.
Hios, Theo — Ptg.
Hiroshige I, Ando — Pr.
Hiroshige II — Pr.
Hiroshige, Ichiryusai — Pr.

Hiroshige, Motonaga — Pr.
Hiroshige, Utagawa — Pr.
Hitchcock, Ora White — Pr.
Hitchens, Ivon — Ptg.
Hoare, William — Ptg.
Hobbs, Morris Heary — Pr.
Hockney, David — Pr.
Hodges, Ian — Ptg., S.
Hodgkinson, Frank — Ptg.
Hofer, Evelyn — Ph.
Hofer, Karl — Pr.
Hoffman, Malvina — S.
Hofmann, Hans — Ptg.
Hogarth, William — Ptg., Pr.
Hogarth, William and Aviline, F.
 — Pr.
Hogarth, William and Grignioni,
 Charles — Pr.
Hogarth, William and Le Cave, P.
 — Pr.
Hogarth, William and Mosley,
 Charles — Pr.
Hokinson, Helen E. — D.
Hokkei, Toyota — Pr.
Hokuju (Hokuba or Hokujiu) Shotei
 — Pr.
Hokusai, Katsushika — Pr.
Hokusai, Katsushika (or school of)
 — D.
Hokusai (Shunro) — Pr.
Holbein the Younger, Hans — Pr.
Holcomb, Alice — Ptg.
Hollar, Wenceslaus — Pr.
Holsteyn, Pieter — Pr.
Homans, Nancy — Wclr.
Homer, Winslow — Ptg., Pr.
Hondius, Gerritt — Ptg.
van Honthorst, Gerrit — Ptg.
Hooker, William — Pr.
Hopfer, Daniel — Pr.
Hopkinson, Charles Sydney — Ptg.
Hopkinson, Robert — Ptg.
Hoppenbrouwers, Johannes
 Franciscus and Ververe,
 Salomon Leonardus — Ptg.
Hopper, Edward — Ptg., Pr.
Hoppner, John — Ptg.
de Horn, Dirck — Ptg.
Hornby, Lester George — Pr.
Horwitt, Will — S.
Hosiasson, Philippe — Ptg.
Houbraken, Jacobus — Pr.

Hu Chi-Chung — Ptg.
Huard, Charles — Pr.
Hubbell, Henry S. — Ptg.
Huber, Adriaen — Pr.
Hudson, Eleanor Erlund — Pr.
Huet, Paul — Pr.
Humphrey, John — D.
Hunt, Richard — Pr.
Hunt, Samuel Valentine — Pr.
Hunt, William Morris — Ptg., D.
Huntington, Anna Hyatt — S.
Huntington, Daniel P. — Pr.
Huntington, Jim — S.
Hurwitz, Reuben — Pr.
Hurwitz, Sidney — Pr.
Hutty, Alfred — Pr.

I

Ibbetson, Julius Caesar — Wclr.
Indiana, Robert — Pr.
Ingres, Jean-Auguste-Dominique —
 Ptg., D.
Inman, Henry (attributed to) —
 Wclr.
Inness, George — Ptg.
Inokuma, Genichiro — Ptg.
Irvine, Wilson H. — Ptg.
Irwin, Gwynther — Pr.
Isabey, Eugène — Pr.
Isabey, Jean-Baptiste — Pr.
Isenbrandt, Adriaen (school of) —
 Ptg.
Isobe, Yukihisa — Pr.
Israel, Murray — Ptg.
Itchkawich, David — Pr.
Itten, Johannes — Pr.

J

Jackson, Herb — Pr.
Jackson, Millicent — Pr.
Jacob, Nicolas-Henri — Pr.
Jacob-Hood, George Percy — Pr.
Jacque, Charles-Émile — Ptg., Pr.
Jacque, Léon — Pr.
Jacquemart, Jules-Ferdinand — Pr.
James, Alexander — Ptg.
James, Christopher P. — Ph.
Janes, Norman — Pr.
Jaques, Ronny — Ph.
Jauner, J. N. (attributed to) — Pr.
Jennys, William — Ptg.
Jensen, Alfred — Pr.

Jimenez Jr., Luis Alfonso — D.
John, Augustus — D.
John, Gwen — Ptg.
Johns, Jasper — Pr.
Johnson, Eastman — D.
Johnson, Lester — Ptg.
Johnson, Marshall — Ptg.
Johnson, Peter — Ph.
Johnston, Randolph W. — S., Pr.
Jones, Allen — Pr.
Jongkind, Johan Barthold — D., Pr.
Jordaens, Jacob — D., Pr.
Joren, Teppitsun — Pr.
Jouvenet, Jean — Ptg.
Judd, Donald — D., Pr.
Jules, Mervin — Ptg., D., Pr.,
 Woodblocks
Jung, Simonetta Vigevani — Ptg.
Junyer, Joan — Pr.

K

Kadar, Livia — Pr.
Kadish, Reuben — S., Pr.
Kahn, Wolf — Ptg.
Kalckreuth, Karl — Pr.
Kalff, Willem — Ptg.
Kaltenbach, Steven — S.
Kamys, Walter — D., Pr.
Kanaga, Consuelo — Ph.
Kandinsky, Wassily — Pr.
Kano School — Ptg.
Kaprow, Alyce — Ph.
Karsch, Joachim — Pr.
Käsebier, Gertrude — Ph.
Kasimir, Luigi — Pr.
Kass, Ray — Ptg.
Katzman, Herbert — Ptg.
Kaufman, Daniel — Ph.
Kaula, William J. — Ptg.
Kawabata, Minoru — Ptg.
Kawashima, Takeshi — Ptg.
Kearns, James — S.
Keely, Isaac H. — Ptg.
Keisai, Yeisen — Pr.
Kelly, Ellsworth — Pr.
Kelly, Leon — D.
Kennedy, Clarence — Ph.
Kensett, John Frederick — Ptg.
Kent, Rockwell — Ptg., D., Pr.
Kepes, Gyorgy — Ptg.
Kerciu, Raymond — Pr.
Kertész, André — Ph.

Khanna, Krishen — Ptg.
King, Clinton — Pr.
King, G. — Pr.
Kingsley, Elbridge — Wclr., Pr.
Kinigstein, Jonah — Ptg.
Kirby, Rollin — D.
Kirchner, Ernst Ludwig — Ptg., Pr.
Kirk, Thomas — Pr.
Kirmse, Marguerite — Pr.
Kiyoshiro, Torii — Pr.
Kiyomitsu, Torii — Pr.
Kiyonobu, Torii — Pr.
Kiyonaga, Torii — Pr.
Klee, Paul — D., Wclr., Pr.
Kleinschmidt, Paul — Wclr., Pr.
Klimt, Gustav — D.
Kline, Franz — Ptg.
Kline, Fred — Ptg.
Klinger, Max — Pr.
Kloss, Gene — Pr.
Knell, Gustave — Pr.
Knigin, Michael — Pr.
Kohn, Misch — Pr.
Kokoschka, Oskar — Pr.
Kollwitz, Käthe — D., Pr.
Kolos-Vari, Sigismond — Pr.
König, Johann — Ptg.
de Kooning, Willem — Ptg., D., Pr.
Koppe, Richard — D.
Korn, Elizabeth P. — Ptg.
Koryusai, Isoda — Pr.
Kowal, Dennis — Pr.
Kozloff, Joyce — Pr.
Kratschkowsky, Joseph E. — Ptg.
Krauskopf, Bruno — D.
Kruell, Gustave — Pr.
Kruger, Franz (attributed to) — D.
Krushenick, Nicholas — Pr.
Kubin, Alfred — Pr.
Kucerova, Alcna — Pr.
Kugler, Rudolph — Pr.
Kunisada I — Pr.
Kunitsuna — Pr.
Kuniyasu — Pr.
Kuniyoshi, Ichiyusai — Pr.
Kuniyoshi, Utagawa — D., Pr.
Kuniyoshi, Yasuo — D.

L

Labille-Guiard, Adelaide (attributed to) — Ptg.

Labino, Dominick — S.
Laboreur, Jean-Émile — D., Pr.
Lachaise, Gaston — S.
La Farge, John — Ptg.
Lagrenée, Louis-Jean-François (attributed to) — Ptg.
de Lairesse, Gerard (attributed to) — Ptg.
de Lalais, Charles — Pr.
Lalanne, Maxime — Pr.
Lambert, Eugène — D.
Lambert, Patricia — Ph.
Lami, Eugène (see Géricault, Théodore)
Landacre, Paul H. — Pr.
Landfield, Ronnie — Ptg.
Landon, Eduard — Pr.
Lane, C. A. — Pr.
Lane, Mary Comer — D.
Lange, Dorothea — Ph.
Lange, Otto — Pr.
Langmuir, Ruggles — Ph.
Lankes, Julius J. — Pr.
Lanyon, Peter — Ptg.
Lapostolet, Charles — Ptg.
Larkin, Oliver W. — D.
Lathrop, Clara Welles — Ptg.
Laucharoen, Prawat — Pr.
Laughlin, Clarence — Ph.
Laurencin, Marie — Ptg.
Laurens, Jules — Pr.
Lautensack, Hans Sebald — Pr.
Lauzzana, Raymond — Pr.
Lawrence, Thomas — Ptg.
Layraud, Joseph-Fortuné-Séraphin — Ptg.
Lear, Edward — Wclr.
Lebduska, Lawrence — Ptg.
Le Cave, Peter (see Hogarth, William)
Leconte de Roujou, Louis-Auguste — Pr.
Lee, Amy Freeman — Wclr.
Leete, William — Pr.
Lefebvre, Jules — Pr.
Léger, Fernand — Ptg., D., Pr.
Legrand, Louis — D.
Legros, Alphonse — D., Pr.
Lehmbruck, Wilhelm — S., D., Pr.
Leibl, Wilhelm — Pr.
Leighton, Clare — Pr.
Leloir, Alexandre-Louis — Pr.
van Lennup, H. J. — Pr.

Leon y Escosura, Ignacio de — Pr.
Leonelli, Dante — Ptg.
Leoni, Leone (follower of) — S.
Leonid (Leonid Berman) — Ptg.
Lepère, Auguste Louis — Pr.
Lepic, Ludovic-Napoléon — Pr.
Le Prince, Jean Baptiste — Pr.
Letterini, Bartolomeo — D.
Leure, George — Pr.
Levée, John — Ptg.
de Levi, Juan — Ptg.
Levine, David — D.
Levine, Jack — Pr.
Levis, Arthur Allen — Pr.
Lexis, John Frederick — D.
LeWitt, Sol — S., D., Pr.
van Leyden, Lucas — Pr.
Lhermitte, Léon-Augustin — D.
Liberman, Alexander — S.
Licata, Riccardo — Pr.
Lichtenstein, Roy — S., D., Pr.
Liebermann, Max — Pr.
Lievens, Jan — D.
Lindner, Richard — Pr.
Lindsay, Lionel Arthur — Pr.
Linton, Henry D. — Pr.
Lipchitz, Jacques — Ptg., S., Pr.
Lipman-Wulf, Peter — D.
Lipstreu, Kenneth — Ptg.
Lise, A. — Pr.
de Lisio, Michael — S.
Littlefield, William — D.
Locatelli, Andrea — Ptg.
Lockwood, Wilton — Ptg.
Loir, Luigi — Ptg.
Loir, Nicolas — Ptg.
Lombard, Louis — Pr.
Lombardo, Tullio (attributed to) — S.
Longhi, Giuseppe — Pr.
Longhi, Pietro — Ptg.
Longueville, Charles-Julien-Fidèle — Pr.
Lorain, Dolia — Ptg.
Lorcini, Gino — S.
Lorne, Naomi — Ptg.
Luce, Maximilien — Pr.
Lucioni, Luigi — Pr.
Lundy, Henry — Pr.
Lungren, Fernald — Ptg.
Lupton, Thomas (see Turner, J. M. W.)

Lurçat, Jean — D., Pr.
Lyght, Andrew — S.
Lyman Jr., Joseph — Ptg.
Lynes, George Platt — Ph.

M

MacBryde, Robert (see Colquhoun, Robert)
Maccari, Miao — Pr.
Mack, Warren Bryan — Pr.
Mackey, William Erno — Pr.
MacIver, Loren — Ptg.
MacLaughlan, Donald Shaw — Pr.
MacLeod, Enis — S.
MacLeod, W. Douglas — Pr.
MacPherson, Robert — Ph.
Magnasco, Alessandro — Ptg.
Magritte, René — Ph.
Maillol, Aristide — S., D., Pr., Livre d'artiste, Book
Malicoat, Phillip — D.
Mallary, Robert — S.
Malone, Robert R. — Pr.
Man Ray — Ph.
Mancini, Antonio — D.
Manessier, Alfred — Pr.
Manet, Edouard — Ptg., Pr., Livre d'artiste, Book
Manlio — Pr.
Mansfield, Robert A. — S.
Manship, Paul — S.
Manso, Leo — D.
Mantegna, Andrea (school of) — Pr.
Mapplethorpe, Robert — Ph.
Maratta, Carlo — D.
Marc, Franz — Pr.
Marcks, Gerhard — S., Pr.
Marcoussis, Louis — Pr.
Marden, Brice — Pr.
Margo, Boris — D.
Marin, John — D., Wclr., Pr.
Marini, Marino — S., D.
Marisol (Marisol Escobar) — Pr.
Mark, Enid — D., Pr.
Mark, Ludwig — Ptg.
Markham, Kyra — Pr.
Marquet, Pierre-Albert — D., Pr., Livre d'artiste
Marsh, Eli — D.
Marsh, Molly — D.
Marsh, Reginald — Pr.

Martial (Adolphe-Martial Potemont) — Pr.
Martial, Armand P. — Pr.
Martin, Homer Dodge — Ptg.
Martin, John — D., Pr.
Martins, Aldemir — Pr.
Marvy, Louis — Pr.
Marx, Robert S. — Pr.
Masanoeu — Pr.
Mason, Robert — Pr.
Masson, Alphonse-Charles — Pr.
Masson, André — Ptg., Pr.
Master Z. B. M. — Pr.
Mastro-Valerio, Alessandro — Pr.
Mataré, Ewald — S.
Matero — Pr.
Mathews, William T. — Ptg.
Mathieu, Georges — D.
Mathieu, Marie-Alexandrine — Pr.
Matisse, Henri — D., Pr., Livre d'artiste
Maurer, Alfred Henry — Ptg.
Mauve, Anton — D.
Maxham Studio, Benjamin D. — Ph.
Maxwell, Paul — Wclr.
Mayes, Elaine — Ph.
Mazur, Michael — D., Pr.
McBey, James — Pr.
McClellan, Katherine E. — Ph.
McCoy, Lawrence R. — Ptg.
McEntee, Jervis — Ptg.
McGee, Winston — Pr.
McIlworth, Thomas — Ptg.
McMillan, Mary — Ptg.
van Meckenem, Israhel — Pr.
Medina, Rafael — D.
Meid, Hans — D., Pr.
Meidner, Ludwig — Pr.
Meiere, Hildreth — Ptg.
Meissonier, Jean Louis Ernest — Ptg.
Mellan, Claude — Pr.
Melzer, Moritz — Pr.
Mendez, Leopoldo — Pr.
Menpes, Mortimer — Pr.
Menyof, T. — D.
Menzel, Adolph — D., Pr.
Merian, Matthäus — Pr.
Merida, Carlos — Pr.
Merrild, Knud — Ptg.
Meryon, Charles — Pr.
Mess, George Joseph — Pr.

Metcalf, Willard Leroy — Ptg.
Meunier, Constantin — S.
Michalik, Chester — Ph.
Michel, Georges — Ptg.
Michelin, Jules — Pr.
van Mieris the Younger, Frans — Ptg.
Mignon, Abraham — Ptg.
Miller, Brenda — D., Pr.
Miller, Richard — D.
Milles, Carl — S.
Millet, Eugène — Pr.
Millet, Jean-François — Ptg., D., Pr.
Millman, Edward — Pr.
Mindlin, Vera Bocayuva — Livre d'artiste
Minton, John — D., Pr.
Mirko (Mirko Basaldella) — S., Pr.
Miró, Joán — Pr.
Mitchell, Joan — Ptg., D.
Mitchell, Margaretta K. — Pr., Ph.
Mitsunobu, Hasegawa — Pr.
Mittleman, Ann — D.
Mizofune, Rokushu — Wclr.
Modigliani, Amedeo — D., Pr.
Moffet, Ross — D.
Moholy-Nagy, László — Ptg., Ph.
Molenaer, Klaes — Ptg.
de Momper, Joos — Ptg.
Mondrian, Piet — Ptg., D., Book
Monet, Claude — Ptg.
de Monfried, Georges-Daniel — Pr.
Monks, John Austin Sands — Pr.
Monnier, Henry — D., Pr.
Monsiaux, Nicolas André — D.
Monten, Heinrich Maria Dietrich — Pr.
de Montfort, Ernest — Pr., Copper plate
Moore, Henry — S., D., Pr., Livre d'artiste
Moore, John — Ptg.
Moran, Mary Nimmo — D., Pr.
Moran, Peter — Pr.
Moran, Thomas — Pr.
Morandi, Giorgio — Ptg., Pr.
Moreau, Luc-Albert — Pr.
Moreau, P. Louis — Pr.
Moreau the Younger, Jean-Michel — D., Pr.
Morehouse, William P. — Ptg.

Morgan, Barbara — Ph.
Morgan, William — Ptg., D.
Morghen, Filippo — Pr.
Morisot, Berthe — Ptg., D., Pr.
Morita, Shiryu — D.
Morlotti, Ennio — Ptg.
Moronobu, Hishikawa — Pr.
Moronobu, Hishikawa (or school)
 — Pr.
Morrison, George — Pr.
Mortenson, Virginia Fuller — Ptg.,
 Pr.
Mosha, Ivan — Pr.
Moser, Barry — Pr.
Moser, David Lee — D.
Mosley, Charles (see Hogarth,
 William)
Motherwell, Robert — Collage, Pr.
Movitz, Edward — S., D.
Moy, Seong — Pr.
Moyano, Luis — Ptg.
Moyse, Edouard — Pr.
Mozyn, Michiel — Pr.
Mudge, Polly — Pr.
Mueller, Hans Alexander — Pr.
Muench, John — Pr.
Müller, Otto — D., Pr.
Mullican, Lee — Ptg.
Munakata, Shiko — Pr.
Munch, Edvard — D., Pr.
Munn, Paul Sandby — D.
Murillo, Bartolomé Esteban
 (attributed to) — Ptg.
Murphy, John Francis — D.
Musi, Agostino (called Agostino
 Veneziano) — Pr.
Music, Antonio — Ptg., Pr.
Muybridge, Eadweard — Ph.
Myslowski, Tadeusz — Pr.
Mytens the Elder, Daniel — Ptg.

N

Nadar (Gaspard-Félix Tournachon)
 — Ph.
Nadelman, Elie — S.
Naha, R. — D.
Naonobu, Kano — Ptg.
Nanteuil, Célestin François — Pr.
Nanteuil, Robert — Pr.
Nash, Paul — D.
Nason, Robert — Pr.
Nason, Thomas Willoughby — Pr.

Natkin, Robert — Wclr.
Natoire, Charles-Joseph — D.
Nauman, Bruce — S.
Neal, Avon and Parker, Ann — Pr.
Neel, Alice — D.
Nelson, Leonard L. — Pr.
Nessler, Walter — Pr.
Nestler, Steven — Ph.
Netscher, Constantin — Ptg.
Neustadt, Barbara — Pr.
Nevelson, Louise — Ptg., S., Pr.
Nevjestic, Virgilije — Livre d'artiste
Newman, Arnold — Ph.
Newman, Barnett — D., Pr.
Newman, R. G. — Pr.
Newman, Robert Loftin — Ptg.
Nicholson, Ben — Ptg., Pr.
Nicholson, William — Pr.
Nickford, Juan — S.
Nicoll, James Craig — Pr.
Niswonger, Gary — Pr.
de Nittis, Giuseppe — D.
Niviaksiak — Pr.
Noël, Alphonse Léon — D.
Nogari, Giuseppe — Ptg.
Nolan, Sidney — D.
Nolde, Emil — Pr.
Noterman, Emmanuel — Pr.
Novelli, Pietro Antonio (attributed
 to) — D.
Novros, David — D.
Nuyttens, Joseph-Pierre — Pr.

O

Oberadt, Peter — Pr.
Ochtman, Dorothy — Ptg.
O'Connell, Frédérique-Emilie — Pr.
O'Conner, Thom — Pr.
O'Conor, Roderic — Ptg.
Odate, Toshio — S.
Odieuvre, Michel — Pr.
Offner, Elliot — D., Pr.
O'Hanlon, Richard — D.
O'Keeffe, Georgia — Ptg.
Okyo, Maruyama — Ptg.
Oldenburg, Claes — S., Pr.
Olitski, Jules — Ptg.
van Oosterwyck, Maria — Ptg.
Oppenheim, Moritz — D.
Orlik, Emil — Pr.
Orloff, Chana — S., D.
Orozco, Jose Clemente — Pr.

Ortman, George — Pr.
van Os, Jan — Ptg.
van Ostade, Adriaen — Pr.
Ostrowsky, Abbó — Pr.
Owen, Samuel — Wclr.

P

Palmer, Alice Hoyt — Ptg., Pr.
Palmer, Samuel — Ptg. (attributed
 to), Pr.
Panini, Giovanni Paolo — Ptg., D.
Paolozzi, Edouardo — Pr.
Parker, Ann (see Neal, Avon)
Parker, Olivia — Pr., Ph.
Parker, Robert Andrew — Wclr.
Parmigianino (Francesco Mazzola)
 — D., Pr.
Parr, Nathanial — Pr.
Parrish, Stephen — Pr.
Partridge, Roi — Pr.
Pascin, Jules — D., Pr., Livre
 d'artiste
Passaroti, Bartolomeo — D.
van der Passe, Crispin — Pr.
Pastelot, Jean-Amable — Pr.
Paxton, Joseph — Pr.
Peale, Margaretta Angelica — Ptg.
Pearce, Charles Sprague — Ptg.
Pearlstein, Philip — Pr.
Pearson, Henry — Pr.
Pechstein, Max — D., Pr.
Peirce, Gerry — Pr.
Penauille, Edme — Pr.
Pencz, Georg — Pr.
Pennell, Joseph — Wclr., Pr.
Percier, Charles and Fontaine,
 Pierre (school of) — D.
Pereira, Irene Rice — Ptg., D.
Perelle, Adam — Pr.
Perino del Vaga (attributed to) —
 D.
Perlin, Bernard — Ptg.
Petegorsky, Stephen — Ph.
Peterdi, Gabor — Wclr., Pr.
Peto, John Frederick — Ptg.
Petrovna, Valentina — Pr.
Pfahl, John — Ph.
Pfeiffer, S. H. F. — Pr.
Phillips, Marjorie — Ptg.
Piazzetta, Giovanni Battista
 (attributed to) — D.

Picasso, Pablo — Ptg., D., Pr.,
Livre d'artiste, Book
Pikhadlkar — S.
Pillement, Jean — Ptg.
Pinelli, Bartolommeo — D.
Piper, John — Ptg., D., Pr.
Piranesi, Francesco — Pr.
Piranesi, Giovanni Battista — D.,
Pr.
Pirelli — Pr.
Pissarro, Camille — Ptg., D., Pr.
Pistoletto, Michelangelo — Ptg.
Pitts, William — D.
Platt, Charles Adams — Pr.
Pleasure, Fred — Ph.
Pleissner, Ogden — Ptg.
Ploos van Amstel, Jacob Cornelius
— Pr.
Plowman, George T. — Pr.
Poccetti (Bernardo Barbatelli) — D.
van der Poel, Egbert (attributed to)
— Ptg.
van Poelenburg, Cornelis — Ptg.,
D. (attributed to)
Pogue, Dwight — Pr.
Pomodoro, Arnaldo — S., D.
Pomodoro, Gio — S.
Poons, Larry — Pr.
Portocarrero, René — Ptg., D.
Posada, José G. — Pr.
Potter, Paulus — D., Pr.
Pougny, Jean — Ptg., Pr.
Pousette-Dart, Richard — Ptg.
Povi, Thun — Pr.
Powell, Earl — D., Pr.
Powell, John (Joseph) — D.
Prendergast, Maurice B. — Wclr.
Presser, Josef — Pr.
Prestel, Johann Gottlieb — Pr.
Price, Ken — Pr.
Priest, Hartwell — Pr.
Prior, Scott — D.
Prior, William Matthew — Ptg.
Prout, Samuel — D., Pr.
Prud'hon, Pierre Paul — D.
Pseudo Pacchia — D.
Psychedelic Posters — Pr.
Pushman, Hovsep — Ptg.
Puvis de Chavannes, Pierre — Ptg.,
D.
Pyle, Howard — D.

Q

Quaglio the Younger, Domenico —
Pr.
Quandt, Abigail — Pr.
Querido, Zita — Ptg.
Queyroy, Armand (Mathurin Louis)
— Pr.
Quirt, Walter — Ptg.

R

Rabinovitz, Harold J. — Pr.
Rademaker, Abraham — D.
Radziwill, Franz — D., Pr.
Raeburn, Henry — Ptg.
Raffael, Joseph — Pr.
Raffaëlli, Jean François — Pr.
Raffet, Auguste — Pr.
Raffet, Auguste (see Grandville,
Jean-Ignace)
Raimondi, Marcantonio — Pr.
Rajon, Paul A. — Pr.
Rand, Ellen Emmet — Ptg.
Ranger, Henry Ward — Ptg.
Rapin de Thoyras, Paul — Pr.
Rathbone, Augusta — Wclr.
Rauschenberg, Robert — Pr.
Ravier, François-Auguste — Wclr.
Ray, Patricia — Pr.
Rayo, Omar — Pr.
Reder, Bernard — Pr.
Rederer, Franz — Pr.
Redon, Odilon — Ptg., D., Pr.,
Livre d'artiste
Regensburg, Sophy — Ptg.
Regnault, Henri A. — Ptg.
Reichert, Donald — S.
Reid, Charles — Ptg.
Reinhardt, Ad — Pr.
Rembrandt van Rijn — D., Pr.
Reni, Guido (attributed to) — Ptg.
Renoir, Pierre Auguste — Ptg., S.,
D., Wclr. (attributed to), Pr.,
Book
Renouard, Charles-Paul — D., Pr.
Rettoner, M. J. — Pr.
Rexach, Juan (or follower) — Ptg.
Reynolds, Joshua — Ptg.
Ribera, Jusepe de — Pr.
Ribot, Théodule Augustin — Ptg.,
Pr.
Ricci, Dante — Wclr.
Rice, Ann — Pr.

Rich, Frances — S.
Richards, William Trost — Ptg., D.
Richier, Germaine — S., Pr.
Richmond, William Blake — D.
Richter, Ludwig — D.
Rickey, George — S.
Rigaud, Hyacinthe — Ptg.
Rimmer, William — Ptg.
Ritchie, Alexander Hay — Pr.
Rivera, Diego — Ptg., D., Pr.
de Rivera, José — S.
Rivers, Larry — Ptg., Pr.
Rizzi, James — Pr.
della Robbia, Andrea (studio of) —
S.
Robert, Fanny — D.
Robert, Hubert — Ptg.
Roberts, W. — Pr.
Robins, Brian — S.
Robinson, Alan James — D., Pr.
Robinson, Boardman — Pr.
Robinson, Theodore — Ptg.
Robiquet, M. Lucas — Ptg.
Rockwood Studio — Ph.
Rodin, Auguste — S.
Rogers, John — S.
Roghman, Roland — D.
Rohrer, Warren — Ptg.
Romagnoni, Bepi — Ptg.
Romako, Anton — Ptg.
Romanini — Ptg.
Rops, Félicien — D., Pr.
Rorer, Abigail — D., Pr.
Rosa, Salvator — D. (attributed to),
Pr.
Rose, Francis Cyril — D.
Rosenberg, James N. — Ptg., Pr.
Rosenquist, James — Pr.
Rosenthal, Louise M. — Ptg.
Rossellino, Antonio (attributed to)
— S.
Rosso Fiorentino — D.
Rotella, Mimmo — S.
Roth, Ernest David — Pr.
Rothko, Mark — Ptg.
Rothschild, Judith — Collage
Rouault, Georges — D., Pr.,
Woodblock, Livre d'artiste,
Book
Rousseau, Henri — Ptg.
Rousseau, Pierre-Etienne Théodore
— Ptg., Pr.
Roussel, Ker-Xavier — Pr.

Stamos, Theodoros — Ptg., Pr.
Stankiewicz, Richard — S.
Stark, Larry — Pr.
Starke, Ottomar — Pr.
Steen, Jan — Ptg.
Steichen, Edward — Ph.
Steig, William — S., D.
Steinberg, Saul — Pr.
Steiner, Ralph — Ph.
Steinhardt, Jakob — Pr.
Steinlen, Théophile-Alexandre —
 D., Pr.
Steinmetz, Lois Foley — Ph.
Steir, Pat — Pr.
Stella, Frank — Ptg., Pr.
Stern, Lucia — Collage
Sternberg, Harry — Ptg., Pr.
Sterne, Maurice — Ptg., D.
Sterner, Albert E. — Pr.
Ste. Ribis, André — Pr.
Stettheimer, Florine — Ptg.
Stevens, Edward John — Wclr.
Stevens, John — Wclr.
Stewart, Reba — Pr.
Stieglitz, Alfred — Ph.
Stillman, Ary — Ptg.
Stimson Jr., Cyrus Flint — D.,
 Wclr.
Stoltz, David — S.
Stone, Arnold — S.
Storm van s'Gravensande, Charles
 — D., Pr.
Story, George Henry — Ptg.
Strang, Ian — Pr.
Strang, William — Pr.
Strater, Henry — D.
Street, Robert — Ptg.
Streeter, Tal — S.
Stuart, Gilbert — Ptg.
Suavius, Lambert — Pr.
Subleyras, Pierre — Ptg.
Sucho, Katsukawa — Pr.
Le Sueur, Nicolas — Pr.
Summers, Carol — Pr.
Susini, Antonio — S.
Sutherland, Graham — Ptg., Pr.
Suzuki, James H. — Ptg.
Swan, Barbara — Pr.
van Swanevelt, Herman — Pr.
Swank, Luke — Ph.
Swann, James — Pr.
Swinton, George — Ptg., D.,
 Wclr., Pr.

Syburg, Barbara Simonds — Ph.
Symington, J. — Wclr.
Szabo, Laszlo — Pr.

T

Tachibana, Morikuni — Pr.
Taddeo di Bartolo — Ptg.
Taeuber-Arp, Sophie — D.
Tait, Agnes — Pr.
Taito (Hokusai) — Pr.
Talbot, Jonathan — Ptg.
Talbot, William Henry Fox — Ph.
Talcoat, Pierre — Pr.
Talleur, John — Pr.
Tamayo, Rufino — Ptg., Pr.
Tanguy, Yves — Ptg.
Tanning, Dorothea — Livre d'artiste
Tàpies, Antoni — Pr.
Tarbell, Edmund C. — Ptg.
Tatlock, Anne — D.
Tatlock, Hugh — Ph.
Tatlock, J. F. — D.
Taussig, H. Arthur — Ph.
Taylor, James — Ptg.
Taylor, Richard L. D. — D.
Tchelitchew, Pavel — D.
Telling, Elizabeth — D., Pr.
Ter Borch the Younger, Gerard
 (attributed to) — D.
Terbrugghen, Hendrick — Ptg.
Thayer, Albert R. — Pr.
Thibault, Jean Thomas — D.
van Thielen, Jan Philip — Ptg.
Thiemann, L. — Pr.
Thoeny, William — Ptg.
Thoma, Hans — Pr.
Thompson, Ernest Heber — Pr.
Thomson, Rodney — Pr.
Thurber, James — D.
Tice, George — Ph.
Tiepolo, Giovanni Battista — D.,
 Pr.
Tiepolo, Lorenzo — D.
Tillac, Jean Paul — Pr.
Tilson, Joe — S.
Tintoretto (Jacopo Robusti) — D.
Tissot, James Jacques Joseph — D.,
 Pr.
Tittle, Walter — Pr.
Tobey, Mark — D., Pr.
Todd, A. R. Middleton — Pr.
Todorov, Lara — Pr.

Tofel, Jennings — Ptg.
Toms, W. H. — Pr.
Tonny, Kristians — D., Pr.
Toorop, Jan — D., Pr.
Torond, Francis — D.
Toshinobu — Pr.
Toulouse-Lautrec, Henri de — D.,
 Pr., Livre d'artiste, Book
Townley, Hugh — S.
Toyohiro, Utagawa — Pr.
Toyohisa — Pr.
Toyokuni, Utagawa — Pr.
Toyokuni I — Pr.
Toyokuni III — Pr.
Toyonobu, Ishikawa — Pr.
Trager, Philip — Ph.
Train, Margaret — Wclr.
Triscott, Samuel — Ptg.
van Troostwijk, Wouter Johannes
 — Pr.
Trova, Ernest — Pr.
Troyon, Constant — Ptg.
True, David — Pr.
Trügel, Bruce — D.
Tryon, Dwight W. — Ptg., D.
Tschacbasof, Nahum — Ptg.
Tsuchimochi, Kazuo — Pr.
Tsuji, Shindo — S.
Tubby, Joseph — Ptg.
Tucker, Allen — Ptg., D.
Tudlik — Pr.
Tufino, Rafael — Pr.
Turken, Hendrick — Ptg.
Turnbull, William — Pr.
Turner, Charles (see Turner, J. M.
 W.)
Turner, Janet E. — Wclr.
Turner, Joseph Mallord William —
 D., Pr., Book
Turner, J. M. W. and Clint, George
 — Pr.
Turner, J. M. W. and Dawe, Henry
 — Pr.
Turner, J. M. W. and Lupton,
 Thomas — Pr.
Turner, J. M. W. and Say, William
 — Pr.
Turner, J. M. W. and Turner,
 Charles — Pr.
Turner, Ross Sterling — Wclr.
Turner of Oxford, William — D.
Turrell, James — Pr.

Twachtman, John Henry — D., Pr.
Twardowicz, Stanley — D.
Tworkov, Jack — D., Pr.

U

Uchima, Ansei — Pr.
Uhl, Joseph — Pr.
Underhill, Dorothy Alice — Ptg.
Urruchua, Demetrio — Pr.
Usher, Leila — S.
Utagawa, Toyokuni — Pr.
Utamaro, Kitagawa — Pr.
Utamaro II — Pr.
Utrillo, Maurice — Ptg., D., Pr.

V

Valadon, Suzanne — D. (attributed to), Pr.
Valerio, Théodore — Pr.
Valenti, Italo — D.
Valentin de Boulogne (attributed to) — Ptg.
Valentin, Henry — Pr.
van der Valk, Maurits Willem — D.
Vallotton, Félix Edouard — Pr.
Van der Poel, Washington Irving — D.
Vanloo, Carle (Charles André Vanloo) — D., Pr.
Varley the Elder, John — D.
Vasarely, Victor — Ptg., Pr.
van Vechten, Carl — Ph.
Vedder, Elihu — Ptg., D.
van de Velde, Adriaen — Ptg.
van de Velde, Esaias — Ptg.
van de Velde II, Jan — Pr.
van de Velde the Younger, Willem — D.
Vénard, Claude — Ptg.
Venezia, Michael — D.
Verboeckhoven, Eugène Joseph — Ptg.
Verboom, Adriaen — Pr.
Verbruggen the Younger, Gaspar Pieter — Ptg.
Veretshchagin, Vassili — Ptg.
Vernay, François (see Baudin, Eugène)
Vernet, Carle — Pr.
Vernet, Joseph — Ptg.
Vernier, Emile — Pr.
Verschuier, Lieve — Ptg.

Verspronck, Jan Cornelis (attributed to) — Ptg.
Verveer, Salomon Leonardus (see Hoppenbrouwers, Johannes Franciscus)
Vesalius, Andreas — Pr.
Vespignani, Renzo — D.
Veyrassat, Jules Jacque — Pr.
Vicente, Esteban — Collage
Vieira da Silva, Maria Helena — Pr.
Villevieille, Léon — Pr.
Villon, Jacques — Pr., Livre d'artiste
de Vilmorin, Louise — Livre d'artiste
Vincent, George — Ptg.
Vinkeles, Reinier — Pr.
Viollet le Duc, Eugène — D.
Visscher, Claes Jansz. — Pr.
Visscher II, Cornelis — Pr.
Vlaminck, Maurice de — Ptg., D., Pr., Livre d'artiste
van Vliet, Jan Georg — Pr.
Volaire, Charles (attributed to) — D.
Vollard, Ambroise, publisher — Pr., Livre d'artiste
Vollon, Antoine — Pr.
Volmar, Joseph Simon (see Géricault, Théodore)
Vordemberge-Gildewart, Friedrich — Ptg.
de Vos, Marten — D.
Vuillard, Edouard — Ptg., D., Pr., Livre d'artiste, Book

W

Wagemaker, Jaap — Collage
Wagner, Wilhelm — Pr.
Wakeman, Marion Freeman — Ptg., D.
Walker, Alexander — Pr.
Walker, Horatio — Wclr.
Walker, S. H. — Ph.
Walkowitz, Abraham — D.
Wallingal, Cecil A. — Ptg.
Walter, Martha — Ptg.
Walters, Harry — D.
Wang Hsi Tch — Pr.
Ward, Charles Caleb — Wclr.
Ward, James — Pr.

Ward, Lynd — Livre d'artiste
Warhol, Andy — Pr.
Warlow, Herbert Gordon — Pr.
Warneke, Heinz — S.
Warren, Marian — Pr.
Washburn, Cadwallader — Pr.
Washburn, Mary N. — Ptg.
Washburn, W. B. — Pr.
Washington, William — Pr.
Wasserman, Cary — Ph.
Waterloo, Antoine — Pr.
Waters, A. W. — Wclr.
Watkins, Carleton — Ph.
Watkins, Franklin — Ptg.
Watson, Elizabeth Taylor — Ptg.
Watts, Frederick W. — Ptg.
Webber, Wesley — Ptg.
Weber, Max — Ptg., Pr.
Weber, Otto — Pr.
Wedgwood, Josiah — S.
Wedin, Elof — Ptg.
Wei Tao-ien — Ptg.
Weidenaar, Reynold Henry — Pr.
Weinzheimer, Friedrich August — Pr.
Weir, Julian Alden — Ptg.
Weirotter, Franz Edmund — Pr.
Wei-tao-rin (attributed to) — Ptg.
Welliver, Neil — Ptg.
Wells Jr., Charles — D., Pr.
Wellstood, William — Pr.
Wendt, Margaret Fabens — Wclr.
Wengenroth, Stow — Pr.
Wessel, Fred — Pr.
West, Benjamin — Ptg.
West of Salem, Benjamin — Ptg.
van Westerhout, Arnold — Pr.
Weston, Edward — Ph.
Weston, Frances Ross — D.
Whinston, Charlotte — D.
Whistler, James Abbott McNeil — Ptg., Pr.
White, Clarence H. — Ph.
White, Minor — Ph.
White, Robert — Pr.
Whitney, Anne — S.
Whittredge, Thomas Worthington — Ptg.
Wickey, Harry Herman — Pr.
Wieghardt, Paul — D.
van Wieringen, Cornelis Claesz. — D.

Wierix, Hieronymous — Pr.
Wiles, Irving R. — Ptg.
Wiley, William T. — Pr.
Wilkie, David — D., Pr.
Wilkinson, Henry — Pr.
Wilkinson, Jack — Ptg.
Willard, Asaph — Pr.
Wille, J. A. — D.
Williams, Gluyas — D.
Williams, Hugh William — D.
Williams, Mary Rogers — Ptg., D.
Williams, Richard E. — Pr.
Williams, William Joseph
 (attributed to) — D.
Williamson Studio, C. H. — Ph.
Wilson, Frank Avray — Pr.
Wilson, John — Ptg., Pr.
Wilson, Richard — Ptg.
Wilson, Robert Wesley — Pr.
Wines, James — Pr.
Winkler, John — Pr.
Woiceske, Ronau William — Pr.
Wolf, Henry — Pr.
Wolfsfeld, Erich — Pr.
Wolgemut, Michael — Pr.
Wong, Anna — Pr.
Wood, Grant — Pr.
Wood, K. J. — D.
Wood, Mary Earl — Ptg.
Wood, Thomas Waterman — Pr.
Woodbury, Charles M. — Pr.
Woodhaven, Charles — Pr.
Woodward, John Douglas — Pr.
Wouwerman, Philips — Ptg.
Wright, Alice Morgan — S.
Wright, George Hand — Pr.
Wright, John Buckland — Pr.
Wright of Derby, Joseph — Ptg.
Wunderlich, Paul — Pr.
Wyant, Alexander Helwig — Ptg.
Wyeth, Andrew — D.

Y

Yale, Leroy Milton — Pr.
Yamada, T. — Pr.
Yamamoto, Sei — Ptg.
Yarde, Richard — Wclr.
Yazz, Beatien — D.
Yazzie, Peter — D.
Yeates, John Butler — D.
Yeisen — Pr.
Yeishi — Pr.

Yeizan, Kikugawa — Pr.
Yoakum, Joseph — D.
Yoshida, Chizuko — Pr.
Yoshida, Hiroshi — Pr.
Yoshida, Toshi — Pr.
Yoshisada — Pr.
Yoshitora — Pr.
Young, Peter — Ptg.
Ysenhut, Lienhart — Pr.
Yunkers, Adja — Pr.
Yunsheng, Yuan — Ptg.

Z

Zaleski, Bronislas — Pr.
Zanetti, Anton Maria — Pr.
Zao Wou-ki — Pr.
Zeeman, Reinier (Rienier Nooms)
 — Pr.
Zetterstrom, Tom — Ph.
Zille, Heinrich — Pr.
Zim, Marco — Pr.
Zimmerman, Catherine — Wclr.
Zoffany, Johann Joseph — Ptg.
Zorn, Anders — Ptg., Pr.
Zuccarelli, Francesco — Ptg.
Zukhotor, Feodor — Wclr.

ARTISTS *AFTER* OTHER ARTISTS

Alkan, S. — Pr. (after Thomas
 Rowlandson)
Andreani, Andrea — Pr. (after
 Alessandro Casolani)
Anonymous — Ptg. (after Chou
 Chen, Correggio, Peter Lely), S.
 (after Alessandro Algardi), D.
 (after Adolphe William
 Bouguereau, Jacques Callot,
 Niccolo Circignani, Polidoro da
 Caravaggio, Jusepe de Ribera),
 Pr. (after G. Barrett, Domenico
 Campagnola, Thomas Cole,
 Anthony van Dyck, Odilon
 Redon)
Aubert, Georges — Pr. (after Pablo
 Picasso)
Audran, Jean — Pr. (after Antoine
 Watteau, Adriaen van der
 Werff)

Bargue, Charles — Pr. (after
 Auguste Toulmouche)
Baron, Bernard — Pr. (after
 William Hogarth)
Bartoli, Gennaro — Pr. (after Carl
 Hackert)
Bartolozzi, Francesco — Pr. (after
 William Hamilton, Hans
 Holbein the Younger, Mattia
 Preti)
Beatrizet, Nicolas — Pr. (after
 Michelangelo)
Belin-Dollet, Georges Gaspard —
 Pr. (after Jean-François Millet)
Blake, William — Pr. (after William
 Hogarth)
Blooteling, Abraham — Pr. (after
 Peter Lely)
Bolswert, Schelte A. — Pr. (after
 Peter Paul Rubens)
Bond, William — Pr. (after Simon
 de Koster)
Bonnard, Pierre — Pr. (after Paul
 Cézanne)
Bonnet, Louis-Marin — Pr. (after
 François Boucher)
Bowen, J. T. — Pr. (after John
 James Audubon)
Boydell, Josiah — Pr. (after William
 Leney, James Ogborne,
 Rembrandt van Rijn)
Boys, Thomas Shotter — Pr. (after
 John Ruskin)
Bracquemond, Félix Auguste Joseph
 — Pr. (after Gustave Courbet,
 Eugène Delacroix)
Brandard, Robert — Pr. (after
 William Henry Bartlett)
Brillon (Brion), Etienne — Pr. (after
 Antoine Watteau)
Bromley, William — Pr. (after
 Thomas Stothard)
Browne, John — Pr. (after William
 Hodges)
van der Bruggen, Jan — Pr. (after
 Anthony van Dyck)
Buillard, E. — Pr. (after Paul
 Cézanne)
Burke, Thomas — Pr. (after William
 Hamilton)
Burt, Charles — Pr. (after Richard
 Caton Woodville, Sr.)

Büsinck, Ludwig — Pr. (after Abraham Bloemaert, Georges Lallemand)

de Bye, Marcus — Pr. (after Marcus Geeraerts)

Canot, P. — Pr. (after R. Short)

Cardon, Anthony (Antoine) — Pr. (after Francis Wheatley)

da Carpi, Ugo — Pr. (after Raphael)

Carracci, Agostino — Pr. (after Jacopo Tintoretto, Paolo Veronese)

Challis, E. — Pr. (after E. Walker)

Champney, James Wells — D. (after Raphael)

Cole, Timothy — Pr. (after George de Forest Brush, Thomas Gainsborough, Leonardo da Vinci, George Romney, Andrea del Sarto, Jacopo Tintoretto, J. M. W. Turner, Jan Vermeer), Woodblock (after Bartholomeus van der Helst)

Cole, Walter — Pr. and Woodblock (after Diego Velasquez)

Coriolano, Bartolomeo — Pr. (after Guido Reni)

Cousen, J. — Pr. (after William Henry Bartlett)

Cunego, Domenico — Pr. (after Jacopo Bassano, Annibale Carracci)

Delaunay, Nicolas — Pr. (after Jean-Honoré Fragonard, Niclas Lafrensen)

Delaunay, Robert — Pr. (after Charles Nicolas Cochin)

Delff, Willem Jacobsz. — Pr. (after David Bailly, Paulus Moreelse)

Delfos, Abraham — Pr. (after Jan de Beyer)

Demarteau, Gilles — Pr. (after Peter Paul Rubens)

Demarteau, Serviteur — Pr. (after Jean-Baptiste Huet)

Denis, Maurice — Pr. (after Paul Cézanne)

Dente da Ravenna, Marco (attributed to) — Pr. (after Marcantonio Raimondi)

Donaldson Art Sign Company, publisher — Pr. (after William Harnett)

Doney, Thomas — Pr. (after George Caleb Bingham)

Drevet, Pierre-Imbert — Pr. (after Carle Vanloo)

van Duetecum, Jan or Lucas (attributed to) — Pr. (after Pieter Brueghel the Elder)

Dunhier, B. A. and Eccher, M. G. — Pr. (after Jacob Philipp Hackert)

Earlom, Richard — Pr. (after Claude Lorrain, Gainsborough Du Pont, Henry Fuseli, Joseph Wright of Derby, John Zoffany)

Eccher, M. G. (see Dunhier, B. A.)

Edelinck, Gerard — Pr. (after Hyacinthe Rigaud, Andreas Stech)

Faber Jr., John — Pr. (after John van der Bank, Godfrey Kneller)

Ficquet, Etienne — Pr. (after Charles Eiser)

Fittler, James — Pr. (after Francis Wheatley)

Flameng, Leopold — Pr. (after Rembrandt van Rijn)

Franquinet, Willem Hendrik — Pr. (after Philips Wouwerman)

Froment, Eugène — Pr. (after Henri Fantin-Latour)

Gaugain, Thomas — Pr. (after Richard Westall, Francis Wheatley)

Girard, Louise — Pr. (after Jean-Auguste-Dominique Ingres)

Girard, Marie François — Pr. (after Ary Scheffer)

Goltzius, Hendrik — Pr. (after Bartholomaeus Spranger)

Goudt, Hendrik — Pr. (after Adam Elsheimer)

Green, Valentine — Pr. (after Joseph Wright of Derby)

Grignioni, Charles — Pr. (after William Hogarth)

Hackert, George — Pr. (after Jacob Philipp Hackert)

Harding of Deerfield, James — Pr. (after William Leighton Leitch)

Havell the Elder, Robert — Pr. (after William Havell)

Havell Jr., Robert — Pr. (after John James Audubon)

Haward, Francis — Pr. (after Joshua Reynolds)

Hertel, G. L. — Pr. (after Rembrandt van Rijn)

Hollar, Wenceslaus — Pr. (after Hans Holbein the Younger)

Hopfer, Hieronymous — Pr. (after Albrecht Dürer)

Houbraken, Jacobus — Pr. (after Arthur Pond, Jonathan Richardson the Elder, Peter Paul Rubens)

Huber, Adriaen — Pr. (after Martin Schongauer)

Ingouf the Younger, François Robert — Pr. (after Sigmund Freudeberg)

Jacobé, John — Pr. (after George Romney)

Jacquemart, Jules Ferdinand — Pr. (after Jan Vermeer)

Jones, Alfred — Pr. (after Francis William Edmonds, Emmanuel Leutze, Richard Caton Woodville, Sr.)

Jones, John — Pr. (after Joshua Reynolds)

Jukes, Francis — Pr. (after G. Barrett)

Kellog, Daniel Wright and Co. — Pr. (after Richard Westall)

Kingsley, Elbridge — Pr. (after Jean-Baptiste Camille Corot, Charles-François Daubigny, Narcisse Virgile Diaz de la Peña, Georges Michel, Albert, Pinkham Ryder, Théodore Rousseau, Dwight W. Tryon)

Lalanne, Maxime — Pr. (after Constant Troyon)

Landgridge, James L. — Pr. (after John Douglas Woodward)

Lankes, Julius J. — Pr. (after Charles Burchfield)

de Larmessin IV, Nicolas — Pr. (after Antoine Watteau)

Laurens, Jean Paul — Pr. (after Eugène Delacroix)

Legat, Francis — Pr. (after James
Northcote, George Romney)

Legros, Alphonse — Pr. (after
Edward Poynter)

Leney, William — Pr. (after Josiah
Boydell, John Downman)

Leroy, Alphonse — Pr. (after
Raphael)

Le Sueur, Nicolas — Pr. (after
Raphael)

Liotard, Jean Etienne — Pr. (after
Antoine Watteau)

Loemans, Arnold — Pr. (after
Abraham Bosse)

Loggan, David — Pr. (after Godfrey
Kneller)

Lombart, Pierre — Pr. (after
Anthony van Dyck)

de Longueil, Joseph — Pr. (after
Sigmund Freudeberg)

Lopisgich, Georges A. — Pr. (after
Rembrandt van Rijn)

de Loutherbourg, Philip James —
Pr. (after Jean Claude Richard,
Abbé de Saint-Non)

Lowell, John A. & Co. — Pr. (after
Winslow Homer)

Lucas, David — Pr. (after John
Constable)

Mansfeld, Johann Ernst — Pr. (after
Ant. v. Wenzely)

Masson, Antoine — Pr. (after
Nicholas Mignard)

Matham, Jacob — Pr. (after P.
Moreelse)

Matisse, Henri — Pr. (after Paul
Cézanne)

McArdell, James — Pr. (after Joshua
Reynolds)

Middiman, Samuel — Pr. (after
Robert Smirke)

Milius, Félix Augustin — Pr. (after
Francisco Goya)

Mills, J. — Pr. (after William
Hogarth)

Moitte, Pierre Etienne — Pr. (after
Maurice Quentin de la Tour)

Moreau the Younger, Jean-Michel
— Pr. (after Pierre Antoine
Baudouin)

Moreland, George — Pr. (after J.R.
Smith)

Morel-Lamy, Félix — Pr. (after
Jean-Baptiste Camille Corot)

Morghen, Raphael — Pr. (after
Raphael)

Moyreau, Jean — Pr. (after Antoine
Watteau)

Muller, Jan — Pr. (after Heinrich
Aldegrever)

de Necker, Jost — Pr. (after Hans
Leonard Schäufelein)

Nitot, Michel (called Charles
Dufresne) — Pr. (after Titian)

Noël, Alphonse-Léon — Pr. (after
William Sidney Mount)

Ogborne, James — Pr. (after Josiah
Boydell, Robert Smirke)

Ormsby — Pr. (after Trumbull)

Osborne, Malcolm — Pr. (after
Andrew Richardson)

Overadt, Peter — Pr. (after Albrecht
Dürer)

Parker, James — Pr. (after Richard
Westall)

Parmigianino (Francesco Mazzola)
— Pr. (after Raphael)

Perfetti, Antonio — Pr. (after Guido
Reni)

Pether, William — Pr. (after Joseph
Wright of Derby)

Playter, Charles Gauthier — Pr.
(after James Northcote)

Ploos van Amstel, Jacob Cornelius
— Pr. (after Adriaen van
Ostade)

Polanzani, Felice — Pr. (after
Giovanni Battista Piranesi)

Ponce, Nicolas — Pr. (after Charles
Nicolas Cochin)

Pontius, Paul — Pr. (after Anthony
van Dyck)

Prang, Louis and Co., publisher —
Pr. (after Winslow Homer)

Prud'hon, Jean — Pr. (after Pierre
Paul Prud'hon)

Purcell, Richard — Pr. (after Joshua
Reynolds)

Pye, John — Pr. (after J. M. W.
Turner)

Raimondi, Marcantonio — Pr. (after
Raphael)

Ravenet, Simon François — Pr.
(after William Hogarth)

Reeve, R. G. — Pr. (after Samuel
Owen)

Romanet, Antoine Louis — Pr.
(after Jean-Michel Moreau the
Younger)

Rosaspina, Francesco — Pr. (after
Parmigianino)

Roussel, Ker-Xavier — Pr. (after
Paul Cézanne)

Ryder, Thomas — Pr. (after James
Durno, William Hamilton,
Johann Heinrich Ramberg, John
Francis Rigaud, Thomas
Stothard)

Sadd, Henry S. — Pr. (after Gilbert
Stuart)

Sadeler, Aegidius — Pr. (after Peter
Stevens)

Sadeler, Raphael (attributed to) —
Pr. (after Albrecht Dürer)

Saenredam, Jan Pietersz. — Pr.
(after Hendrik Goltzius)

Saint-Non, Jean Claude Richard,
Abbé de — Pr. (after Hubert
Robert)

Sands, Robert — Pr. (after William
Henry Bartlett)

Say, William — Pr. (after J. M. W.
Turner)

Schiavonetti, Luigi — Pr. (after
William Blake, Angelica
Kauffman)

Schmidt, Georg Friederich — Pr.
(after Pietro Testa)

Schultze, Christian Gottfried — Pr.
(after Marie Louise Elizabeth
Vigée Le Brun)

van Schuppen, Pierre Louis — Pr.
(after Jean Nocret the Elder)

Scotin, Gérard J. B. — Pr. (after
Ferdinand S. Delamonce,
William Hogarth)

Sharp, William — Pr. (after
Anthony van Dyck, Benjamin
West)

Sherwin, John Keyes — Pr. (after
Richard Cosway, William
Hogarth)

Simon, Jean-Pierre — Pr. (after
James Northcote, Matthew
Peters, Robert Smirke, Richard
Westall, Francis Wheatley)

Simonet, Jean Baptiste — Pr. (after Pierre Antoine Baudouin, Jean-Michel Moreau the Younger)

Skelton, William — Pr. (after James Northcote)

Skippe, John — Pr. (after Andrea del Sarto)

Smart, R. W. — Pr. (after Richard Banks Harraden)

Smillie, James D. — Pr. (after Thomas Cole, Jasper F. Cropsey)

Smith, Benjamin — Pr. (after Thomas Banks, George Romney)

Smith, John Raphael — Pr. (after Joshua Reynolds, Joseph Wright of Derby)

Soiron, F. D. — Pr. (after Henry Singleton)

Soulange-Teissier, Louis Emmanuel — Pr. (after William Sidney Mount)

Stadler, Joseph Constantin — Pr. (after Auguste C. Pugin)

Strange, Robert — Pr. (after Jean Baptiste Greuze)

Strixner, Johann Nepomuk — Pr. (after Dietrich Meyer, Ventura Salimbeni)

Sullivan, Luke — Pr. (after William Hogarth)

Suyderhoef, Jonas — Pr. (after Hendrik Goltzius)

Teyssonnières, Pierre (Tessionieres, T. E.) — Pr. (after Winslow Homer)

Thew, Robert — Pr. (after William Hamilton, John Hoppner, James Northcote, John Opie, Matthew Peters, Robert Smirke, Richard Westall, Joseph Wright of Derby)

Thoma, Hans — Pr. (after Leonardo da Vinci)

Tiepolo, Giovanni Domenico — Pr. (after Giovanni Battista Tiepolo)

Turner, Charles — Pr. (after J. M. W. Turner)

Vendramini, Giovanni — Pr. (after Francis Wheatley)

Villon, Jacques — Pr. (after Marcel Duchamp, Pablo Picasso)

Vivarès, François — Pr. (after Nicolas Berchem)

Volpato, Giovanni — Pr. (after Raphael)

Vorsterman, Lucas — Pr. (after Peter Paul Rubens)

Wallis, Robert — Pr. (after William Henry Bartlett)

Ward, James — Pr. (after Joseph Wright of Derby)

Watson, Caroline — Pr. (after Joshua Reynolds, Francis Wheatley)

Watson, James — Pr. (after Joshua Reynolds)

Watson, Thomas — Pr. (after Joseph Wright of Derby)

Weisbrodt, Carl — Pr. (after Adriaen van de Velde)

van Westerhout, Arnold — Pr. (after Francesco Fontana)

White, Robert — Pr. (after Godfrey Kneller)

Wierix, Hieronymous — Pr. (after Marten de Vos)

Wilkin, Charles — Pr. (after John Hoppner)

Wille, Johann Georg — Pr. (after Maurice Latour, Etienne Parrocel)

Willmore, James Tibbitts — Pr. (after William Henry Bartlett, Thomas Creswick)

Wolf, Henry — Pr. (after Jean Léon Gérome, Homer Dodge Martin, Michel Realier-Dumas, James Abbott McNeill Whistler)

Selected publications of the Smith College Museum of Art

COLLECTIONS CATALOGUES

1985 *Nineteenth and Twentieth Century Prints, The Selma Erving Collection.* Essays by Charles Chetham and Elizabeth Mongan. Catalogue by Colles Baxter, Sarah Ulen Henderson, Leslie Mitchell, Elizabeth Mongan, Linda D. Muehlig, Nancy Sojka, Christine Swenson, and Marilyn Symmes. Edited by Nancy Sojka and Christine Swenson. 162 illustrations, 140 pp.

1977 *The Selma Erving Collection, Modern Illustrated Books.* Introduction by Charles Chetham. Essay by Ruth Mortimer. Catalogue by Colles Baxter, Charles Chetham, Betsy B. Jones, John Lancaster, Linda D. Muehlig, Sarah Ulen. Edited by John Lancaster. 59 illustrations, 60 pp.

1970 *19th and 20th Century Paintings from the Collection of the Smith College Museum of Art.* Edited by Mira Matherny Fabian, Michael Wentworth, and Charles Chetham. 58 illustrations, 104 pp.

1963 *Archaic Chinese Jades, Mr. and Mrs. Ivan B. Hart Collection.* Introduction by Charles MacSherry. Catalogue by Elizabeth Lyons. Edited by Robert J. Poor. 50 illustrations, 70 pp.

1937 *Smith College Museum of Art Catalogue.* Foreword by William Allan Neilson. Introduction by Jere Abbott. 115 illustrations, 136 pp. *Supplement*, 1941, 32 illustrations, 45 pp.

1925 *Handbook of the Art Collections of Smith College.* Preface by Alfred Vance Churchill. 43 illustrations, 80 pp.

EXHIBITION CATALOGUES

1985 *Chester Michalik: Photographs.* Introduction by William L. MacDonald. 19 illustrations, 32 pp.

1983 *Edwin Romanzo Elmer 1850 – 1923.* Biography and catalogue raisonné by Betsy B. Jones. 175 illustrations, 180 pp. Distributed by the University Press of New England, Hanover, New Hampshire.

1982 *Charles Hullmandel and James Duffield Harding: A Study of The English Art of Drawing on Stone 1818 – 1850.* By Christine Swenson. 24 illustrations, 46 pp.

1981 *Speaking a New Classicism: American Architecture Now.* Essays by Helen Searing and Henry Hope Reed. 48 illustrations, 72 pp.

1980 *The Bodhisattva and the Goddess: Deities of Compassion in Buddhist and Hindu Art.* Catalogue by Marylin Rhie. Essays by Dennis Hudson and Taitetsu Unno. 51 illustrations, 116 pp.

1980 *Promoted to Glory: The Apotheosis of George Washington,* By Patricia Anderson. 58 illustrations, 67 pp.

1979 *Antiquity in the Renaissance.* By Wendy Stedman Sheard. Foreword by Charles Chetham. 178 illustrations, 240 pp.

1979 *Degas and the Dance.* By Linda D. Muehlig. 35 illustrations, 56 pp.

1977 *Michael Singer.* Essay by Lucy Lippard. 6 illustrations, 16 pp.

1976 *Joseph Whiting Stock.* Preface by Betsy B. Jones. Essay by Juliette Tomlinson. 44 illustrations, 40 pp.

1976 *S. S. Carr.* By Deborah Chotner. 27 illustrations, 40 pp.

1974 *Abbott/Frankenthaler/Grosman/Nevelson.* Introduction by Charles Chetham. Essays by Marilyn Symmes, Ellen R. Berezin, and Elizabeth Evans. 5 illustrations, 13 pp.

1967 *Clarence Kennedy* (Exhibition of photographs organized by the Museum Seminar). Foreword by Charles Chetham. Essay by Beaumont Newhall. 22 illustrations, 48 pp.

1967 *A Land Called Crete: Photographs of Minoan and Mycenaean Sites and Works of Art by Alison Frantz.* Foreword by Machteld J. Mellink. 53 illustrations, 71 pp.

1967 *A Land Called Crete: Minoan and Mycenaean Art from American and European Public and Private Collections.* Essay by Alden Murray. 81 illustrations, 60 pp.

1966 *Fantin-Latour.* By Charles Chetham. 26 illustrations, 66 pp.

1965 *Chinoiserie.* By Hugh Honour and Nelly Schargo Hoyt. 32 illustrations, 68 pp.

1965 *Willem de Kooning.* By Dore Ashton and Willem de Kooning. 30 illustrations, 48 pp.

1964 *Renaissance Bronzes in American Collections.* Introduction by John Pope-Hennessy. 28 illustrations, 66 pp.

1963 *Robert Motherwell.* By Margaret Paul. 14 illustrations, 32 pp.

1962 *Antique Greek and Roman Coins Accompanied by Some Renaissance Illustrated Books.* Introduction by Patricia Milne-Henderson. Essays by Cornelius C. Vermeule III and Reziya Ahmad. 16 plates, 56 pp.

1961 *Piranesi.* Introduction by Robert O. Parks. Essays by Philip Hofer, Karl Lehmann, and Rudolf Wittkower. 57 illustrations, 160 pp.

1952 *The Crystal Palace. The Structure, Its Antecedents, and Its Immediate Progeny.* By Henry Russell Hitchcock. 5 illustrations, 38 pp.

1951 *Winslow Homer: Illustrator.* Foreword by Henry Russell
 Hitchcock. Catalogue, checklist of wood engravings, and list of
 illustrated books by Mary Bartlett Cowdrey. 24 illustrations, 66 pp.

PERIODICALS

Journal, Smith College Museum of Art (1982 to present).

Smith College Museum of Art Bulletin, nos. 1–41 (1920–1961).

ADDITIONAL PUBLICATIONS

"Why the College Should Have Its Gallery of Art," Smith College
Alumnae Quarterly. By Charles Chetham. February, 1980. 15
illustrations, 6 pp.

"The New Smith College Museum of Art," *Art Journal.* By
Charles Chetham. Spring 1974, 4 illustrations, 7 pp.

THE SMITH COLLEGE MUSEUM OF ART
The Smith College Museum of Art is managed by the Trustees of Smith College and is supported primarily through private gifts. Its purpose is to give college students direct acquaintance with original works of art. The permanent collections of the Museum are supplemented by special exhibitions and by loans from other institutions and from private collections. Although an integral part of the College, which is a private institution, the Museum is open to the public without charge.

GIFTS AND BEQUESTS
The growth of the Museum is assured by donation of funds and by bequests for the purchase of additions to the collection. Donations of works of art are welcome. Names of donors and those honored are permanently linked to gifts. The Director is pleased to discuss offers of assistance for the work of the Museum.

MUSEUM MEMBERSHIP
Museum Members, Smith College Museum of Art, an organization of friends and supporters of the Museum, has continued to grow since its founding in 1920. Today, with a nationwide enrollment of over eight hundred, the Members contribute enthusiasm and vital financial support in aid of the Museum's program of exhibitions, publications, and cultural events. Members receive invitations to exhibition openings, lectures, concerts, films, Museum trips, and all events associated with the annual Members' Day. Members also receive copies of Museum catalogues, newsletters, posters, and the *Journal, Smith College Museum of Art.* To become a member, please contact the Membership Secretary.

Smith College Museum of Art, Elm Street (Route 9) at Bedford Terrace, Northampton, Massachusetts 01063.
Telephone (413) 584–2700, extension 2770.

By Car

From the South: Route 91 North to the first Northampton exit (number 18), down the ramp, turn left onto Route 5 to the center of Northampton, turn left on route 9 west.

From the North: Route 91 South, to the first Northampton exit (number 20), down the ramp, follow Route 5 to the center of Northampton, turn right onto Route 9.

By Bus

Greyhound, Vermont Transit, and Peter Pan serve the area. The bus station is four blocks from the Museum, and taxis are available.

By Air

Bradley International, serving the Springfield-Hartford area and 35 miles from Northampton, is the nearest airport.

Ten thousand copies of this book, designed by
Gilbert Associates, typeset in Mergenthaler Optima,
have been printed at Meridian Printing in December, 1986
for the Smith College Museum of Art.